# DRAWING, DESIGN, AND CRAFT-WORK

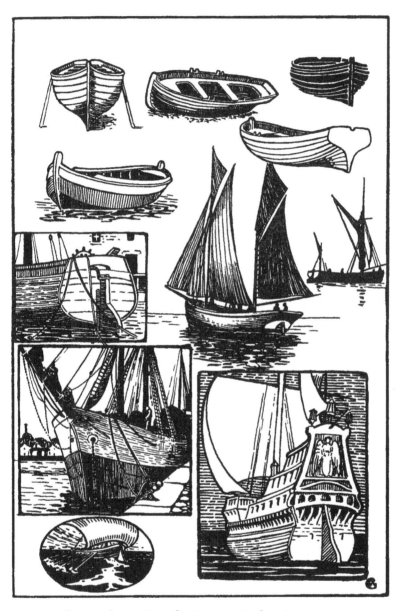

Boats—Suggestions for treatment of various types.

# DRAWING, DESIGN, AND CRAFT-WORK

by

*Frederick J. Glass*

YESTERDAY'S CLASSICS

ITHACA, NEW YORK

This edition, first published in 2018 by Yesterday's Classics, an imprint of Yesterday's Classics, LLC, is an unabridged republication of the text originally published by B. T. Batsford Ltd. in 1920. For the complete listing of the books that are published by Yesterday's Classics, please visit www.yesterdaysclassics.com. Yesterday's Classics is the publishing arm of the Baldwin Online Children's Literature Project which presents the complete text of hundreds of classic books for children at www.mainlesson.com.

ISBN: 978-1-63334-097-8

Yesterday's Classics, LLC
PO Box 339
Ithaca, NY 14851

# PREFACE

THIS little book, which is the outcome of some fourteen years' teaching experience, was originally suggested by my work in connection with the training of teachers. I was often asked to recommend some book dealing concisely with the various subjects touched upon in the course of instruction. I was not acquainted with one which exactly met the need, and it was suggested to me that I should arrange my notes in book form. This I have done in the hope that they may be of some service to teachers, and others; especially at this juncture when Art training seems likely to take its proper place in the scheme of Education. This book does not pretend to deal exhaustively with any of the subjects touched upon, but is intended more as a series of suggestions upon which teachers may build up their own schemes, and also as an introduction to the subjects for the benefit of amateurs. Nor has any attempt been made to arrange the work in exercises suitable for the pupils of various years, since the classes differ so much in separate schools that only the teacher in charge of the particular class can form any estimate of what is suitable or otherwise.

I can only hope that the suggestions given here may be of use to teachers, students, and others interested

in the plastic and graphic Arts, for much work still remains to be done before these subjects can occupy their proper sphere in the life of the nation.

This book is also intended to meet the requirements of the syllabus recently issued by the Board of Education.

My thanks are due to Mr. W. A. Burton for the photographs which appear in this book, and for his kind permission to publish the illustration of filagree work executed by him.

FRED. J. GLASS.

LONDONDERRY,
*July*, 1920.

# CONTENTS

# CHAPTER I

# INTRODUCTION

"You've seen the world—
The beauty and the wonder and the power,
The shapes of things, their colours, lights and shades
Changes, surprises—and God made it all!
For what? do you feel thankful, aye or no?
    What's it all about?
To be passed o'er, despised? or dwelt upon
Wondered at? Oh! this last of course, you say."

—BROWNING.

IT is hardly necessary to-day to advance a plea for the teaching of drawing, design, and craft-work. Their importance is, or should be, recognised by all authorities on education. It is well, however, that the teacher should have a clear comprehension of the part played by these subjects in the development of the intellect and character of the scholar. This is essential, firstly, that he may have confidence in his teaching, with a corresponding strength of purpose and enthusiasm; and, secondly, that he may be in a position to defend effectively his belief in the work he is doing. Despite

1

the fact that the majority of educational authorities recognise its value, critics still abound who would have us believe that such work merely panders to effeminate tastes and a love of luxury, whilst denying its practical utility. Such critics need to be confuted; and this can only be done by formulating definite reasons for the serious study of the subjects in hand. At the outset we must recognise that man is complex and many sided, hence his needs are complex and multifarious. An unfortunate tendency exists in some quarters to regard human beings merely as productive machines with a capacity for executing so much work upon which the profit (usually accruing to those holding this view) will be so much, and that education should, therefore, be designed on this basis. Such an opinion is unworthy of consideration, and may be dismissed at once. It must be granted that, as far as possible, all human capacities are worth developing, otherwise the curriculum will have a bias, tending to develop certain faculties, leaving others to become atrophied. It is in some such comprehensive scheme that art work, as here dealt with, plays its part. It develops certain powers for which no scope is permitted in other subjects. The faculty of observation is quickened by training the vision, whilst the memory is cultivated to retain the images thus correctly seen. Drawing is a method of expression older by far, and more natural than writing, for the alphabet in use to-day is a development of early picture writing. Again, the child as soon as he can walk endeavours to express graphically the beings and objects amongst which he lives, making no attempt to write.

It is interesting to note the gradual progression of these childish efforts even without guidance. The first productions are unintelligible to all but the child who readily gives names to them. Then shapes begin to appear, almost invariably men and houses—the first things about which the child has definite thoughts. As the mental power grows the house will develop chimneys, windows, and a door; the man will become possessed of arms, legs, a body, and a head with features, for which details there has previously been a sublime disregard. With the increase of ideas the need for expression will expand, and boats, horses, engines, trees, and even sky and clouds are attempted, all regardless of such trifling things as proportion, perspective, or colour. They are statements of impressions made upon the consciousness, knowledge gained from feeling, smelling, tasting, and hearing, as well as seeing. The wise teacher bears this in mind and encourages the individuality. The first lesson for infants should be an opportunity for the expression of thought, and the things drawn will be those which are clearest in the mind. Objects and people at home, toys and characters from nursery rhymes—things which have impressed him. The savage, too, unable to write, draws. Our prehistoric forefathers have left us rude representations of animals drawn long before writing came into use. The creative faculties are also encouraged by this work, and the love of making things (common to all healthy children) is turned to educational advantage. At the same time there is inculcated a sense of neatness and accuracy combined with skill in handling tools. This results in a perfect harmony between brain and

muscle, unattainable by any other means. Finally it develops an appreciation of the beautiful, thus adding a source of enjoyment capable of giving much pleasure. Taste grows also as the mind unfolds, and, if wisely directed, will lead to the choice of beautiful objects with which to surround themselves. This will have its effect in the home, in the buildings and streets of cities, towns, and villages, which sadly need beautifying; and the beautifying of the environment will react on the minds and characters of the generations growing under its influence. The influence of environment is too widely recognised to need dilation.

Reasons enough surely for the inclusion of the work in our school curriculum!

Much harm has been done in the past by unintelligent methods of teaching. A copy was put before the pupil (beautiful enough perhaps to one capable of appreciation, but to the child meaningless) and the order issued "Copy that!" No explanation of its meaning or wherein lay its beauty, for too often the teacher would have been nonplussed if asked to explain it. And so the drawing lesson was usually a period of boredom. This can hardly be called drawing instruction, for unless the interest is aroused, and the mind fixed on the subject in hand, no impression is made, and as far as education is concerned the time is wasted.

This difficulty still presents itself, and will continue to do so. The teacher's aim must be always to hold the interest of the class. Presuming that the lesson we have in hand is a first lesson to young children, it is easy

to make it worrying or boring by insisting too much upon the correct method of holding chalk, crayon, or pencil, or by setting an uninteresting subject. Lead up to methods of handling by easy stages.

## MATERIALS

The materials at our command are chalk, charcoal, pencils, H., H.B., and B., india-rubber, pen, Indian ink, brush, water or body colour, clay, modelling paste or plasticine, and paper.

**CHALK:** For chalk a specially prepared blackboard is best, but linoleum, or American Morocco cloth of dull surface, or even brown paper, make good substitutes.

**CRAYON OR CHARCOAL:** For crayon or charcoal, brown paper or tinted crayon paper are used in addition to white. The best paper for charcoal is that which is specially prepared for the purpose, "Michallet" or "Ingres." These can be obtained in buff, white, and grey, and drawings of practically any degree of finish can be executed upon them. A beautiful range of tone from a delicate grey to a velvety black is easily obtainable with charcoal, and it may be rubbed with the finger or stump to produce even tones, the lights being picked out with chamois leather, bread, or rubber.

**CRAYON:** Crayons bring in colour, and as colour has a strong appeal for the child, an early use is recommended. The soft type are preferable, being easy to handle, the only drawback is that they smudge easily and are very fragile. The wax crayons are stronger and

do not rub so easily, but they are less sympathetic. Each pupil should be supplied with a box and taught the names of the colours, beginning with the primaries— red, yellow, and blue. Crayons are excellent for mass drawing on brown paper, and may also be used for pattern, object, and nature drawing. The teacher should instruct the class in the use of the crayon and show them how to obtain the secondary colours by mixing two primaries, red and yellow = orange; red and blue = purple, and yellow and blue = green. The mixing may be done either by rubbing one colour over another, or by placing alternative strokes of the two colours side by side, the effect of which will be a blend of the primaries resulting in the desired secondary. Textures may also be suggested by varying the direction and quality of the stroke.

**TINTED PAPER**: Tinted paper should be selected with the desired result in mind; thus, china and glass on grey paper could be represented with chalk for the high lights and charcoal for the shade. White objects on white paper can be represented by toning the background. Again the crayon is applied openly, with a space between each stroke; the colour of the paper helps to bind the tints together and so to produce harmony. Light and shade of a simple nature should be attempted at an early stage, such as fruit with a spot of high light and a passage of shade, leaves with light on one side and dark on the other, etc.

**PENCIL**: This is perhaps the most useful of all the implements in use. For freehand a fairly soft *pencil*

is best as it requires but little pressure; B. or H.B. is the most useful, while for geometrical work an H. is necessary. The pupil should be taught to sharpen the pencil correctly, as a poor point is difficult to draw with. The cut should taper smoothly and evenly to the point, with no unsightly jags. The chief danger to be guarded against in this work is holding the pencil too stiffly and using the fingers only instead of the whole arm, for wrist, elbow, and shoulder joints should be allowed free play. This the teacher must watch, the more so as the writing lesson tends to restrict the free play of joints. The most suitable position for the paper in free drawing is nearly vertical, with the pencil lightly held between the thumb and the first two fingers, and the little finger resting lightly on the paper. Easels, or a specially constructed stand, for the board (with the paper pinned on it) to lean against whilst the lower edge rests on the knees, are the most suitable for free drawing.

For geometrical and the more accurate types of drawing a desk, or table with a board rest, is necessary. Heavy lines that plough into the paper should be discouraged, but at the same time the pupil should be instructed to take advantage of the whole range of which the pencil is capable, from a delicate grey to a velvety black. The system of "lining in" with a thin wirey line is of no value. Let the aim be the representation of form; suitable methods of expression will follow, and at any time a varied line is better than a thin monotonous one.

**RUBBER:** The rubber should be soft, or the surface of the paper will be destroyed. Some teachers advocate the abolition of the rubber owing to its abuse, but it is very doubtful whether any useful purpose would be served. It might be withdrawn occasionally as a disciplinary measure if the teacher feels that the pupils are using it too much; the best corrective, though, is brush drawing.

**BRUSH:** The brush is the most sympathetic of all the implements used in drawing. It should be of good quality, even for beginning. Sable is best, but fitch is a good substitute; camel hair is poor, and, excepting a large one for laying washes, brushes of camel hair are not worth while, as the hair has a tendency to stay at an awkward angle to the shaft when in use. Sable and fitch have more spring and will return instantly to the straight when lifted from the paper.

**WATER-COLOUR:** Water-colour is useful for brush work, exercises in colour, still-life, etc. (See Colour Section, Chapter IV.)

**BODY COLOUR:** Body colour is the term used to distinguish between opaque colour and transparent water-colour. In water-colour, as generally understood, the light is supplied solely by the white paper upon which the work is executed. The colour is applied in transparent washes in such a way as to tint the surface to the required depth. The light parts would consequently receive a thinner wash (*i.e.* the paper would shine through more distinctly) than in the dark portions, where the light of the paper requires veiling. With body

colour the paper plays no part in the lighting. This is obtained by the use of an opaque white pigment, either Chinese white mixed with transparent colour to give it body and to render it opaque, or powder colour ground with gum and glycerine, or other suitable medium. The sketches of Brabrizon show the use of Chinese white with water-colour, and the colour is very charming, the lights being of a beautiful pearl-tinted quality. For larger work of a coarser nature, such as scene painting, powder colour mixed with glue size is frequently used.

**TEMPERA:** Yolk of egg is another medium, and tempera colour in tubes can be purchased from fine art dealers. For poster work Winsor and Newton Matt colours, or the Clifford Milburn colours are useful. They dry flat and are even in texture. For designs and work intended for reproduction, when an even flat surface is desired, body colour is of great value.

**MODELLING CLAY:** For modelling, clay is the most sympathetic and most easily handled material. It works smoothly and freely, and a good surface is readily obtainable. It is perhaps a trifle messy for very elementary pupils, and it needs some attention to keep it in a workable condition.

**PLASTICINE:** Plasticine or modelling paste is therefore often used in preference, as it is cleaner and more easily kept, but for any work of importance, or requiring a good finish, clay is decidedly the best.

## FIRST LESSONS

**THOUGHT AND EXPRESSION:** Drawing is a method of expression, but unless there is something to express, the acquisition of a method is useless, hence the primary aim of the drawing lesson should be the formulating of clear definite thoughts, together with practice in expressing them. A thing must be seen intelligently before it can be drawn correctly, and the quality of thought behind the look determines the accuracy of the vision. "The eye sees only that which it brings the power to see." Bad drawing is the result of wrong thinking, and the mental effort made by the child is of greater importance than the actual drawing. Aim then at teaching the child to think; facility in expression will follow. If something really needs expressing it will find a medium somehow. A certain amount of instruction in holding chalk, crayon, or pencil, and in controlling the muscles involved is necessary at first.

**CHALK DRAWING:** A few exercises in free-arm chalk drawing, similar to those illustrated on **Plate 1**, will be useful. Oval and circular forms, swinging curves, and exercises based on letter forms (all easily and naturally obtained) afford fine practice in control and freedom. The interest and mental effort is enhanced by allowing the child to embellish and elaborate, producing animal, bird, flower, or any form that fancy may dictate. The teacher should demonstrate the swing of the arm, using shoulder, elbow, and wrist, just to indicate the method. The exercises based on simple letter forms (**Plate 1**)

10

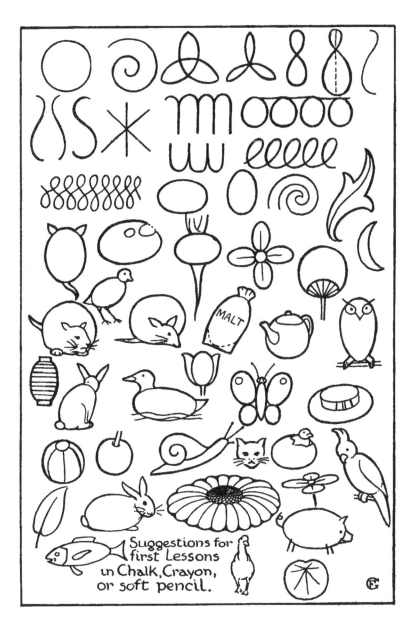

PLATE 1—*Suggestions for Free-arm Exercises in Chalk, Crayon, or Soft Pencil*

is a useful adjunct to the writing lesson, and helps to counteract the cramping tendency of that lesson. This might be followed by vertical, horizontal, and oblique strokes, turned later into boxes, houses, frames, or anything else that encourages thought. See that the lines are free, bold, and decided, for self-reliance and decision are worth developing.

As soon as interest begins to flag, start something else, for nothing is achieved by keeping children at a lesson that has become boring. It is well to return to blackboard work from time to time, between the later exercises in pencil, colour, etc., for the sake of its freedom.

**PENCIL:** For pencil work a soft pencil (say a B.) is preferable, and here again methods of handling might form the first lesson. Just show them how to hold it, and tell them to draw anything they like. Generally they will have no difficulty in deciding on a subject, but if they have, then a few vague suggestions may be offered. Remember that the object is to stimulate thought and to teach the child to decide for itself. Young children are usually quite confident, and will tackle anything, from a cathedral to an express train; the timidity and diffidence that comes later are too often the results of unintelligent teaching and carping criticism on the part of the teacher.

These first drawings may be altogether unlike the objects as we understand them, but the child draws from imagination, building round some salient features which have impressed themselves upon him. For

instance, the express will be a cloud of smoke with a few circles suggested for wheels, and the rest a meaningless lot of lines. Meaningless to us perhaps, but the child will explain it all, and it is better to suggest improvement than to condemn, because we do not understand. Better take it that we have lost the power of reading these shorthand notes, than to try to impose our own conception. Try to enter into the child's thoughts and help to mould and direct.

**TEARING SHAPES:** A useful variation is afforded by allowing the children to tear simple shapes from paper, an easy leaf or vegetable form, or anything else that may occur. Pricking round the outline and then tearing is another variation, both of which add interest and afford valuable training. If these torn shapes are mounted on a background of suitable colour, the effect will be improved.

## OBJECT DRAWING

The aim in the object drawing lesson is primarily to teach the pupils to see correctly, to set down truthfully and freely the facts seen, and to store the mind with definite mental images for future reference.

**FLAT SHAPES:** In the early stages, simple flat shapes such as envelopes, fans, kites, frames, or shapes cut from cardboard, *e.g.,* shields, heart shapes, diamonds, crosses etc., placed within full view of the class are perhaps the best, the aim being to teach the pupils to see the relative proportions of the different parts. The

teacher should then discuss the width as compared with the height, the length of one line as compared with another, etc., taking care not to tire the children before allowing them to draw. The object might be drawn on the blackboard either before the class has attempted it or afterwards, as the teacher shall decide. If it is demonstrated before they make their attempt, they are apt to copy the teacher's drawing instead of trying to draw what they see of the object. If the demonstration takes place afterwards, they can compare what they have done with the drawing on the board. Whether the demonstration should be before or after the child has drawn is a matter for each teacher to decide according to individual taste and experience.

**OBJECTS DRAWN WITH STRAIGHT LINES:** A few lessons on flat shapes might be followed by simple cylindrical shapes, such as jars, tins, jam-pots, etc., placed on the eye level to avoid ellipses, and drawn with straight lines. This is an easy approach to forms in the round. Here again proportion and the relation of part to part form the basis of the instruction. Conical objects and objects of combined cylindrical and conical form will follow. **Plate 2** illustrates a few suitable objects for these lessons.

**ELLIPSES:** After a sense of proportion and some ability to draw has been acquired, the ellipse might be attempted. This is always a difficulty with beginners. They know that the object is actually circular in plan, and usually they draw it so. The teacher carefully explains the principles that underlie the foreshortening of the circle, making it appear as an ellipse. Some simple

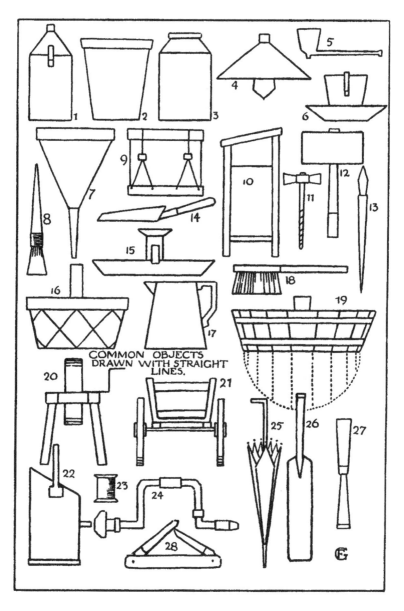

PLATE 2—*Common Objects drawn with Straight Lines.*

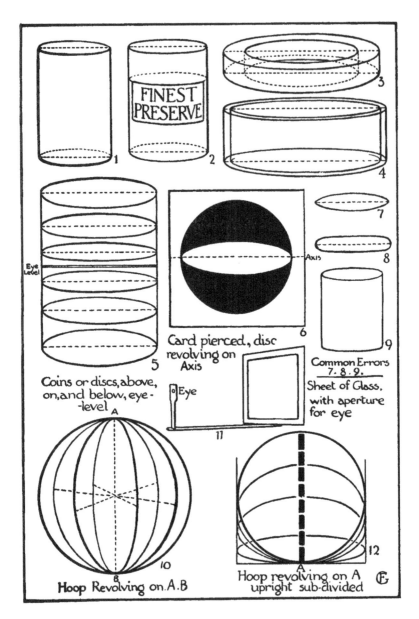

PLATE 3—*Diagrams to illustrate the "Ellipse."*

device for illustrating this should be exhibited, so that the ellipse alone occupies the attention. In **Plate 3** methods of dealing with this problem are illustrated. **Figure 6** shows a card from which a disc has been cut, and afterwards arranged so as to revolve within the circular hole left in the card. By placing the card against a dark background, the alterations in the apparent width of the disc, as it revolves, can readily be observed. The dark gap which retains the circular shape will act as a gauge, by which may be estimated the varying widths of the ellipse. Placing the disc at about the pupil's eye level, the teacher points out the gradual narrowing of the ellipse as it approaches the horizontal, until, when perfectly horizontal, only the edge is visible, appearing as a simple straight line. A hoop is also useful for demonstrating, and may be revolved as shown in **Figure 10**, or placed flat as in **Figure 12**. In the latter case a rod with equal divisions plainly marked upon it is placed vertically in front of the hoop. The rim part of the hoop farthest from the class is then gradually raised (or lowered), and the changes in height as indicated on the rod pointed out to the class. The width from side to side remains unchanged, only the height varies. The teacher's object is to give the children an intelligent grasp of the principles, and any method that stimulates the necessary reasoning may be adopted. After a little explanation the pupils might be allowed to draw the ellipse in a horizontal position. It should be pointed out that the long axis will be parallel to each pupil, and therefore horizontal with the short axis, making angles of 90° with the long one. The teacher will find that the

commonest errors in drawing are either to make the narrow end of the ellipse too square or too pointed. **Figures 7 and 8**.

**CYLINDRICAL OBJECTS:** The next lesson might involve the drawing of a jar or other simple cylindrical object. It will be necessary here to point out the alteration that occurs in the width of an ellipse according to its position with regard to the eye level. **Figure 5** illustrates a series of discs arranged at different levels showing the apparent widening from back to front as the discs rise or fall below the eye level. At the eye level a disc placed horizontally will exhibit only its edge, and will, therefore, appear as a straight line. As it descends below the eye level (still horizontal) more of its surface is seen; it, therefore, becomes wider from back to front, until, directly below the eye, we see its true shape, a plan in fact. The same change takes place as it rises above the eye. A clear grasp of this will help in the drawing of cylindrical objects, and will enable the pupil to get the upper and lower ellipses in correct relationship, together with any that may occur between. A common error is to make the base ellipse narrower than the upper when both are below the eye level, **Figure 9**. When the ellipse has been fairly well understood, conical objects and objects that combine cylinder and cone will follow. Geometric models can be employed to demonstrate principles, but when possible it is better to use common objects.

**COMMON OBJECTS:** Those objects which form part of everyday surroundings possess greater interest on that account for the pupil than geometric models,

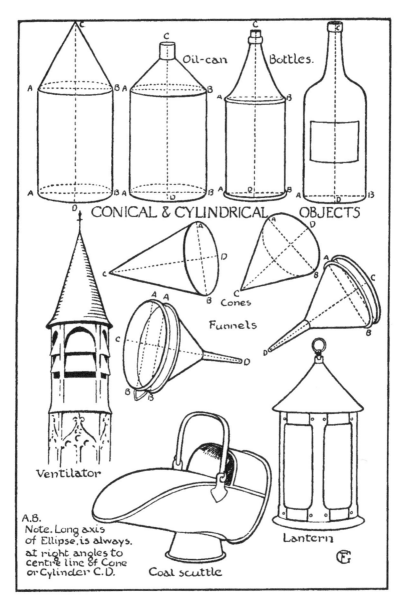

PLATE 4—*Cylindrical and Conical Objects.*

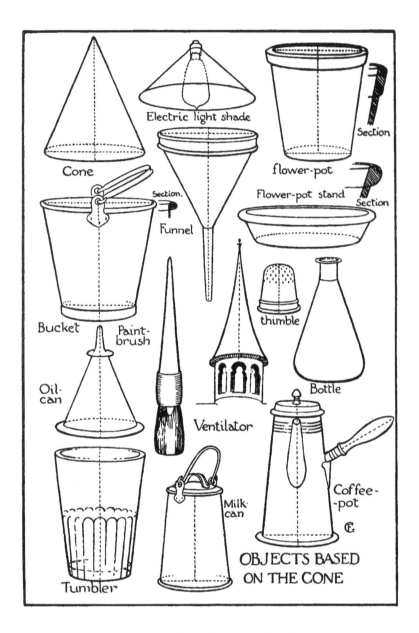

Cone

Electric light shade

flower-pot

Section

Funnel

Section.

Flower-pot stand

Section

Bucket

Paint-brush

thimble

Oil-can

Ventilator

Bottle

Tumbler

Milk-can

Coffee-pot

OBJECTS BASED
ON THE CONE

PLATE 5—*Objects based on the Cone.*

20

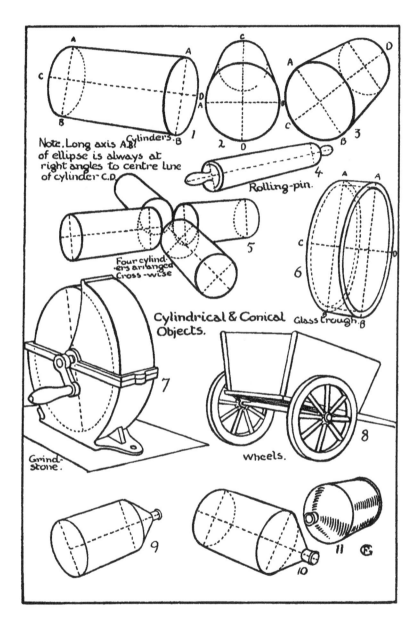

PLATE 6—*Cylindrical and Conical Objects.*

which seem detached from ordinary experience. Suitable objects abound; cans, electric light shades, flowerpots, buckets, bottles, and many others form useful models. **Plates 4 and 5** illustrate a few of the more common ones. The teacher should see that the lines representing the sides in these objects are tangential to the ellipses. A common error is to make a sharp angle between the side and the base ellipse. **Figure 9, Plate 3.** This is caused by not drawing the complete ellipse. Following the lessons dealing with the ellipse in a horizontal position, the vertical and oblique ellipse should be dealt with. The principle involved here is that the long axis or longest dimension of the ellipse is at right angles to the line of vision and not necessarily vertical. This is illustrated on **Plate 6.** In the cylinders it will be noted that the long axis is at right angles to a line drawn midway between the two converging lines of the cylinder. **Plate 4** shows the cone on its side, a line from the apex midway between the two sides is at right angles to the long axis of the ellipse. A considerable amount of practice will be required to force home these principles so that the pupil will be able to draw the ellipse correctly in any position. Jars with labels afford good examples of ellipses at varying heights. Generally the pupil forgets that the label follows the contour of the jar, and will make it, together with the lettering on it, square. Where rims and mouldings occur it will be found useful to explain the section, purpose, and construction of such details. The pupils will obtain a more intelligent grasp of the form, and consequently a surer method of representing it. At this stage of the

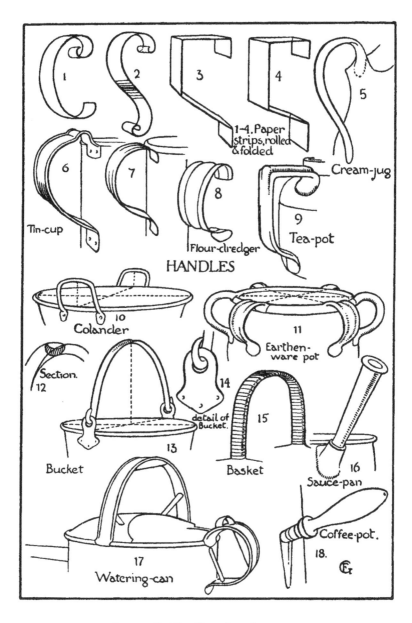

1. 
2. 
3. 
4. 
5. Cream-jug

1–4. Paper strips, rolled & folded

6. 
7. Tin-cup

8. Flour-dredger

9. Tea-pot

HANDLES

10. Colander

11. Earthen-ware pot

12. Section.

13. Bucket

14. detail of Bucket.

15. Basket

16. Sauce-pan

17. Watering-can

18. Coffee-pot.

PLATE 7—*Handles of various types.*

pupil's development the teacher cannot afford to let details be scamped. It is not merely the ability to draw that is involved, but also the character of the pupil. A difficulty overcome will render other problems easier, at the same time developing habits of concentration. The length to which details should be carried is a delicate matter to decide, for little good can come of keeping pupils at a task from which all interest has vanished. The suggested explanation of the section, construction, and the purpose of these details will help to stimulate interest, and consequently further effort.

A separate lesson or series of lessons dealing with such details as spouts, handles, rims, etc., might be given. Strips of paper rolled and folded to resemble handles form an easy approach. This might be done by each pupil following the teacher's example. Drawings from these, placed at different angles, will render the task of drawing handles from the actual objects an easier one. **Plate 7** illustrates a few of the various types of handle in common use. The difference between wood, metal, and earthenware handles dependent on the nature of the material is worth pointing out, also the methods of construction, fixing, etc. A few enlarged drawings made on these lines will facilitate the rendering of such details as they occur in future lessons.

**RECTANGULAR OBJECTS:** Rectangular objects in perspective should now be attempted. It is hardly wise at first to worry the pupils with perspective theory. They should be taught to gauge the relative sizes of different parts, at first with the eye alone, for the object aimed at is to train the eye to see, rather than to impart a

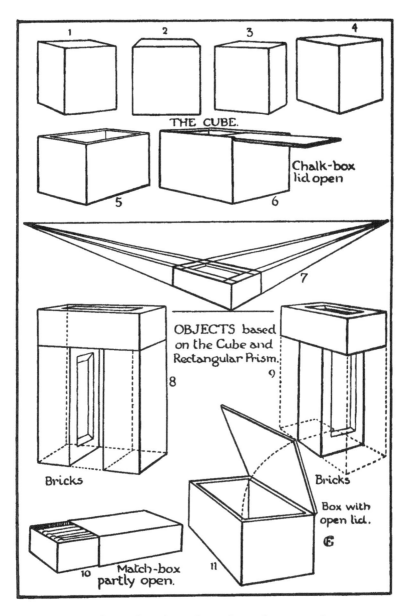

The Cube.

Chalk-box lid open

OBJECTS based on the Cube and Rectangular Prism.

Bricks

Bricks

Box with open lid.

Match-box partly open.

PLATE 8—*Objects based on the Cube and Rectangular Prism.*

knowledge of mechanical aids. The pencil held at arm's-length between the eye and the object may be used to correct the measurements after they have been gauged by the eye; but a series of measurements taken with the pencil, and set down on paper without a preliminary judgment by the eye is of little value. A box or a brick are good objects to start with. **Plate 8**. First see that each pupil is directly facing the object. It should be possible merely by raising the eyes to obtain a direct view of the object. In schools where the desks are fixed in rows it is difficult to arrange this, but by providing a number of objects this difficulty can to some extent be overcome. The ideal classroom should be furnished with a seat and a trestle (to lean the drawing board against) for each pupil. These can be readily adjusted, so that each pupil has a direct view of the object. When the class is properly arranged the teacher might discuss the object and ask a few questions with regard to its proportions, the direction of its boundary lines, etc. By these means he impresses upon the pupils such facts as, vertical lines are always vertical no matter what their position with regard to the eye; horizontal lines parallel with the spectator remain horizontal, whilst horizontal lines receding from the spectator do so at an angle. Horizontal parallel lines receding from the spectator appear to converge, and distant lines naturally appear shorter than similar lines which are nearer to the eye. A framed sheet of glass, to the bottom of which a strip of wood is fixed, having an upright with a hole pierced for the eye at the end farthest from the glass (**Figure 11, Plate 3**) is useful in helping the pupils to

realise the appearance of objects. The pupil closes the left eye and with the other looks through the aperture. With a piece of soap, damp chalk, or a brush and stiff paint, he proceeds to trace the outlines of the object as he sees them on the glass. This helps him to realise the difference between the object as it actually appears, and the object as he thinks it appears. We must not forget that things become familiar to us in their entirety; we know them from handling and from seeing them from all points of view. The child would fain give us the whole of the facts as he knows them. Some little care and patience is necessary to get him to see correctly without confusing what he knows of the object with what he sees at the moment. When the teacher considers it advisable a simple explanation of the laws of "Perspective" may be given. It is hardly necessary for ordinary purposes to go beyond "Horizontal Perspective." The position of the horizon, and the fact that all parallel horizontal lines receding from the spectator converge to an imaginary point upon it, is enough. Where the pupils are grouped round a central object the height of the horizon can readily be judged by the eye-level of the pupil opposite. An estimate of its height can be formed by comparing it with some line in the object. Its relative position on the paper can then be judged. Parallel lines above the spectator and receding from him appear to converge downwards towards the horizon; similar lines below appear to converge upwards towards the horizon. Lines parallel to the spectator are represented as geometrically horizontal, and lines parallel to the spectator and to each other are also horizontal and parallel. Vertical lines

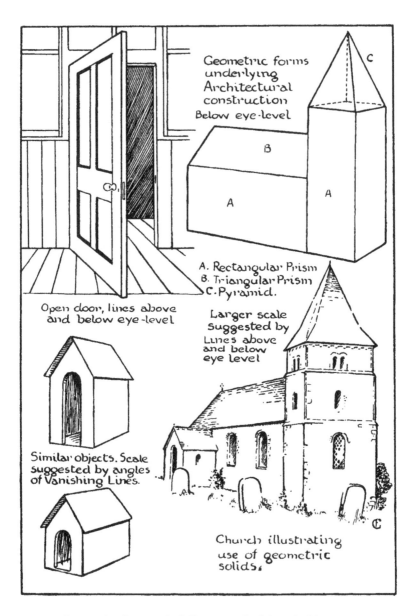

Geometric forms
underlying
Architectural
construction
Below eye-level

B

A

A

C

A. Rectangular Prism
B. Triangular Prism
C. Pyramid.

Open door, lines above
and below eye-level

Larger scale
Suggested by
Lines above
and below
eye level

Similar objects. Scale
suggested by angles
of Vanishing Lines.

Church illustrating
use of geometric
solids.

PLATE 9—*Geometrical Forms underlying Architecture.*

28

remain vertical. The lines of ceiling, floor, and walls of the school-room afford a useful demonstration of these facts. In the street the lines of house-fronts, pavements, roadways, and tram-rails can be used to illustrate the convergence of line. The aim is to teach the pupils to see the diminution of surface and convergence of line, and it is a good plan to extend the lines beyond the limits of the object to ensure correct "vanishing." The "Scale" or apparent size of the object depends entirely upon the relation which these converging lines bear to each other and to the horizon, as will be seen by referring to **Plate 9**. The Church and the geometric models illustrating the forms upon which it is based are instances of the difference in size suggested by lines above and below the eye-level, and lines entirely below the eye-level. The kennel and the sentry-box are other instances of different sizes in similar objects suggested by this means. Parallel lines that are oblique rather than horizontal will appear to converge to an imaginary point situated above or below the horizon and not to a point upon it. The difficulty here is usually to determine in which direction they do converge. A useful plan is to decide upon the nearest lines and to remember that lines "vanish" from the spectator and not towards him.

A knowledge of perspective will certainly be an aid in solving some of the problems that occur in object drawing, but the eye should be trained to see as much as possible. The difficulty of gauging the angles made by receding lines is hard for the pupil to overcome. The sheet of glass previously mentioned will assist, but

other devices may be adopted. The pencil held at arm's-length and revolved in a plane parallel to the pupil until it lays along the line helps in gauging the angle. Care must be exercised to keep the pupil from turning the pencil away from him instead of revolving it in a plane parallel with himself. It should be explained that all lines are drawn on the surface of the paper, and cannot be drawn through; therefore, if the pencil be not parallel with himself it indicates a line that cannot be drawn on paper. If the sheet of glass is placed in front and the pencil revolved whilst lying flat on the surface of the glass until it lays along the line, it would help to demonstrate the point. The hands of a clock revolving round the dial can be so placed as to represent any straight line that can be drawn on paper. All the straight lines in an object or group of objects are either vertical, horizontal, or somewhere between the two. The lines between—the oblique lines—may be either midway between, *i.e.*, making an angle of 45°, or they may approach either the vertical or the horizontal, but all must bear some relationship to these two. A large dial with revolving hands is useful in assisting the pupils to grasp this truth. The main difficulty lies in the fact that the line in the object recedes from them, and they are nonplussed at the idea of representing it on a flat sheet of paper. When this obstacle has been overcome the gauging of the angle is easily accomplished. The clock affords an interesting example of this, for it is rarely necessary to read the numerals to know the hour, the position of the hands, the angles at which they stand is sufficient. Some clocks have no numerals, merely spots

to indicate their positions, but so accustomed are we to the XII. vertically above the VI., to the IX. and the III. lying in a horizontal line, with the other numerals placed at equal thirds between, that the numerals are not necessary; the marks serve equally well. This being the case with the clock, a similar comparison of oblique lines with the vertical and the horizontal will help in judging their angles. The upper edge of the drawing board resting on both knees will serve as a gauge for the horizontal, and the pencil held vertically for the vertical lines. Teach the pupils to see the shapes in the background, and the spaces that occur between the objects; this helps considerably, and is far too often neglected.

## MEMORY DRAWING

Memory drawing should be practised in conjunction with object drawing. The pupils may be asked to draw from memory an object previously drawn from sight, either from the same position or to imagine themselves in another, and to draw the object as they think it would appear from the altered view point. Again, an object may be studied for four or five minutes while the teacher suggests a few points to be observed, such as the proportion of height to width, position of handle (if any), or any noticeable feature connected with the object. The object is then withdrawn and the drawing made from memory. It is a useful plan to make the pupils close their eyes and try to visualise in the mind the object studied. When they have done this they will

probably find that some details have escaped them; another glance at the object will fix the details in the mind. This should take place before the drawing is attempted, for upon the clarity of the mental image depends the drawing. The pupils may afterwards be allowed to correct their own drawings whilst the teacher again points out the salient features of the object in full view of the class. Another plan is for the teacher to describe an object and its position, as, a box with one angle directly in front and two sides receding at equal angles at a certain distance below the eye-level; two jars, one standing upright and the other lying on its side close against the first, its open end or top facing towards the right and on the eye-level; an electric light shade above the eye-level, and so on. The teacher can easily find examples.

Still another form is drawing an object studied out of school, the choice being either left to the pupil or suggested by the teacher.

Memory drawing is invaluable in developing the faculty of observation. It necessitates a mental effort to fix the form in the mind, and also enlarges the imagination; for imagination is simply the power of calling up at will the images stored in the memory for such purposes as we may desire. Unless an object is correctly observed it cannot be correctly memorised, the result being that nebulous indefinite images impossible to express will float through the mind, and exasperate us when we are needing the accurate definite ones which can only be formed by correct observation.

# METHODS

Much controversy has been waged from time to time as to the merits and demerits of the various methods of treatment. Thick line, thin line, sketchy line, precise line, shading and no shading have all had their advocates and their opponents. It scarcely seems worth while arguing about it; the aim should be to teach observation and expression, and the particular method adopted is not of primary import. The "neat line" is too often the standard by which the work of a class is judged, rather than by its capacity to express form. Outline is, after all, an arbitrary method of depicting form—a mere convention. Objects are visible to us as tone against tone and colour against colour, so the most truthful method is the "light and shade" method. There is no reason why this should not be adopted as soon as muscular control and a moderate capacity for expressing form has been acquired. Where the outline convention is adhered to the line should be as free as possible, using the whole arm to produce it, and not confining the movements to wrist and fingers only. Realisation of shape is the end in view, not neat lines. It is true that in careful finish and neat lines lies the evidence of a certain discipline, which may be of value; but the teacher is the best judge in such matters, and no rules can be laid down as to the type of line that should be used. Let it be an expressive line that shall represent form as accurately as the pupil's skill will permit, and as free as may be.

# CHAPTER II

# MECHANICAL DRAWING

THE approach to this subject should be made as easy and as interesting as possible. The child mind has to be led gradually up to the neatness and accuracy inseparable from mechanical drawing.

**RULER:** Perhaps the first instrument to begin with should be the ruler, which will need explanation from the teacher, who expounds what the divisions are, and how to use them. The use is best illustrated by allowing the class to measure their pens and pencils, pieces of string, coloured paper, etc., one dimension only, after which, two dimensions; post-cards, envelopes, slates, book-covers, lids of boxes or anything handy.

**PAPER RULER:** Another interesting lesson may be given by allowing the class to make a paper ruler of their own from strips of paper. A halfpenny is exactly 1 inch in diameter, and if one is placed on a strip of paper the inch may be marked and the paper folded so that the creases mark the inches. By folding again half-inches may be indicated, and a further fold will give quarter-inches, and so a serviceable ruler may be made. This can be used in the manner suggested for the ruler.

The next stage is drawing straight lines in various directions, after which two points may be placed at a convenient distance and a line drawn between, followed by measured drawings of post-cards, envelopes, etc.; then larger objects such as slates, frames, book-covers drawn to scale.

**SQUARES:** A lesson on the use of T square and set squares should follow and parallel lines drawn vertical, horizontal, and at angles of 45°, 60°, and 30°. The teacher points out the fact that one angle of the square is a right angle or 90°, and the other two angles make 90° between them; it will thus be easily seen that in the 45° square, the two angles being equal will necessarily be half of 90°. The 60° set square is explained in a similar manner.

**COMPASS:** The compass is now introduced and the fact that the circumference of a circle is everywhere equidistant from the centre. Here again a slip of paper is useful. If a number of holes are perforated at one end and a pin stuck through the other into the drawing paper, a pencil may be inserted into the holes perforated and circles drawn. This serves to impress the fact that the circumference of the circle is equidistant from the centre. Other facts connected with the circle should be dealt with; the radius (distance from centre), diameter (width from side to side, or two radii), arc (any part of circumference), segment (part of circle bounded by arc and chord), semi-circle (half-circle), and so on. There are many books on Geometry available; these notes are merely intended to serve as an introduction. **Plate 10** indicates a few exercises that might follow

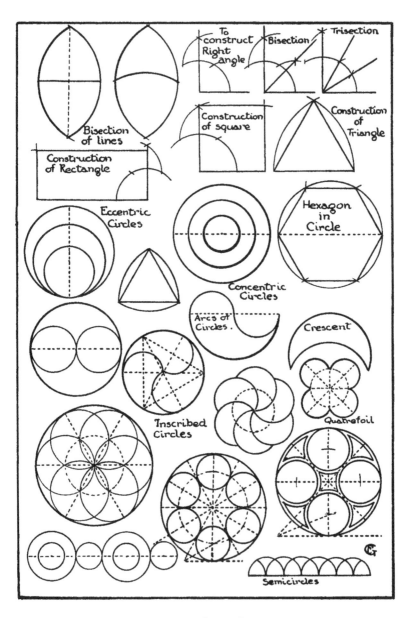

PLATE 10—*Mechanical Drawing.*

PLATE 11—*Pattern Drawing.*

when the instruments are understood and some facility in handling has been acquired. Sub-division of lines and angles, construction of simple figures, concentric and eccentric circles, inscribed circles, etc. Pattern drawing would follow upon this. **Plate 11** illustrates a few simple ones; the teacher can easily evolve a number of others, and also allow the pupil to do so. Many geometric patterns can be obtained from linoleums, wallpapers, and other designs, whilst quite a number of books are available from which to draw inspiration.

## NATURE STUDY

"For, don't you mark, we're made so that we love
  First when we see them painted, things we have passed
  Perhaps a hundred times, nor cared to see;
  And so they are better painted—better to us,
  Which is the same thing. Art was given for that—
  God uses us to help each other so,
  Lending our minds out."

—BROWNING.

"The boy encouraged to imitate some natural object will ever after see in that object something unseen and unknown to him before, and he will find the time he formerly did not know what to do with henceforth full of pleasurable sensations."

—G. F. WATTS.

Nature affords an endless variety of form and colour from which to choose. In introducing this subject each child might be given a simple leaf, fruit, vegetable, or

shell, and told to draw it, allowing each pupil to do it in his own way.

**MASS DRAWING:** Mass drawing with crayon or brush is best for first lessons. After this attempt the teacher, by means of questions, leads to a truer perception of shape and detail. Another method is to point out some essential features before the drawing is commenced. But whatever method is adopted it should be borne in mind that the end in view is to teach the child to see, and to see he must think. It is better to give a separate object to each child, for then other senses than sight are brought into play, and the knowledge thus gained is rendered more exact and permanent by the attempt made to draw it. The child will, at first, only be able to express some part of the truth, the amount increasing with the development of the vision and the power of expression. Give the pupil a cherry and his first attempt will probably produce a flat circular mass. The teacher inquires if nothing more can be seen, which inquiry might elicit "the stalk." A further question may lead to a darkening of one side and the adding of light to the other, so by questioning the facts become apparent, and the power of expression grows *pari passu* with the vision.

As before stated, in these early lessons where detail cannot be expected, chalk, crayon, or direct brush work is most suitable. For variety, the shapes drawn can be cut with a penknife or scissors and mounted on paper of a suitable colour. White flowers on brown paper, green leaves on white are effective, and the interest thus given to the lesson is well worth the teacher's trouble.

Care is necessary in the selection of objects for study, for, on the one hand, if they are too easy, the pupil loses interest, whereas, on the other, if too difficult, or if too much is expected, he loses confidence.

**DETAILS:** As control of the hand increases, more careful studies with the pencil may be attempted, and even a light wash of colour added. When this stage is reached more accurate rendering of details must be insisted upon. There will always be a tendency to scamp joints, serrations, veins, and other difficult parts. This the teacher has to watch, and should insist upon an effort being made to overcome these difficulties. This will result in increased facility and power of concentration.

**PENCIL:** In pencil work, variety in the line helps to express the characteristics of a plant. The pencil (really a very sympathetic implement) is capable of producing tones varying from a velvety black to a delicate tender grey. The whole range is at the command of the draughtsman, and the power of expression depends upon the ability to use it. A strong line for the contour of a leaf (varied to suggest the undulations of the edge) with more delicate lines for veins and inner markings, and sharp dark touches at the joints, all help to give life to the drawing. The foreshortening and curvature of leaves, of which a few examples are given on **Plate 13**, will afford excellent practice. Flowers too are best expressed by a line of uneven quality. A strong varied line for the contours, with delicate markings at the petals, and sharp sparkling touches on pistils and stamens, all make for charm and vitality.

**PEN AND BRUSH:** The pen and brush are both useful for making studies. They lead to precision of treatment, and a surer handling. The same object treated in different media helps to bring out its characteristic features, form, colour, light and shade, texture, etc. Pupils should occasionally be allowed to bring their own objects for study; this encourages them to think and to use their eyes in the selection of the object. The interest thus aroused is naturally far greater than when the object is placed before them in class. The teacher will probably find that young children will be more strongly influenced in their choice by the colour of an object than by its form. The range of natural objects suitable for study is very wide, and material can easily be found for all classes; from the youngest child to the most advanced art student. It is useless to suggest the objects that should be used for the first standard, second standard, and so on; the teacher is always the best judge in such matters. Pupils vary considerably, and again, what one teacher would consider suitable another would ignore. But in the varieties of flowers, leaves, buds, twigs, fruits, vegetables, fungi, seaweed, birds, animals, etc., there is sufficient material for all tastes and requirements.

**TYPICAL FORMS:** Numerous plant, bird, animal, and other studies of natural form are given in the **Plates 12 to 50**. The majority of the plant studies are accompanied by decorative treatments of leaf and flower. **Plates 14, 19, 20, 22, 23, 24, 27, 28, 29, 32, 33, 35, and 40**. This method of treatment should be encouraged, for, apart from its value in design, the drawings produced

are typical of the plant. Recognition of the type aids in the appreciation of its form, and also of any variation that might occur.

**GEOMETRIC BASES:** Flowers properly grown will generally fit into geometric shapes, *e.g.*, the Syringa, Clematis, and Fuchsia into a square, **Plates 22 and 34**; Columbine into a regular pentagon, **Plate 24**; Daffodil into a regular hexagon, and so on. Those blossoms which most nearly approach the geometric shape, *i.e.*, in which the petals are equally grown, may be accepted as the basic type, and used as a standard. Not only is this type of analysis useful in design, and for acquiring a knowledge of the plant, but it is a valuable mental exercise as well. If the pupil is encouraged to make marginal studies of typical leaves, flowers, joints, etc., before attempting the growing plant as a whole, it will assist him in noting any variation that occurs, and also in rendering truthfully the foreshortened parts.

## MASS DRAWING AND SILHOUETTE

At the best, outline is an arbitrary method, for objects are visible to us as one colour upon another, or as a tone upon a tone. There is an edge of colour or an edge of tone, but never an outline. So for expressing form, mass drawing affords a much truer and simpler method than outline. It is most suitable for early lessons, as the child can realise better the shape of a colour mass than the shape bounded by an outline. Crayon, chalk, and brush, are all good for this purpose. Natural and common objects afford good subjects for mass

treatment, and as the mind is solely occupied with contour and proportion, it affords excellent practice in the expression of form. (See **Plates 53 to 57.**)

## TREES

"The creation of a thousand forests is in one acorn."

—Emerson.

Lessons of absorbing interest can be based on trees. The life-history of a tree is not only interesting but affords valuable opportunities for practice in drawing, as studies of the various parts at different stages of development may be made to illustrate the growth.

**GROWTH:** The seed which matures in the autumn falls into the earth, takes root, sends forth fibres into the soil and an upward tending shoot, which steadily grows from year to year until, in time, the tree attains perfection. From the first shoot which grows from the seed, others branch off annually, each with its group of leaves. When the leaves fall in autumn, buds are left behind them, well protected against the rigours of winter, to await the genial spring. Some of these buds produce new shoots, and some, less fortunate, remain abortive. Each year brings its quota of fresh shoots which spring from the twigs formed from the shoots of the previous year, and as they multiply the main ones grow in bulk, the first one which sprang from the seed becoming the trunk, and others of the earlier shoots becoming the main branches; and so, given favourable conditions, the plant grows and spreads

until in the fulness of time it becomes that wonderful piece of natural architecture, a tree. Its roots burrow deeply into the soil, whilst above the desire of all its parts is to stretch upwards towards the light, which desire is responsible for the bareness of the trunk in the later stages of the tree. For as the leaf-bearing shoots spread above, they intercept the light, and the lower boughs, failing to receive the life-giving rays, drop away, leaving the main stem bare. This dropping away of the branches increases the uninterrupted length of the trunk, and each year adds to its girth. The leaves extract nourishment from the atmosphere, and the roots obtain the necessary mineral elements from the earth. Spring sees the tree put forth flowers, the summer sun turns them into autumn fruits and seeds, which lie dormant during the winter, to shoot up into new plants with the returning spring. And so it proceeds in an endless cycle, for, as Emerson says: "Nature is an endless combination and repetition of a very few laws. She hums the old well-known air through innumerable variations."

**POLLINATION:** Some trees are wind pollinated, others rely upon bees, butterflies, and insects to perform this duty, whilst some are capable of self-fertilisation.

**FLOWERS:** The "complete" flower is composed of "stamens" (male organs), "pistil" (female organs), and a leafy envelope for their protection. This envelope consists of the "calyx," usually formed of separate green leaves called "sepals" springing from the stalk; the "corolla" or "petals," often brightly coloured, and arranged within the calyx. Inside this envelope come

the stamens, each consisting of a stalk (filament) and a head (anther) which contains the pollen. The centre is occupied by the pistil, the base of which is the ovary, containing the ovules which develop into seeds after being fertilised by the pollen. At the apex of the ovary is the "stigma" which receives the pollen and then transfers it to the ovules or eggs. The calyx and corolla are usually composed of five sepals and five petals, though four is also a fairly common number.

**FERTILISATION:** As may be gathered from the above brief description the "complete" flower contains within itself both pollen and ovules, the fertilising medium and the egg capable of being fertilised. It is, therefore, possible in such trees as produce these complete flowers, for self-fertilisation to take place, but it is of rare occurrence, as cross-fertilisation is more beneficial to the species. It is interesting to note how Nature guards against self-fertilisation even when she gives the complete organs of reproduction to the one flower. This she does in some cases by maturing the stigma before the pollen is ripe, and in others by dispersing the ripened pollen before the stigma is matured. When a flower contains within itself both male and female organs it is termed "bisexual," when one flower contains the male and a separate one the female organs it is "unisexual." Some species bear both male and female (unisexual) flowers on the same tree, others bear male and female on separate trees, others again will bear male on one tree, female on another, and bisexual blossoms on a third. Occasionally the same tree will bear all three types of flower, male, female, and

bisexual, and is aptly termed polygamous. Trees which are wind-pollinated produce a large quantity of pollen, for, being carried by the wind, but a comparatively small proportion will reach the female organs of other blossoms. The petals of these flowers are not so brightly coloured or sweet-scented as are those which rely upon insects for pollination. The colours and scents of the latter have been adopted to attract insects, who, passing from flower to flower and tree to tree in search of honey, perform the office of fertilising agents. Many of these tree blossoms are of exquisite beauty, as apple, pear, cherry, horse-chestnut, hawthorn, cornel, almond, plum, rowan, blackthorn, and guelder rose. Others are difficult to recognise as flowers, the birch, oak, willow, alder, hazel, and sweet chestnut being of this type.

**FRUITS:** The fruits which follow the blossoms are also worthy of study, as, like the blossoms, many of them are beautiful in shape and colour. The red berries of yew, holly, rowan, hawthorn, and wild-rose; the winged seeds of maple, sycamore, ash, lime, and hornbeam; the hairy seeds of willows and poplars; the cones of pine, spruce, larch, and fir, all provide exquisite form and colour for the student. **Plate 51** shows the sycamore with winged seeds, buds, both resting and active, flowers, a leaf, bark, and the tree as it appears in winter and summer. There is an inexhaustible store of material for the teacher and student in the various species and component parts of trees, whilst the artist could hardly do without them, especially if he is a landscape painter. To make a series of studies at different seasons, and so to trace the development

of the various portions, not only affords excellent practice in drawing but is fascinating exercise as well. The wonderful scale patterns in the buds, the diversity in the forms of the leaves, the varieties in the branching, the massing of the foliage, the forms and colours of blossom and fruit, the difference between the smooth bark of the young tree, and the scarred surface of the older one—what a store of material is here afforded for the draughtsman! The sycamore commences flowering when between twenty and thirty years of age. The sepals and petals are both green in colour, hence the blossom is not particularly conspicuous. Despite this, however, it relies upon insects for pollination. The flowers are male and female (unisexual). Its leaves are "opposite" (in pairs, one on either side of the stem) and "palmate." The seeds are winged; the bark remains smooth for a long time, but ultimately becomes rough and breaks off in scales. The tree attains a height of sixty feet, and has a crown of variable form. **Plate 52** illustrates some typical tree forms.

## BRUSH-WORK

**BRUSH:** Of all the implements at the artist's command the brush is easily the best. Flexible and easy to handle, no other tool lends itself so sympathetically to the expression of thought and feeling. The teacher will do well to introduce the brush quite early into the drawing course for such exercises as mass drawing and brush-work. Each child should be provided with two or three brushes of good quality. Sable is undoubtedly

the best, but fitch and Siberian hair are good substitutes. Camel hair is too limp for this purpose, having a tendency to remain at an awkward angle instead of springing back into line with the handle. Nos. 3, 5, and 6 are useful sizes. The pupils should be taught to take care of their brushes, and to bring to a point after each lesson, when they might be stood in a jar, handles down, to preserve the points.

**COLOURS:** Tube colours are the most convenient and may be squeezed into the saucers as required by the teacher. To start with chrome yellow, Prussian blue, and crimson lake are enough. The range of tints obtainable from these three is described in the section on colour. For demonstration the instructor will need a large sable, Siberian, or soft hog-hair brush, well pointed. The colour must be fairly thick or it will run, as the teacher needs to have his paper vertical in order to be seen by the pupils. Whiting is useful for blackboard work.

**BRUSH STROKES:** The first exercises will consist of brush strokes. A fully charged brush applied to the paper gives a characteristic blob. Variation in the amount of pressure will produce a thick or thin stroke. These strokes or blobs placed in vertical, horizontal, and oblique directions form the first exercise. **Plate 53**. When facility of handling has been acquired, the blobs may be combined to produce flower-forms, leaf-forms, buds, shells, and later, pattern. The brush might with advantage be used far more in the teaching of drawing than it is. The pupil learns that once a stroke is on the paper it cannot be erased like pencil; he consequently

thinks a little more before applying it, and ultimately acquires a more decisive, direct method of drawing.

**LEAVES**: After a few preliminary practices in handling the brush, a simple spray of privet, laurel, or such like leaves might be attempted in direct brush-drawing. The midribs may be suggested by leaving a white line, and if the attention is concentrated on the edge nearest the rib instead of the outside curve, it will be found much simpler. **Plate 55**. Straight lines in various directions followed by squares, rectangles, and triangles are also excellent practice. Flower, animal, bird, in fact all natural forms lend themselves readily to this method of treatment. **Plates 20, 25, 28, 33, 35, 40, 43, 44, 45, 49, and 50.** The silhouette treatment peculiar to brush-work is invaluable for the study of form. The whole attention is concentrated on the contour and the shape bounded by it. The sharp contrast between this and the ground to which it is applied, renders the form clearly visible and easy to grasp. No light and shade or surface modelling distracts the attention; it is an exercise in pure form. Its decorative possibilities are enormous. **Plates 53 to 57**.

**NATURAL TINTS:** When some facility in handling the brush has been acquired, and the pupils have been taught the properties of colour, an attempt should be made at painting the objects in their natural tints. This involves the matching of colour. Leaves, flowers, shells, butterflies, etc., form useful subjects. A light but careful pencil sketch is first made, and the colours mixed, matching them as closely as possible to the corresponding colours in the example. Two or three

brushes are necessary, and colours should be applied as directly as possible, using plenty of water. If they are floated on the paper and allowed to run together, hard edges are avoided and a more brilliant transparent effect is obtained than by putting the washes on separately after allowing the previous ones to dry. A further opportunity occurs here for teaching the children to see colour. The child mind is not very sensitive to the more delicate tints, but strongly drawn towards the primary colours. The teacher should endeavour to lead the pupil to see the shades that enter into, and modify the predominating colour. A leaf, though its local colour is green, usually has blue and grey; and even purple and brown in its make up. This is explained by the fact that the surface of the leaf is more or less reflectory so that the colours of the sky and surrounding objects modify the green. This applies to practically all objects; a red vase will often exhibit purple, orange, and other tints, besides the dominant red. The remarks on harmony in the section on colour also apply in painting from nature. Despite the fact that colour appeals so strongly to children, and that they are more easily influenced by it than by form, it is difficult to teach them to discriminate between the delicate tints, but when pointed out, they soon learn to distinguish them.

For brush drawing pure and simple, the Japanese stand pre-eminent. A few examples of their work hung in the schoolroom would be useful to illustrate the possibilities of the medium, and also to familiarise the pupils with the delicate schemes of colour, and the fine decorative quality of Japanese brush-work. Environment

has a tremendous influence on the growing mind, so the mere presence of such things is bound to have a refining effect upon the scholar seeing them every day in school.

**NATURAL FORMS: Plate 53** shows typical brush strokes and a few natural forms evolved from them. **Plates 53 to 57** show further examples of natural and conventional forms suitable for brush-work.

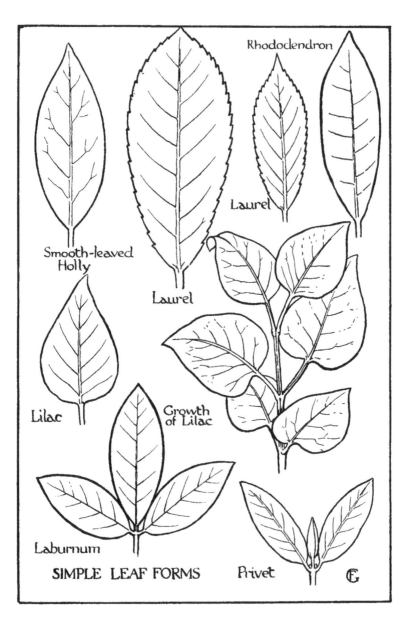

Rhododendron

Laurel

Smooth-leaved
Holly

Laurel

Lilac

Growth
of Lilac

Laburnum

SIMPLE LEAF FORMS

Privet

PLATE 12—*Simple Leaf Forms.*

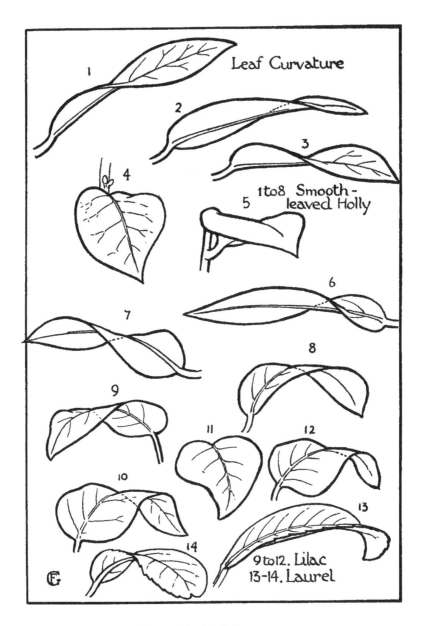

Leaf Curvature

1 to 8 Smooth-leaved Holly

9 to 12. Lilac
13-14. Laurel

PLATE 13—*Leaf Curvature.*

53

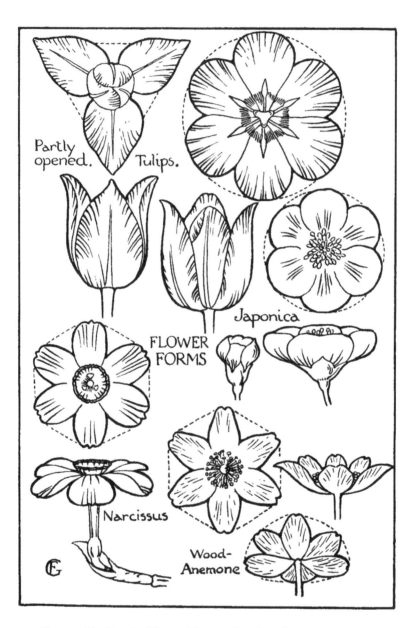

Partly opened. Tulips.

Japonica

FLOWER FORMS

Narcissus

Wood-Anemone

PLATE 14—*Simple Flower Forms, showing Geometric Basis.*

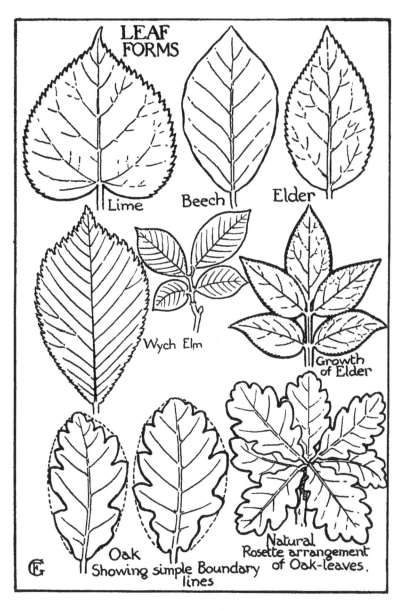

LEAF
FORMS

Lime

Beech

Elder

Wych Elm

Growth
of Elder

Oak
Showing simple Boundary
lines

Natural
Rosette arrangement
of Oak-leaves.

PLATE 15—*Leaf Forms.*

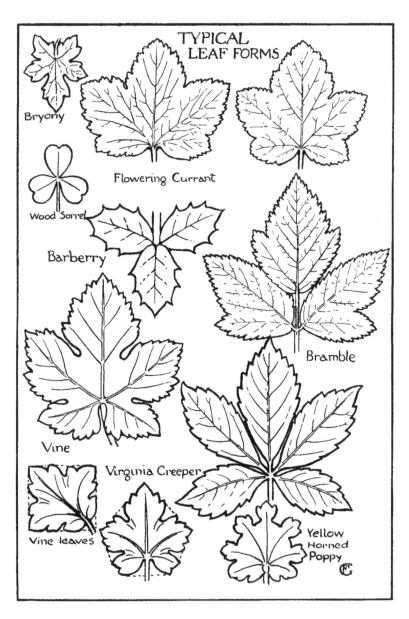

PLATE 16—*Typical Leaf Forms.*

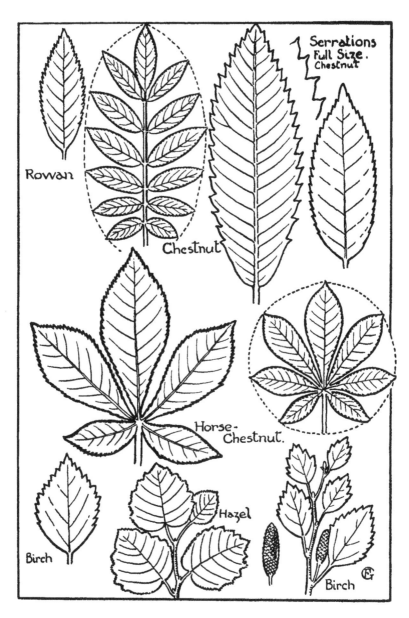

PLATE 17—*Typical Leaf Forms.*

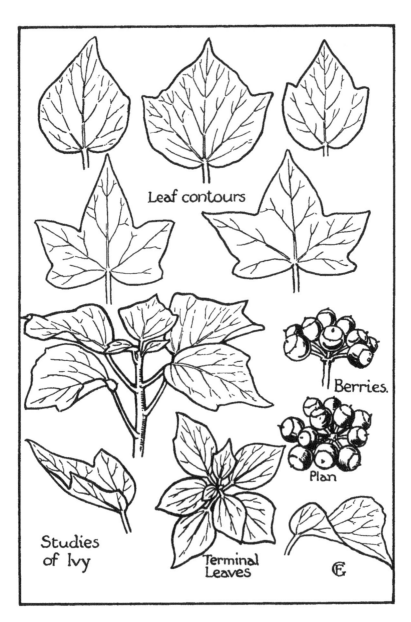

PLATE 18—*Studies of Ivy.*

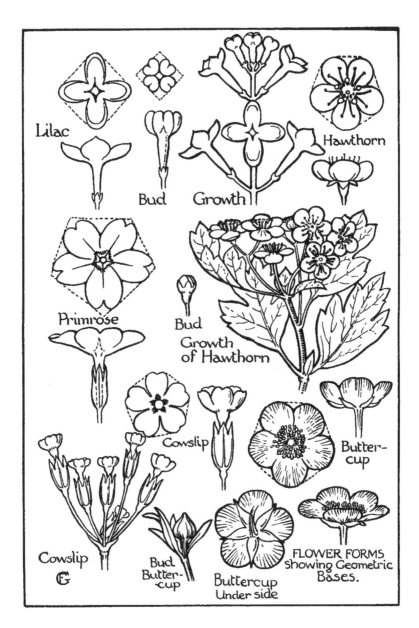

PLATE 19—*Lilac, Primrose, Cowslip, Hawthorn, Buttercup.*

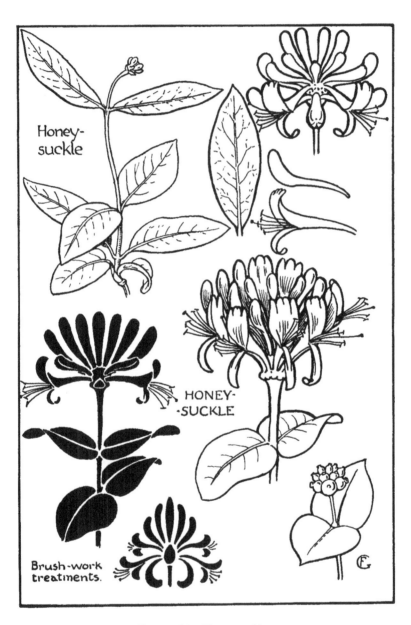

PLATE 20—*Honeysuckle.*

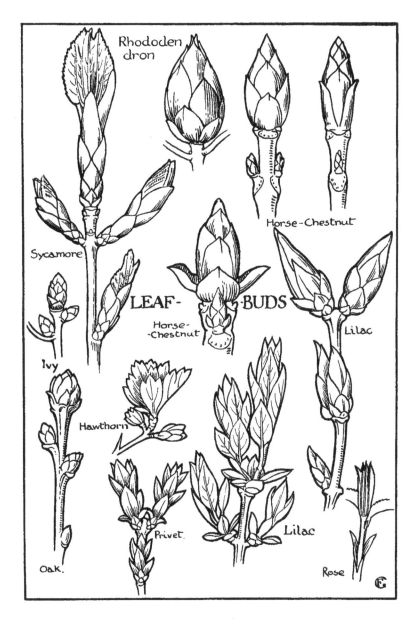

PLATE 21—*Bud Forms.*

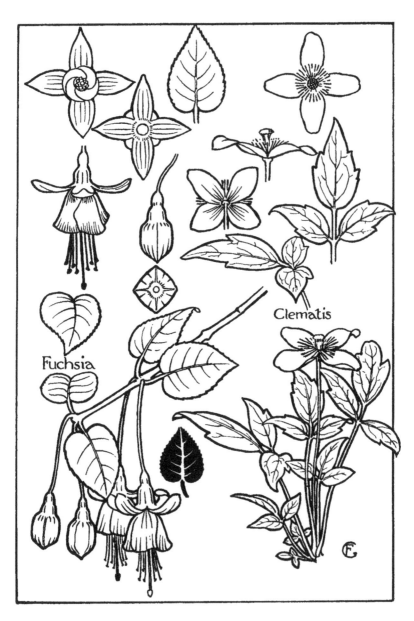

PLATE 22—*Fuchsia, Clematis.*

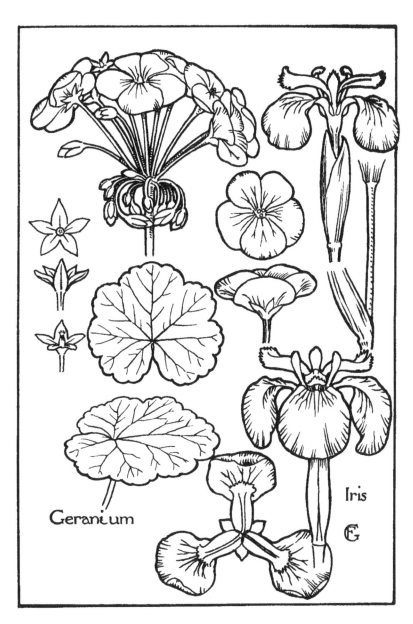

PLATE 23—*Geranium, Iris.*

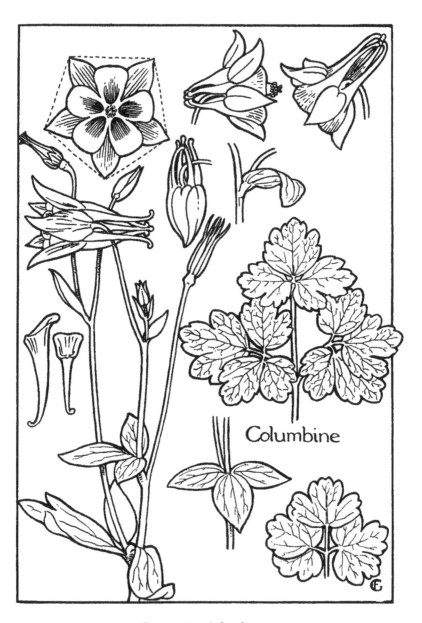

Columbine

PLATE 24—*Columbine.*

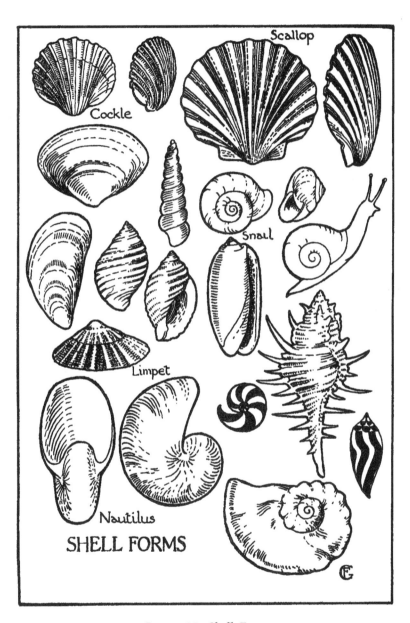

Scallop

Cockle

Snail

Limpet

Nautilus

SHELL FORMS

PLATE 25—*Shell Forms.*

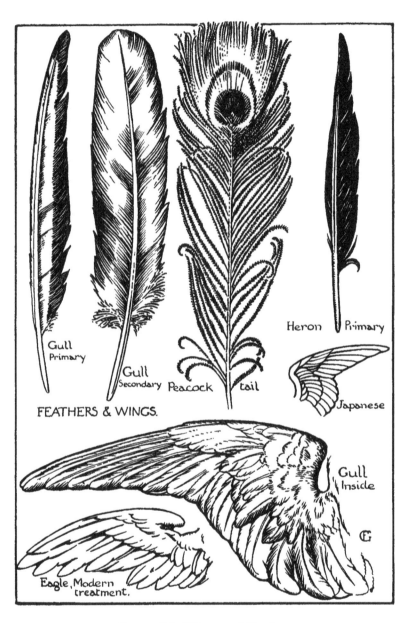

Gull
Primary

Gull
Secondary

Peacock tail

Heron Primary

Japanese

FEATHERS & WINGS.

Gull
Inside

Eagle, Modern
treatment.

PLATE 26—*Wings and Feathers.*

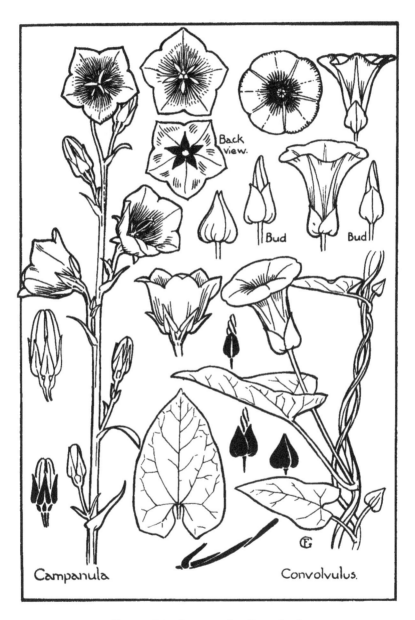

Plate 27—*Campanula, Convolvulus.*

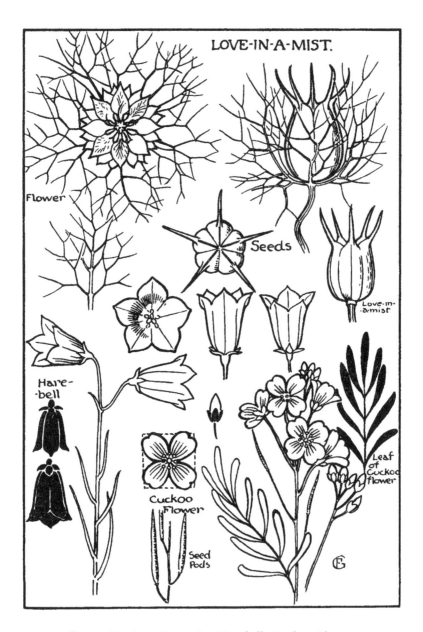

PLATE 28—*Love-in-a-mist, Harebell, Cuckoo Flower.*

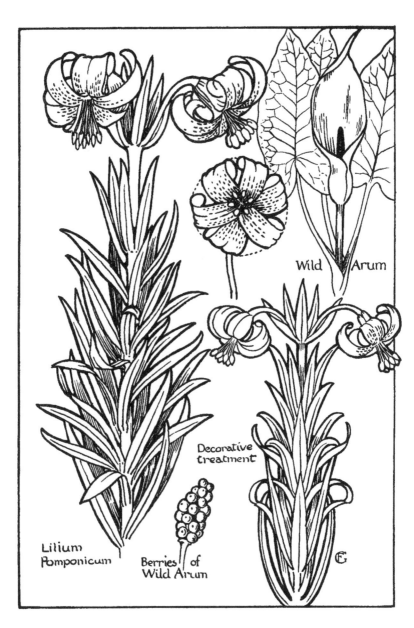

PLATE 29—*Lilium Pomponicum, Wild Arum.*

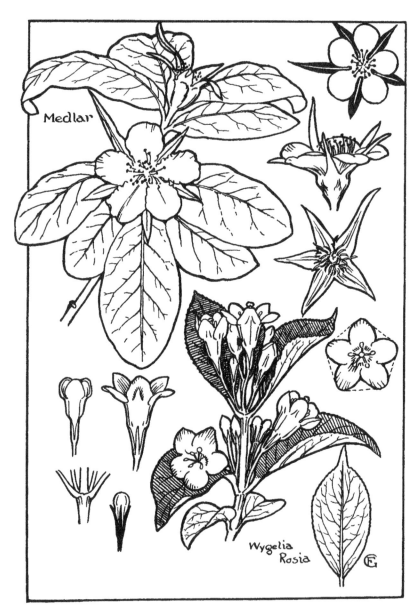

PLATE 30—*Medlar, Wygelia Rosia.*

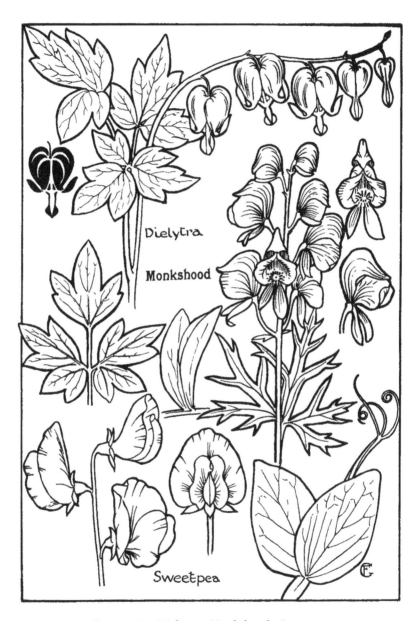

Dielytra

Monkshood

Sweetpea

PLATE 31—*Dielytra, Monkshood, Sweet-pea.*

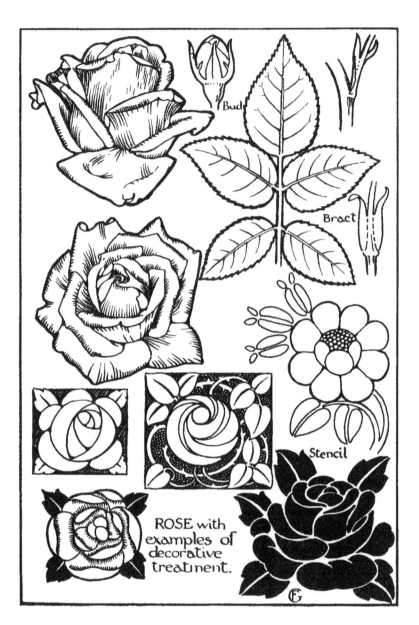

PLATE 32—*Rose.*

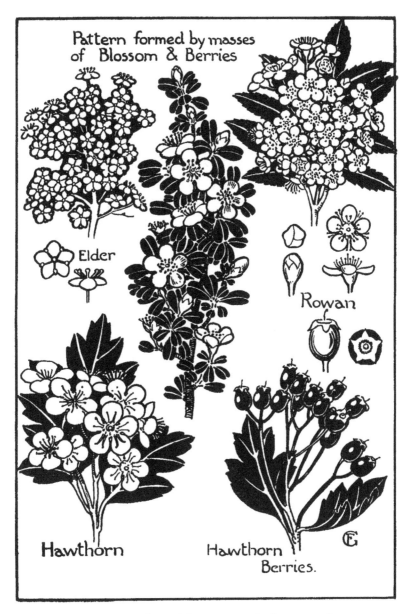

Pattern formed by masses
of Blossom & Berries

Elder

Rowan

Hawthorn

Hawthorn
Berries.

PLATE 33—*Pattern formed by Masses of Blossom and Berries.*

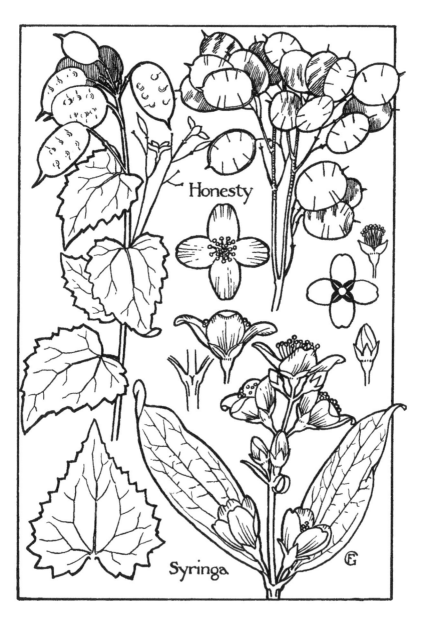

Honesty

Syringa

PLATE 34—*Honesty, Syringa.*

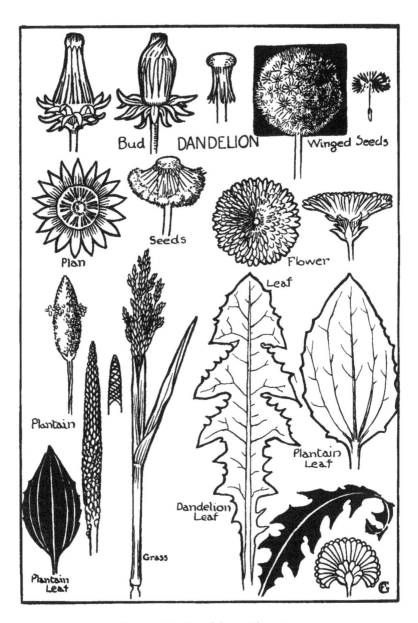

Bud    DANDELION    Winged Seeds

Plan    Seeds    Flower

Leaf

Plantain    Plantain Leaf

Grass    Dandelion Leaf

Plantain Leaf

PLATE 35—*Dandelion, Plantain.*

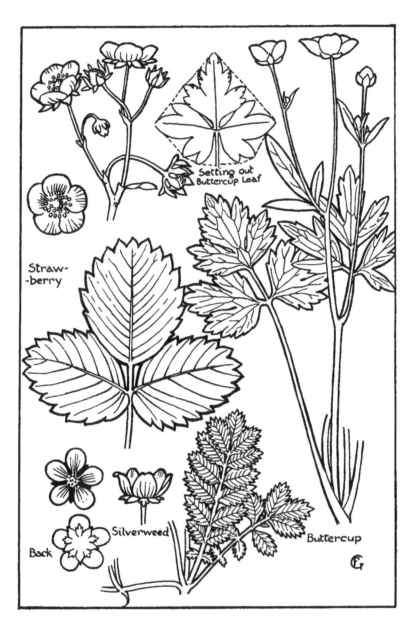

Setting out
Buttercup Leaf

Straw-
-berry

Back

Silverweed

Buttercup

PLATE 36—*Strawberry, Buttercup, Silverweed.*

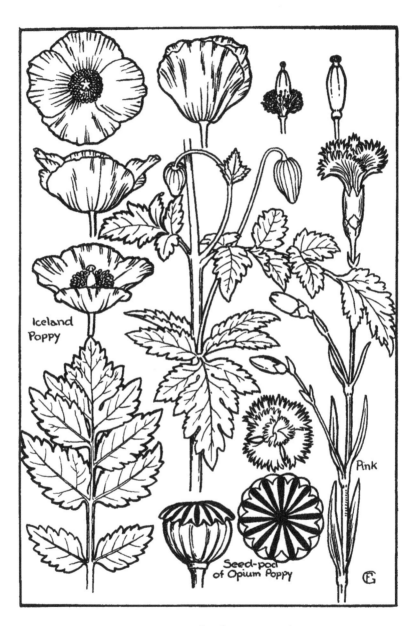

Iceland
Poppy

Pink

Seed-pod
of Opium Poppy

PLATE 37—*Iceland Poppy, Pink.*

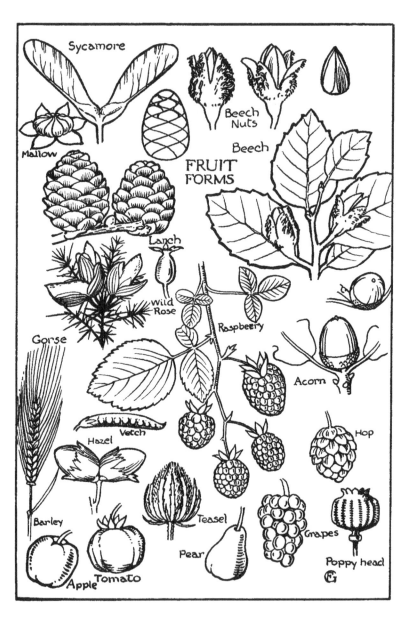

PLATE 38—*Fruit Forms.*

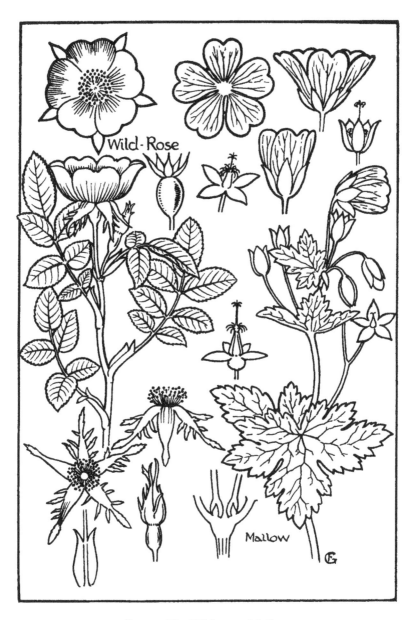

PLATE 39—*Wild-rose, Mallow.*

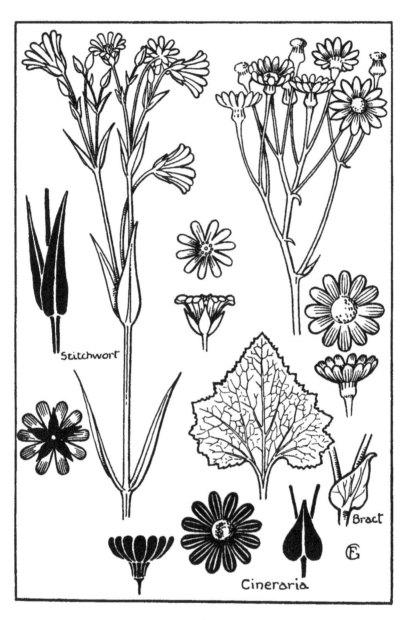

PLATE 40—*Stitchwort, Cineraria.*

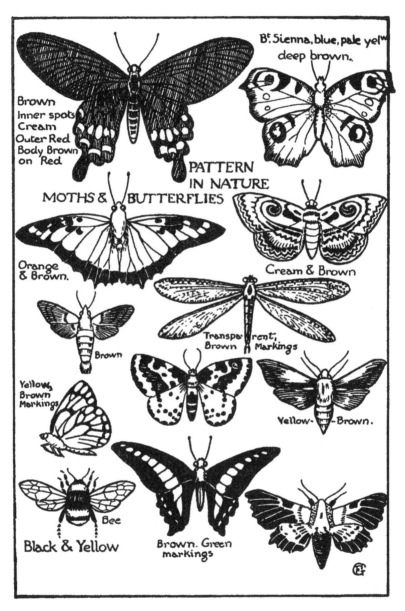

PLATE 41—*Pattern in Nature. Butterflies.*

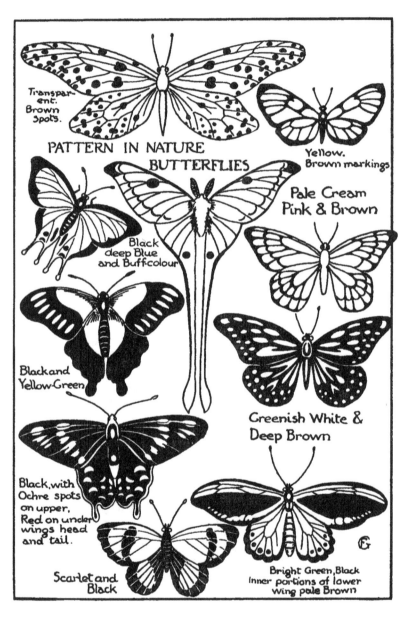

Transparent. Brown Spots.

PATTERN IN NATURE
BUTTERFLIES

Yellow. Brown markings

Pale Cream Pink & Brown

Black deep Blue and Buff-colour

Black and Yellow-Green

Greenish White & Deep Brown

Black, with Ochre spots on upper, Red on under wings head and tail.

Scarlet and Black

Bright Green, Black Inner portions of lower Wing pale Brown

PLATE 42—*Pattern in Nature. Butterflies.*

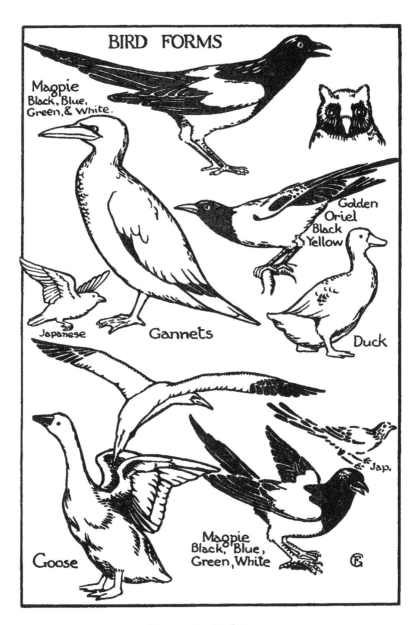

PLATE 43—*Bird Forms.*

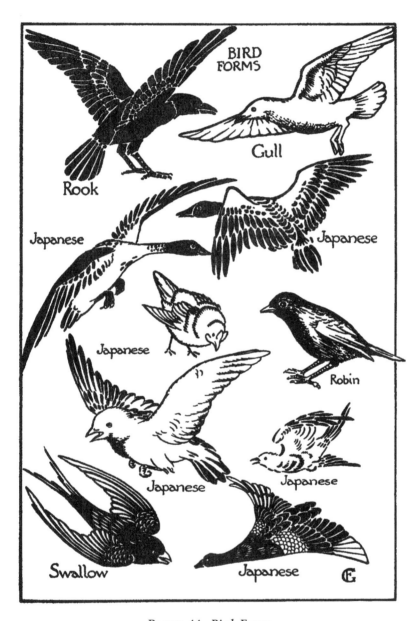

**BIRD FORMS**

Gull

Rook

Japanese

Japanese

Japanese

Robin

Japanese

Swallow

Japanese

PLATE 44—*Bird Forms.*

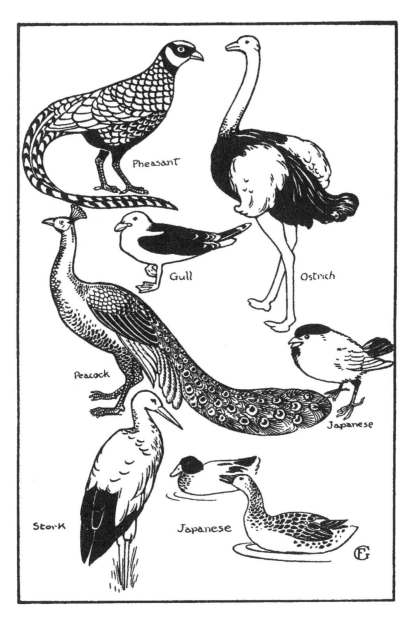

PLATE 45—*Bird Forms.*

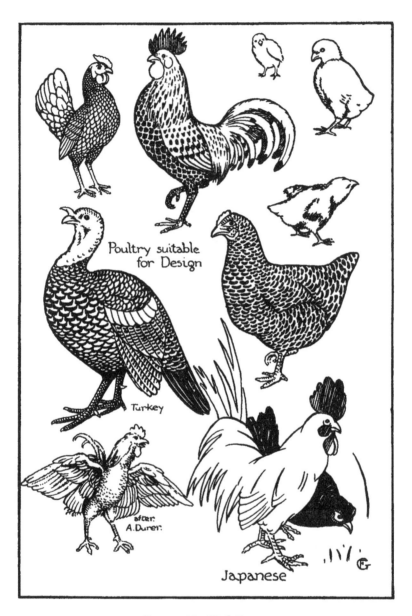

Poultry suitable for Design

Turkey

after A. Durer.

Japanese

PLATE 46—*Bird Forms.*

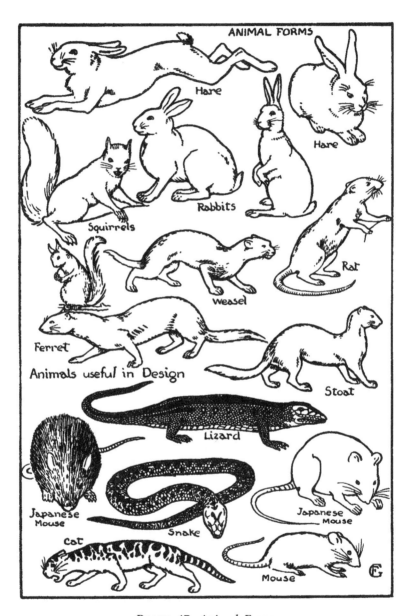

PLATE 47—*Animal Forms.*

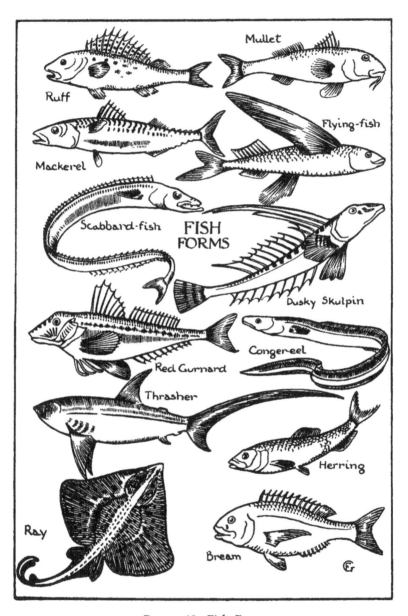

Ruff

Mullet

Mackerel

Flying-fish

Scabbard-fish  FISH FORMS

Dusky Skulpin

Red Gurnard

Conger-eel

Thrasher

Herring

Ray

Bream

PLATE 48—*Fish Forms.*

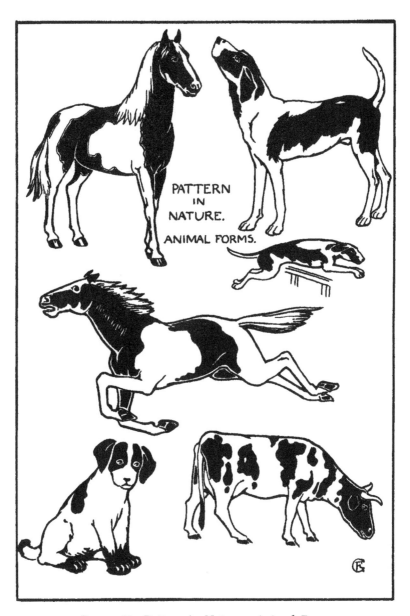

PLATE 49—*Pattern in Nature.   Animal Forms.*

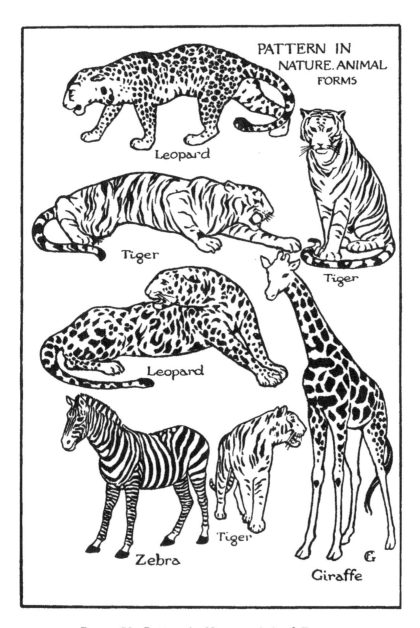

PATTERN IN
NATURE. ANIMAL
FORMS

Leopard

Tiger

Tiger

Leopard

Zebra

Tiger

Giraffe

PLATE 50—*Pattern in Nature. Animal Forms.*

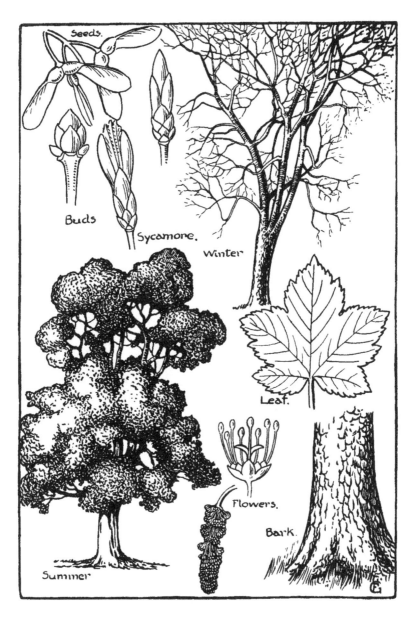

Seeds.

Buds

Sycamore.

Winter

Leaf.

Summer

Flowers.

Bark.

PLATE 51—*The Sycamore.*

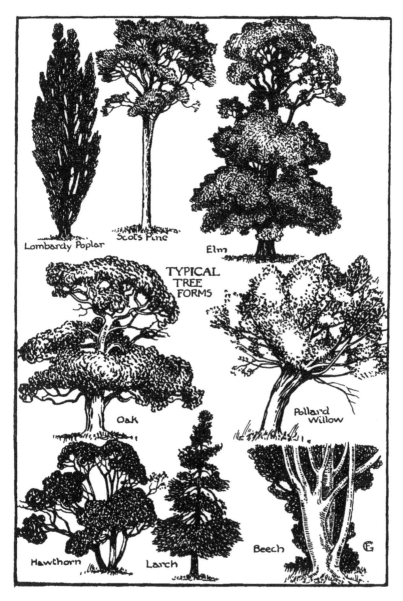

PLATE 52—*Typical Tree Forms.*

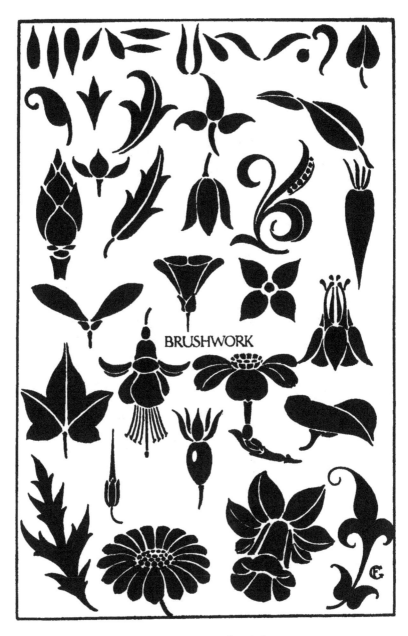

PLATE 53—*Brush-Work.*

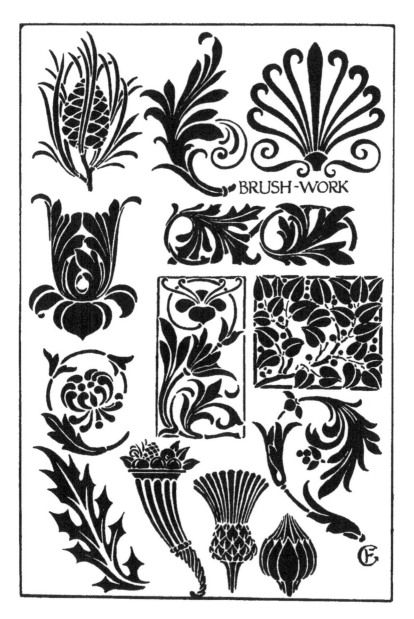

PLATE 54—*Brush-Work.*

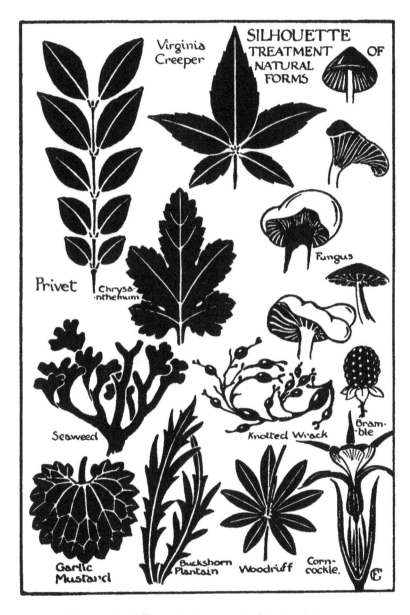

PLATE 55—*Silhouette Treatment of Natural Forms.*

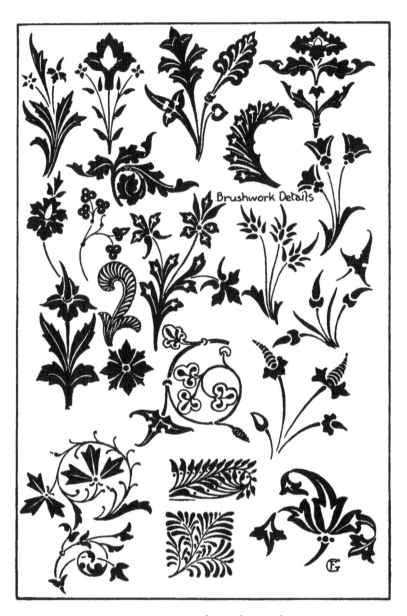

PLATE 56—*Brush-Work Details.*

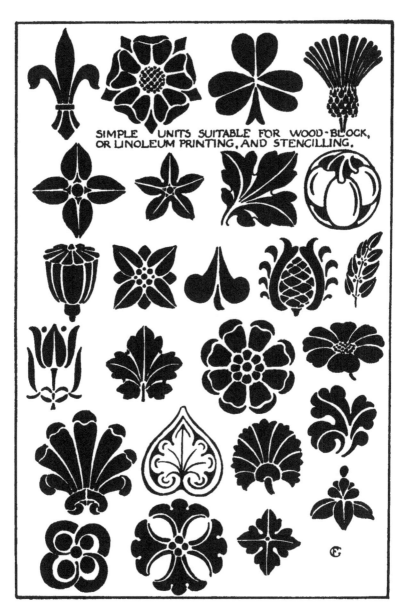

SIMPLE UNITS SUITABLE FOR WOOD-BLOCK, OR LINOLEUM PRINTING, AND STENCILLING.

PLATE 57—*Simple Units for Use in Design.*

## CHAPTER III

# LIGHT AND SHADE

OBJECTS are visible to us only in so far as they are capable of reflecting to the eye the rays of light which fall upon them.

**LIGHT AND VISION:** This, briefly stated, is the theory of vision, light rays emanating from the sun or an artificial source, are intercepted by an object and reflected back to the sensitive optic nerve, which registers the impression on the brain. The visual impression produced depends upon the nature of the object; hence an object which appears green to us, has the capacity of absorbing all but the green rays which are reflected to the eye. A red object absorbs all but the red rays; a blue, all but the blue, and so forth. In the section dealing with colour it is stated that white light is composed of coloured rays which are reflected to us in certain proportions to produce upon us what psychologists term "colour sensation." The stronger the light, therefore, the more powerful the colour, as may be proved by comparing an object in sunlight with the same in shadow. Our subject just now though is not colour, but light and shade. To consider the representation of

objects in light and dark, ignoring for the time being their local colour; all solid objects intercept the light, and are, therefore, capable of producing shadow; hence one portion will be fully lighted whilst another will receive but little light. The appearance thus produced conveys to us the impression of solidity and relief.

**ARTIFICIAL LIGHT:** The simplest way to commence this study is to take an artificial light and carefully consider our chosen object when lit by this alone. Note carefully that the surfaces immediately facing the light are bright, whilst other surfaces are greyer and darker the further they are turned away from the source of light, and again, that a shadow is cast by the object itself. The advantage of using artificial light is that the shapes of shade and shadow are sharply defined, making them easy for the student to see. There is always a tendency to treat shade in a sketchy haphazard way as though it were of no importance.

**SHAPES:** The student must realise that a certain shaped object, placed in a particular light, casts a corresponding shadow, and takes a particular light and shade. This is inevitable, and only a truthful representation can convey to the spectator the object under just those conditions. The necessity for careful treatment is, therefore, obvious. Let us commence our experiments by taking a sphere and placing it in the light of a candle. That portion which is nearest to, and immediately facing the candle is well lighted, whilst the rest remains in shade. By placing a card behind the sphere, a circular shadow is thrown, exactly the shape and size of the light that is intercepted. Move

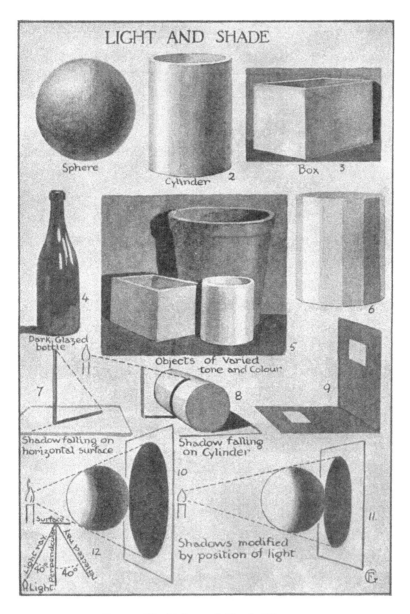

PLATE 58—*Light and Shade Diagrams.*

the candle nearer and the shadow grows larger; further away and it becomes smaller. Trace the light rays to their source, and the reason for this will be understood. The **Diagrams 10 and 11** on **Plate 58** illustrate this. **Diagram 1** shows the sphere in a more diffused light. Here it should be observed that the highest light is not immediately on the edge on the one side, nor the deepest shade on the other. The reason for this is that those rays of light which strike the edge on the light side are deflected away from the eye. Perhaps a statement of the law of optics relating to this will render it clearer. "The angle of incidence of luminous rays is equal to the angle of their reflection. The angle of incidence is the angle made by a light ray directed to a surface, with an imaginary line at right angles to that surface. A glance at **Diagram 12** will help to make this clear. The reason why the deepest shade is not immediately on the edge is because light is reflected into the shadow there from surrounding objects.

As an experiment draw two spheres and treat them in the two different ways, one as in **Figure 1, Plate 58**, and the other with the highest light, and the deepest shade on the extreme edges. By comparing them it will readily be seen which looks the more natural. The same remarks apply to the cylinder illustrated in **Figure 2**. **Figure 6** shows a prism made up of flat planes, to illustrate the effect produced by the light, and to make clearer the fact that as the planes turn away from the source, they must naturally receive less light to reflect. This will help to elucidate the drawing of the cylinder. On **Plate 59, Figure 2**, a cast is shown lit

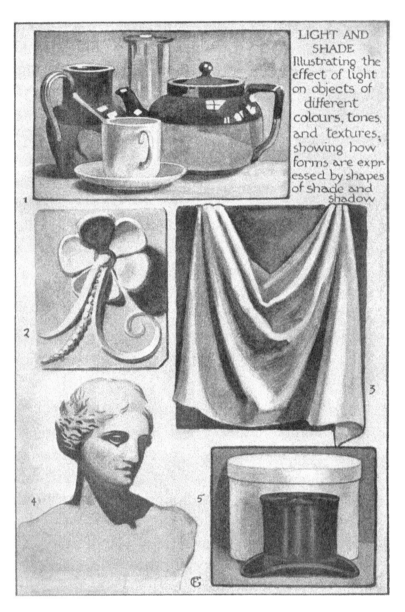

LIGHT AND SHADE Illustrating the effect of light on objects of different colours, tones, and textures, showing how forms are expressed by shapes of shade and shadow

PLATE 59—*Light and Shade Diagrams.*

by a single light falling from the top and left. It serves to illustrate how these surfaces which face the light are fully illuminated, whilst the others are shaded in proportion to the angle at which they are turned from it. The shadow on the right is thrown on to the background because the light rays are intercepted by the ornament. The term "shadow" is used to denote the dark portions caused by the interception of the light rays by an object or part of an object. A shadow is, therefore, cast by one object or part of an object upon another. The term "cast shadow" is often used to define this. The term "shade" is used where the surface loses the light because it is turned away from it. "Tones" and "half-tones" denote intermediate stages between full light and absolute shade. **Figure 4, Plate 59**, is an illustration of form expressed by shade and shadow, giving a sense of solidity to the head which mere outline or sketchy shading could never do. **Figure 3** is another instance of modelling suggested by light and shade.

**SUN SHADOWS:** There is a difference between the rays of light emanating from the sun, and those from artificial sources. In the former case, the sun being so far away all its rays appear parallel, whereas in the latter they proceed from one point and the radiation is therefore apparent. The result of this is that the lines bounding a sun shadow will be parallel, whilst in the case of artificial light the bounding lines will converge towards the source. To make this clearer note the shadows cast by sunlight from a row of posts or railings; you will find them parallel with each other, and the same width throughout; in artificial light they

will converge. To return to our illustrations in **Figures 10 and 11**, **Plate 58**, we have a sphere illuminated by a candle; suppose this sphere to be in the sunlight and the lines which in the illustration radiate from the source of light tangential to the sphere would in the sunlight be parallel instead of radiating. *Shadows conform to the contour of the surface upon which they fall.* This is illustrated in **Figure 8** where the shadow of a vertical rod is thrown on the ground and then over a cylinder. *Shade and shadow are rarely uniform in intensity.* Shadows are usually darkest close to the objects which cast them, losing in depth as they recede, this being caused by reflected light. So far we have dealt with light and shade without taking into consideration the "tone" of the object. It is wiser to deal with light objects first, as the difference between the lights and shades is more clearly defined.

**TONE:** The next stage is the study of objects which vary in "tone," that is, the light-reflecting capacity possessed by them. Here our difficulties are enhanced, for besides the light or dark colour of an object the quality of its surface or texture needs rendering. The bottle, **Figure 4, Plate 58**, is obviously dark but highly glazed. On one side is a reflection (sharp and white) of the window from whence the light fell; at the base, the table on which it stands has modified its dark tone by reflecting light into the bottle. **Figure 5** shows three objects of different tone, a glazed jar, a wooden box, and an unglazed flower-pot. Here the problem is a question of relative "values." Obviously the high light on the glazed jar is the brightest spot in the group, whilst the

shadow cast on the background is the darkest. The scale at our command is white paper for the highest light, and charcoal, pencil, or pigment for the darkest, and between these two lies our whole range. A good plan is to half close the eyes and study the tones through the eye-lashes. This tends to obliterate detail, to lower the tone generally, and so to help us to estimate the difference in value. A black mirror is also excellent for this purpose. The difference of tone and value is hard at first to realise, but unless we do actually see it and appreciate it, we cannot hope to reproduce it. Having made up our minds about the highest light and the deepest dark, we proceed carefully to outline the shapes, and to fill in the dark ones, not sketchily, but as evenly as possible. Then tackle the next quality of tone, and so on to the lightest. Note in the illustration that the box, although facing the light, does not reflect so much of it as the white jar, and the flower-pot less still. This is owing to the darker quality or tone of the objects themselves. Further illustrations of this are shown in **Figures 1 and 5, Plate 59**. In **Figure 1**, we have all glazed objects with "high lights" upon them, but the cup and saucer appear lighter than the tea-pot and jug, owing to the darker colour of the latter, whilst the glass vase behind is transparent, with a few spots of high light, and the background tone showing through. A good plan is to take a simple cast or white object, light it strongly from one artificial source, and treat it in two different tones, *i.e.*, strong black and white only. This is a method largely used in modern black and white illustration and is most effective. It necessitates careful drawing of

shadow shapes. This might be followed by work in three, four, five, or even more tones. It is excellent practice in light and shade, and also tone composition; a very important factor in pictorial design.

As previously stated our scale is limited, on the one hand, by white paper, which is the highest light obtainable, and, on the other hand, by the full strength of our medium—pencil, charcoal, crayon or pigment. With this we have to represent our subject.

**BLACK AND WHITE:** The terms black and white as we use them are only relative; much depends on the illumination. A sheet of white paper in the sunlight is not as white as snow in sunlight, whilst the paper is whiter than another sheet in shadow, which, by comparison, is grey. Again, what we term black is subject to modification, for, fully illuminated, it seems grey in comparison with the same black in shadow. The shadow cast by a slender rod appears darker than the shadow of a larger surface, so also a small patch of light, when surrounded by shadow, seems brighter than a larger one. This is caused by contrast, the eye being dominated by the larger mass is less capable of estimating the actual value of the smaller shape. **Plate 58, Figures 7 and 9**, illustrate this. Again, a black when wet appears darker than when dry, while dark and light are both intensified by placing them side by side.

Light and shade may suitably be introduced into class-work in connection with the object-drawing lesson. As soon as some command of "line" has been acquired,

tone might be adopted for expressing objects. It is more truthful, and less of a convention than outline.

## DESIGN

"Design with the owl's eyes first, you'll get the falcon's after."

—Ruskin.

This advice from John Ruskin is the best possible advice to the student of design, for it really amounts to, plan your essentials first, your details will follow naturally.

Design in its broad sense (*i.e.*, the harmonious disposition of such lines, forms, masses, tones and colours as come into the scheme in hand) enters to a greater or lesser extent into all forms of artistic work. It is, therefore, an important subject, and one that must never be lost sight of. Even in object-drawing the pupil should be taught to plan his work on the paper in such a way that when finished it looks well. A drawing badly placed loses some of its value. If the sense of arrangement is inculcated from the beginning, and throughout the whole course of instruction, there will be no awkward division between the design lesson and the lessons in other subjects.

**REPETITION:** The simplest form of design is that which depends upon repetition; for practically any unit spaced at regular intervals by its ordered arrangement will produce pattern. **Plate 60** illustrates a series of border patterns based on common numerals

Suggestions for Borders based on
Numerals and Roman Caps

PLATE 60—*Border Suggestions.*

and Roman capitals. These units were chosen because they are quite common, so much so, in fact, that they are rarely thought of as elements for design, but they really form excellent ornament because they are highly conventionalised. Through long usage they have become simplified until all that was unnecessary has been eliminated, and only the essential forms remain. By reversing, combining, and repeating, much interesting pattern can be obtained; not only borders but diapers and other repeating patterns. This forms a good lesson in design, as the pupils are dealing with elements that are familiar. Repetition will produce pattern from much apparently unpromising material, whilst in nature will be found a vast store of forms that are beautiful in themselves, and will readily combine to produce ornament. Shells, leaves, flowers, buds, fruits, etc., will all make interesting pattern by repeating at stated intervals, whilst conventional forms such as the fleur-de-lis and Gothic ball flower, nail head, rosette, and four-petal flowers are well-known examples, **Plate 61**. The border suggestions, **Plate 60**—the Celtic interlacing, **Plate 62**—the Fret patterns, **Plate 63**—are all based on the principle of "Repetition," other examples of which occur in the illustrations.

**PROPORTION:** "Proportion" is one of the most important factors in design. The relation of part to part, mass to mass, ornament to background, colour to colour, light to dark, is termed proportion, and upon the harmonious balance of the component parts of a design its beauty rests. In the planning of a building it is the architect's chief concern. The relation of window

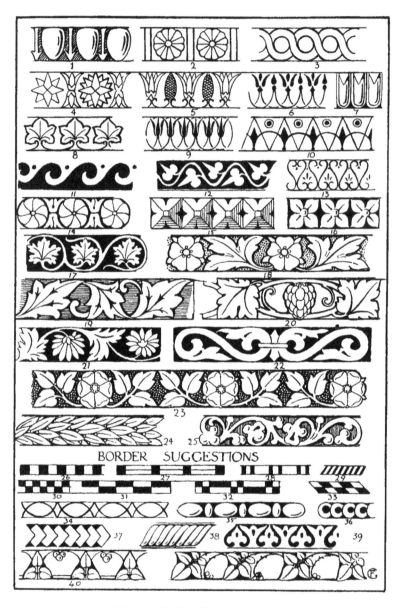

PLATE 61—*Border Suggestions.*

KNOTS & INTERLACED BORDERS

PLATE 62—*Knots and Interlaced Borders.*

111

PLATE 63—*Fret Patterns.*

112

PLATE 64—*Diagrams illustrating "Proportion."*

and door to wall space, the proportion of moulding to plain stretch of brick or stone, the balance of light and dark, will decide the beauty or ugliness of a building. Generally, unequal proportions are best. On **Plate 64** some geometric shapes are illustrated, divided up into good and bad proportion. **Figures 1, 11, 18, and 27** are obviously poor and uninteresting. The reason for this poverty is because the divisions are apparently equal in proportion. The other figures show more interesting spacing, because in each there is a predominant space with other subordinate spaces. From this we may conclude that where there is no dominating mass, a feeling of unrest ensues, the eye wanders from space to space, and, finding no place to settle, will produce a sense of dissatisfaction in the mind of the spectator. If there is a dominant feature the eye settles there, and, having grasped it, roves over the other features, returning always to the important one to rest. It sets the key, as it were, to the whole harmony. In teaching this principle a good plan is to sketch these shapes on the board and ask the pupils to choose, stating the reasons for the choice, after which the teacher explains the difference between good and bad proportion, and what constitutes the difference.

**SUBORDINATION:** Following naturally upon this comes *Subordination*, for in satisfactory proportion all the minor features are subordinated, or kept in subjection to the principal feature. In fact, proportion might be defined as domination and subordination. This seems to imply a contradiction of the first principle mentioned, *viz.*, repetition, but repetition is used for

covering a surface evenly, whilst proportion applies more particularly to an object or piece of decoration complete in itself. An element which is to be repeated over a large surface should be highly conventionalised and unobtrusive. The higher organic elements, such as figures, animals, etc., do not bear repetition well, as, interesting though they may be in themselves, if repeated a number of times they become very monotonous. The mental activity aroused by the interest that the human figure possesses, becomes very tiring by the constant repetition. It only serves to exaggerate the feeling of monotony. Buildings, furniture, and articles in everyday use depend largely upon proportion for any beauty they may possess.

**PURPOSE:** The first thought when planning an object should be its ultimate use. Fitness for the purpose for which it is intended is of primary importance.

**MATERIALS:** The next consideration is the nature of the material. Wood, stone, pottery, bronze, iron, copper, silver, textiles, and printed fabrics, demands each a treatment peculiar to itself. Wood is sawn into planks and in this form generally reaches the hands of the craftsman. Straight lines and the simplest of curves are, therefore, the most suitable for wood, and in articles of furniture these lines are undoubtedly the most satisfying. What is more disconcerting than a chair which by its curly lines, produces a feeling of insecurity when you venture to sit upon it? Stone is a heavier material but more brittle than wood. It has, therefore, to be used in greater bulk, and presents an appearance of greater permanence than timber. Then

again woods and stones differ in quality. Box, pear, and fine-grained woods will take on a higher finish and may be wrought into finer detail than deal, pitchpine, and coarser woods. Marble, alabaster, and white stone of a close texture require different treatment from Bath stone, granite, or slate. Pottery thrown on the wheel or modelled suggests its own peculiar forms. Textiles are dependent on the limitations set by the loom. Bronze modelled and cast is different in quality from silver, which is hammered, pierced, punched, and drawn into wire; whilst iron may be wrought, twisted, and bent into forms unsuited to either bronze or silver. Printing has its own demands dependent on the process, whether line blocks, three-colour, lithography, half-tone, or roller printing for fabrics. Whatever the process or material may be, there is a treatment peculiar to each which must be recognised by the designer. Each object then must fulfil its purpose and be suitable for the material in which it is executed; decoration must not detract from usefulness, but be always subordinate to construction.

**PROPORTION:** Many articles require no decoration whatever, but depend for their beauty upon shape and proportion, and it will always be found that the most beautiful articles are also the fittest for their purpose. To return to the illustration, **Plate 64**, it will readily be seen, in the light of the foregoing remarks, how much more interesting is the unequal spacing. A few lessons in breaking up geometric shapes, by means of lines and masses, into spaces of unequal proportion will prove of great value. For this purpose a brush and black ink, or some dark pigment is best. The lines must be drawn

freehand, the hand is thus more at liberty to obey the dictates of the mind. A series of attempts, which may be compared, are of far greater value than one that has been worried into shape with pencil and rubber. More facility and decision of handling are thus acquired, for once a brush stroke is on the paper it must remain. This space harmony or proportion cannot be too much insisted upon, for all design depends upon it, and unless it exists in the work, no intrinsic interest possessed by the *motifs* can save our design from insipidity. This is unfortunately but little appreciated, for students are inclined to pay more attention to getting the flower or leaf, or whatever form they may be using, to resemble that form in nature, than to its arrangements within the limits of the space. The observer too is often more concerned with the particular flower, or whatever the form may be, than with the planning of the design. A design should satisfy by its harmony of space, tone, and colour alone, before the observer has recognised what natural or artificial forms enter into it. When listening to music we do not ask what the composer desires to represent, we are quite content to enjoy the harmony that floods our sensibility. Line, form, and colour are to the eye what music is to the ear, and the sense of sight may be cultivated to appreciate harmony in visual arrangements, quite apart from any associations or resemblance to known forms.

**PICTORIAL COMPOSITION:** Not only does this principle of proportion apply in what is usually understood as design, but equally so in pictorial composition. **Plate 65** shows the value of spacing in

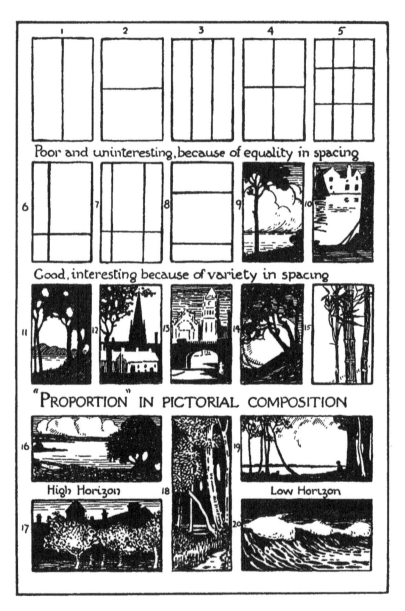

PLATE 65—*"Proportion" in Pictorial Composition.*

this branch of Art. Again, the arrangement depends upon inequality or variety in the spacing of tone and colour. In this case, however, the artifice should not be obvious. The dominant mass, or most interesting feature is, therefore, rarely placed in the centre of the picture. Equal masses of light and dark are avoided as far as possible. The horizon should not divide the picture into equal portions of earth and sky, nor should a vertical line, such as a tree, post, or any like feature, divide it down the centre. A picture is primarily a composition of line, tone, and colour, and every stroke should form part of a deliberate design. That quality in nature we call picturesque is the quality of dark and light—a well-shaped mass of trees silhouetted on a light patch in the sky or a gleam of light that shines out of darker surroundings. The appeal is similar to that of music. It is not because nature has used trees or sky or water for her effect, it is because of its "Visual Music," or fine relationship of tone value that beauty results. This is not generally recognised, but a careful analysis of any good painting will help us to appreciate the value of the tone relationship in arriving at the picturesque.

Pictures are as carefully composed, and often with a more consummate knowledge of and feeling for design, than the most elaborate piece of ornament. The works of the late Alfred East are very beautiful in composition, the more so as the principles involved are not obvious. When the pupil has acquired the ability to draw, and some knowledge of tree, cloud, and other natural forms, exercises should be set in tone composition. The teacher might set an example before the class and

instruct them to make other arrangements, fitting these to square, upright, and horizontal panels, and other shapes. **Plate 65**. Commencing with simple black and white masses applied with the brush, the lessons should later involve the use of three, four, five, and even more tones, in charcoal, pencil, wash, or other medium. These exercises should be limited to tones of one colour, one problem at a time, as the use of colours complicates the study. Here again a number of sketches are of more value than one. The advantage of fitting the same elements to different shapes lies in the practice it gives in dealing with them, and in demonstrating the fact that some compositions fit an upright panel better than a horizontal, others, the horizontal panel better than the upright, while for some a square or circle is best.

LINE: Before the lesson in Pictorial Composition, in fact following immediately upon the one in Proportion, where spaces are broken up by lines parallel to the boundaries, the significance of *"line"* should be explained. Lines, though abstract enough as defined by Euclid, have yet a significance of their own. The student must be taught to differentiate between a good and a bad line, between lines that harmonise and lines that contrast. Much of doubtful value has been written about "curves of beauty," especially the one attributed to Hogarth, but by applying the principle of proportion it is possible to form an estimate of what constitutes a good line. Variety is perhaps the first essential, curves which are uniform in curvature, or, if geometric, are arcs of one circle, are not so interesting as varied

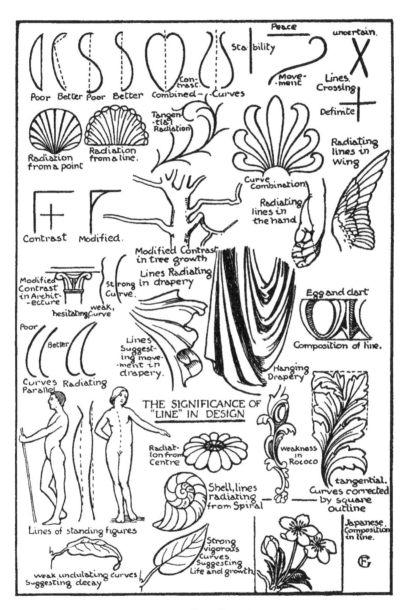

PLATE 66—*"Line" in Design.*

curves, or geometrically, those which combine arcs of different radii. On **Plate 66** an attempt has been made to indicate the difference between good and bad lines. The S curve which is composed of two similar arcs, is not so interesting as the one composed of dis-similar curves. Varied curves arranged symmetrically illustrate the value of contrast or opposition. Contrast may be defined as intensified variety, hence it is exceedingly valuable in composition, whether it be line, tone or colour. The hand has a tendency to repeat a curve it has once traced; this tendency must be guarded against, or the result will be parallelism. Our safeguards are variety and contrast. Often when a line arrangement has been thought out, we feel that it is lifeless and insipid; a few lines in definite contrast will correct this tendency. Too much curvature may be corrected by a few straight lines; or curves which seem to flow too much in one direction may be saved by curves placed in opposition.

**CROSSING LINES:** Straight lines which meet or cross at right angles form definite contrasts which are sometimes too harsh for the subject in hand. A curve sliding from one of the lines forming the right angle into the other will modify this harshness. Roman lettering affords an instance of this, where the gentle curve of the serif modifies the otherwise harsh finish of the straight stroke (**Plate 84**). Nature also provides many examples. The springing of stems and branches which swell into a gentle curve before meeting the parent stem, the flower stem curving out to form the calix upon which the flower is based, are instances which may be multiplied *ad lib.* (see **Plate 66**). Despite the

122

harshness which is sometimes felt when lines cross at right angles it will be found generally that where the arrangement makes a crossing necessary, a definite one making right angles is preferable. Lines which approach each other by a gradual convergence, and cross almost imperceptibly, will be found unsatisfying. The reason seems to be that an air of indecision accompanies the arrangement; the eye follows one line along, comes to the crossing and pauses uncertain as to which line it should continue with. If the lines cross frankly at a right angle or nearly at right angles no doubt exists in the mind, and the feeling of uncertainty is not experienced. It is better then, where lines cross, to see that they do so at right angles, or as nearly as possible. Should the requirements of the design not admit of this, a definite feature should be made of the point at which the lines cross. A leaf or bract or some such feature will usually accomplish this.

**RADIATION:** Possibly the most useful and most widely used principle, both in nature and in ornament, is the principle of radiation. Parallelism tends to monotony. Radiation gives variety; two lines which run parallel are never so interesting as two which converge or radiate. This is proved when looking at a building where necessity usually demands an uncompromising parallelism. A front view or elevation of the building is rarely so pleasing as a "perspective" view where the horizontal lines converge. The architect realises this, for he usually makes an attractive "perspective" sketch to show to his client. Nature uses radiation extensively in her wonderful line compositions. The shell with ribs

that radiate fanwise, the petals of a flower springing from the centre, leaves growing from the twig with veins radiating from the mid-rib, the fibres of a muscle, the feather arrangement in a wing, are a few examples of radiation in nature. A piece of drapery suspended forms a very useful study in radiation. Three types of radiation are recognised: (1) where the lines converge to a point; (2) where they converge to a line; and (3) tangential radiation, where the minor lines spring tangentially from a main line. A feather with the barbs springing from the quill is a good example of tangential radiation. Illustrations of the three forms are given in **Plate 66**.

**QUALITY OF LINE:** The quality of the curve is also important. A doubtful, vacillating curve lacks the conviction of a strong, decided one, and, in rendering plant form, a vigorous curve will suggest life and growth, whilst a weak, undulating one conveys an impression of withering decay. Line composition is a fascinating exercise, but it requires some little practice and analytical observation before harmonious arrangements can be produced. As previously stated, nature provides many examples to be studied, in addition to which an analysis of historic and modern design will help us to grasp the principles upon which line harmony depends. The egg and dart moulding is a fine instance of line composition; the ovoid centre form, with enclosing ridges which converge downwards, affords a good example of complimentary or symmetrical curves, whilst an even sharper contrast is obtained by the straight lines of the dart, which is saved from harshness by the barbs.

**BEAUTY:** The human figure is the most perfect

example of curve combination. If we might venture to define **beauty** (a task that has often been attempted), we might be inclined to say it is perfect fitness. The human frame is perfectly fitted for its varied activities, which are more complex and of a loftier character than those of any other creature. If then the human figure provides the finest combination of line, to say nothing of form and colour, we might conclude that this beauty was the outcome of the fitness. Other instances can readily be found: the lines of a sailing ship, built for speed, to offer the least resistance to water, and to take full advantage of the wind. A comparison between the wings of a hawk and those of an owl, the one suggesting swift and the other slow flight, will afford illustrations of beauty as the outcome or accompaniment of fitness.

**WEAK CURVES:** To return to our examples, the sketch of Rococo ornament errs on the side of weakness: too much curvature has become so insipid that one longs for a strong straight line. Japanese works might be studied with advantage by the student of line. They are excellent in arrangement; the apparently free careless handling is really the outcome of patience, skill, and an exquisite feeling for line. This subject of line is worthy of attention, as it bears the same relationship to design as the skeleton does to the human figure. All work of an artistic nature must be built upon line.

**LINE IN PICTORIAL COMPOSITION:** Under Proportion the main lines that go to the composition of a picture were touched upon purely with regard to the breaking up of the space. Besides their capacity for breaking up the space, the direction, quality, and

curvature of the lines, have a significance in themselves. The vertical line conveys an impression of stability. The upright lines of a building, a tree, a pillar, etc., suggest strength and a capacity for support, which an oblique line lacks. The horizontal line is a peaceful line. Flat stretches of country, a calm sea, level bars of cloud, the lines of a recumbent figure, all have a horizontal tendency, and so convey a sense of peace. The swinging vigorous curve is the line of movement. Rolling clouds, wind-swept trees, breaking waves, and moving figures are all full of strong sweeping curves. Drapery will serve to illustrate this line significance. From a standing figure the folds will fall into vertical lines; a reclining figure will mould them into lines with a horizontal tendency, whilst a figure in action will swing the folds into curves full of movement. This movement is enhanced in a strong wind where the drapery will be blown into fluttering curves that seem full of vitality.

The vertical line is the line of rigidity and permanence; the curved line is the line of growth and movement, and the horizontal line is the line of rest and suspended movement. After the teacher has explained something of the value of pure line the pupils should be allowed to make compositions in line, with no attempt to represent natural forms, after which, designs based on natural or historic forms, and later, simple landscape compositions may be attempted.

**MASS:** When the student has learned something of line, and has acquired some degree of facility in arrangement, he should be taught how to clothe these skeleton lines with mass. Mass might be defined as a

dark tone of definite form upon a light tone, or a light tone of definite form upon a dark one, or again as a patch or shape of one colour upon another, all of which will appeal to the spectator as clearly defined shapes. The first exercises should take the form of mass alone with no attempt at representing natural or artificial objects. It should form a continuation of the lesson in proportion, the only difference being that mass is used instead of line. The aim should be to impress upon the student the fact that beautiful design or composition does not rest upon the imitation of natural forms, though this may give an added interest, but upon the amount of "visual music" contained in it. In other words, the mass and line arrangement are of primary importance, and should be our first consideration.

**SPACE FILLING:** When "line" and "mass" have been mastered the next exercises should take the form of space filling with flower and leaf forms. The drawings used for this purpose should be those which the student has prepared for himself. Under Plant Form will be found a few suggestions regarding the treatment of plants intended for design.

**LINE:** When filling a space with natural forms the first consideration is the skeleton or main lines. These should harmonise with the boundary lines and be such as will not necessitate any violation of the growth of the plant. In fact the plant will often suggest the leading lines for us. **Plates 67, 68, and 69** illustrate a few skeleton line arrangements suitable for a beginning. These lines may be either symmetrical or unsymmetrical. Symmetry is the balancing of similar curves, placed in opposition,

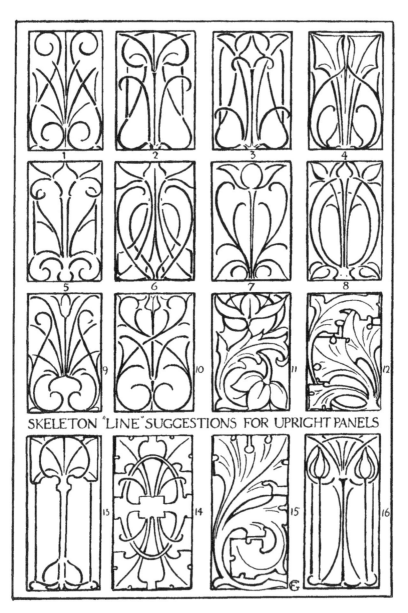

PLATE 67—*Skeleton Line Suggestions for Upright Panels.*

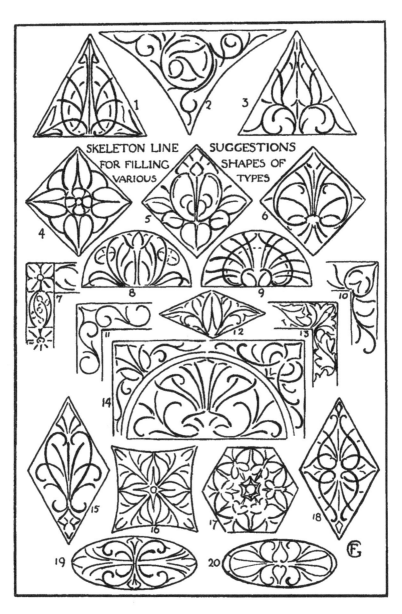

PLATE 68—*Skeleton Line Suggestions for Various Shapes.*

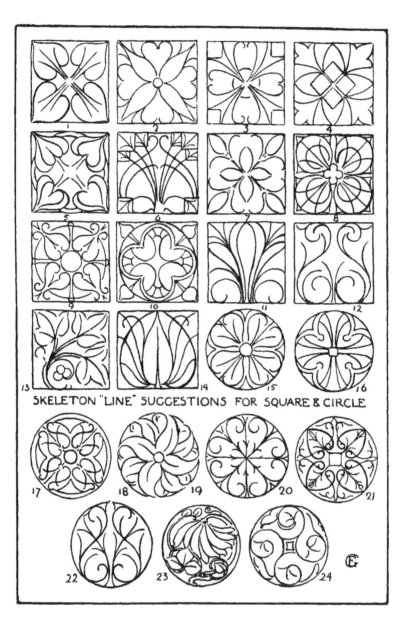

SKELETON "LINE" SUGGESTIONS FOR SQUARE & CIRCLE

PLATE 69—*Skeleton Line Suggestions for Square and Circle.*

on either side of a central line. It is perhaps the simplest method of obtaining ornament, for almost any curve opposed with a similar curve on either side of a central line will produce a sense of order and arrangement, and will, at once, become ornamental. The unsymmetrical system is not so easy to manage, and will depend for its effect upon the balance of the lines.

**MASS:** When these main lines have been harmoniously arranged, with due regard to boundary lines, the masses are planned. Bearing in mind the principle of proportion we decide where to place our principal mass or chief interest, or if an all-over effect is desired, we decide upon the disposition of the equal masses. In the first case, having placed our dominant mass, we proceed to group about it the minor masses, endeavouring always to get fine shapes. In an upright panel the correct place for the heaviest mass seems to be somewhere near the bottom; here it increases the stability of the design. But this is not absolutely necessary, for if the weight be placed higher, the supporting lines may be given an appearance of strength sufficient to counteract this weight. The correct position for the most interesting feature is generally at or near the top of the panel. In this we are following Nature, for she invariably plans her most interesting features so that they crown the structures of which they form a part. Flowers, fruit, faces, etc., are culminating parts, and, therefore, occur at the top.

**CORNERS AND ANGLES:** When the masses have been disposed to our satisfaction, and due attention has been given to the corners, we proceed to fit our leaves and

flowers into the shapes we have designed for them. With regard to these flowers, fruits, leaves, or other natural forms, it is essential that they should be so presented as to require the minimum of mental effort on the part of the spectator. In other words, those forms which are most typical should be chosen for use. The remarks made when dealing with Plant Study, calling attention to the geometric shapes underlying flower forms, the shapes characteristic of leaves, etc., apply particularly in this connection. The typical and characteristic are of greater value in ornament than the accidental. A good design must evince order and arrangement, which can only result from thought and analysis on the part of the designer. A naturalistic rendering of a plant placed haphazard within bounding lines will never produce good ornament. There must exist a feeling of the inevitable. The design when completed should appear as though it belonged to the shape and position it occupies, and no other. Any design which looks as though it could be removed from its surroundings and placed in others, with equal success (or lack of success), is unsatisfactory. To the casual observer it may seem that some Japanese designs would suit other surroundings equally successfully, but the experiment has only to be made to prove how erroneous is this idea. The seemingly careless placing of the component elements in a Japanese composition is not so careless as it seems. In the hands of a master the most difficult task looks easy, and this seeming carelessness is in reality the outcome of consummate skill and feeling for harmony.

**CLEAR RENDERING:** It follows then, if our work is to be easily understood, that the leaves, flowers, or whatever our motifs may be, must be presented in the clearest possible manner. Foreshortened views, or twists and turns that require light and shade to elucidate them, are generally to be avoided. Forms which overlap will sometimes lead to confusion. The aim being clarity rather than obscurity, it is better to be quite sure that the introduction of intricate forms improves the design. A word of warning may here be necessary lest in our desire to obtain simplicity we may only achieve poverty and meagreness. It is quite possible when we have arranged our natural details in a readable manner that they may appear disconnected and thin. This appearance may be corrected by grouping the leaves, flowers, or what not, so that they overlap and form masses. This arrangement is not only permissible but frequently desirable, for it is only when overlapping leads to confusion that it is to be avoided. It is quite possible to group a mass of details together and still leave them clear and easily grasped, and the result will be added richness. With regard to twists and turns also it is necessary to say a word, for they are often exceedingly valuable in supplying a useful curve, and when this is the case there should be no hesitation in introducing them. It is only when they confuse the spectator that these things should be eschewed.

**CORNERS:** It has been said that due attention should be paid to the corners. The rectangle owes its name to the right angles that form its corners; they are, therefore, peculiar to the shape, and so to emphasise

the character we must give due thought to the angles. Students are rather inclined to scamp them, as it requires some thought to fit natural forms into the corners, but the instructor should impress upon the class the need for care in this matter. It is a good plan to attend to the corners as soon as the skeleton line arrangement has been planned; the principal masses and the corners should be schemed at the same time. This will help to ensure a good groundwork, for no rectangular design can be entirely pleasing if the angles are treated as after-thoughts.

**BACKGROUND SHAPES:** The spaces that occur in the background between the shapes in the ornament are of great importance. The design when finished appeals to the spectator as a whole, and the background plays its part in the scheme quite as much as the ornament. The student should, therefore, be taught to design with background as well as ornament, and to watch the spaces between as carefully as the shapes in the ornament. Often a design which lacks cohesion, in which the ornament looks scattered and poor in shape, may be saved by simplifying the spaces between the ornament. If these spaces or background shapes are kept simple and of pleasing form, and receive as much attention as the pattern, the design will proceed more fluently, and the ultimate effect will be more harmonic, than if they are left to take care of themselves.

**DELINEATION:** When the design is planned, the method of delineation must be decided upon. The first exercises might suitably be in silhouette, either black and white or two tones of one colour, after

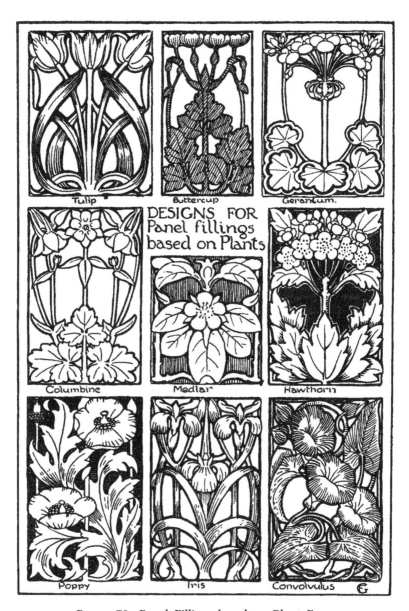

PLATE 70—*Panel Fillings based on Plant Forms.*

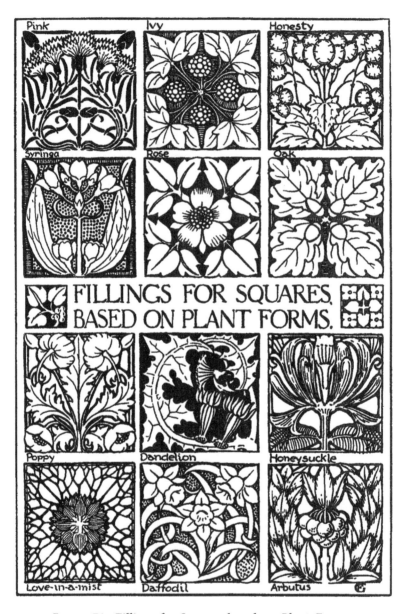

PLATE 71—*Fillings for Squares based on Plant Forms.*

136

which simple surface modelling might be introduced. **Plates 70 and 71** illustrate some treatments in pen and ink. In some instances outline alone has been relied upon, in others the ornament is dark on light, and in others, light on dark. In the latter cases the background is treated in a variety of ways, crosshatched, dotted, lines vertical and horizontal, and solid black. In a number of the designs a double boundary line is used, with the ornament overlapping the inner one. This is often very useful in emphasising the shape and in binding the forms together. It is especially valuable in correcting irregularities in the edges of the ornament, and in giving a sense of fulness to the panel. A double outline to the ornament, as in the Hawthorn design (**Plate 70**), where a white line is imprisoned between the blacks, is often of great value. When flat tones are applied with a brush similar treatments may be adopted, except that flat washes take the place of lines and dots. An outline is usually necessary to emphasise the shapes, but is by no means essential, as the difference in tone is often sufficient for the purpose.

**BRUSH FORMS:** No outline is required for forms developed from brush strokes, as described under Brushwork, which is an excellent method of producing ornament. Very beautiful work has been executed in direct brushwork by various craftsmen, especially the Japanese. A few examples of form developed by the brush are illustrated on **Plates 54 to 57**. Another type of brush decoration is where the forms are modelled in light and shade to give an appearance of relief, sometimes painted in monochrome and sometimes in polychrome.

When in monochrome it is known as Grissaile, and practice in this type of work forms valuable exercises for the student. Body colour, either oil colour or powder colour ground in gum and glycerine or other suitable medium, is the best, as the tones may be blended one with another or laid directly upon one another, without losing their quality, as would be the case if transparent colour were used. Three tones of grey, quiet brown, or other soft colour, are prepared, light, middle, and dark, and with these a suggestion of relief of great decorative value may be obtained. It is generally assumed for this work that the light falls from above, on the left of the painter; the lights will, therefore, be kept on the left-hand upper surfaces of the ornament, whilst the lower and right-hand surfaces will be in shade, intermediate planes being of middle tone. This convention with regard to lighting is invariably adopted where a suggestion of relief is desired. It therefore holds good with regard to polychromatic work of this nature, and the method of painting is similar to that used in monochrome. Raphael and his pupils produced a quantity of decoration in this style that is well worth studying.

**COLOUR:** Where the design is to be carried through in colour, whether in flat tints or with a suggestion of relief, it is essential that a scheme of colour should be thought out with a view to securing a harmony. The remarks under Colour can be usefully applied for this purpose. The aim should be to secure a fine relationship of hues and tones, considered purely from the standpoint of colour harmony. There is no need to hamper the student by insisting upon the use of colours that occur

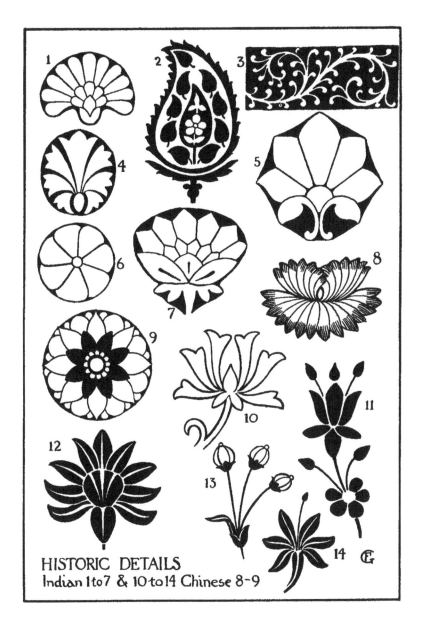

HISTORIC DETAILS
Indian 1 to 7 & 10 to 14 Chinese 8-9

PLATE 72—*Historic Details.*

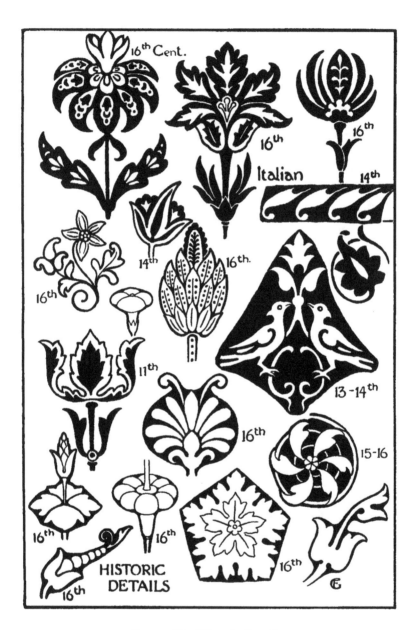

PLATE 73—*Historic Details.*

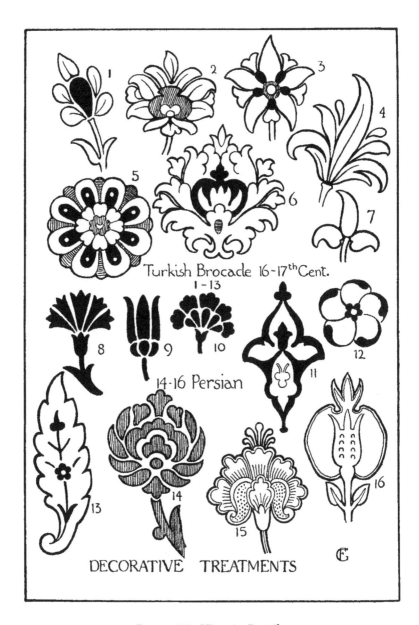

PLATE 74—*Historic Details.*

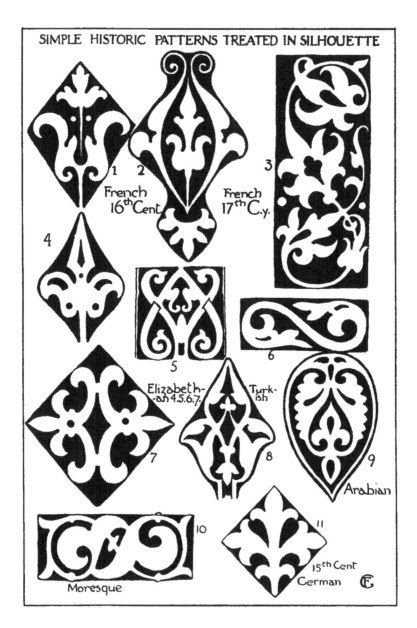

PLATE 75—*Historic Details.*

142

in the plant. They should be allowed to think out a scheme simply as colour, ignoring the hues of leaves and flowers. It is not, of course, absolutely necessary to do this, for nature often supplies a fine scheme of colour which may be adopted, and adapted to suit the design. Note that nature's scheme may be **adapted** to suit the design; it is very rare that some adaptation is not required to fit the colours to the purpose in hand. Colour is so subtle and elusive, dependent upon light and environment, and as many hues enter into even the simplest of nature's products that selection and rejection is unavoidable when it comes to using colour in design. It is well to impress this upon the students, as, generally, they are too prone to take the local colours of the plant, for fear they maybe departing from nature. As design is primarily a planning and arranging of the elements chosen with a view to securing a harmony, it becomes an individual matter dependent entirely upon the fancy of the designer, and to hamper him in any avoidable way is to enhance his difficulties.

There are critics who will demand that leaves shall be green, cornflowers blue, poppies red, and primroses yellow, but their demands may be ignored, as they do not understand the most elementary principles connected with design. Let the student get a firm grip of the fact that design consists in the harmonious relationship of line, shape, tone, and colour, and that these things should be the first consideration, and much that before puzzled him and clogged his fancy, will disappear. Students should be advised to keep note-books, wherein to make

studies of skeleton lines, shapes, decorative treatments, etc., for use in design.

**ANALYSIS:** They should be taught to analyse any design that takes their fancy, find out where the charm lies, and make notes of whatever appeals to them. It may be the planning of the lines, the arrangement of the masses, the beauty of the shapes, the harmony of the colour, the method of treatment, or a combination of these that constitutes the charm of the work. If the student is trained to analyse, he will add to his knowledge of what is essential in ornament, at the same time adding to his stock of material for future use. **Plates 72 to 75** illustrate a few decorative treatments culled from various sources, which are useful in design. Diagrams such as these set before the students, not necessarily to be copied, but rather to suggest methods of treatment, will be found of great service.

**MEMORY WORK:** Another useful exercise is to exhibit for a few minutes some simple decorative unit for the class to memorise; withdraw the unit and instruct the students to make patterns from the unit as they remember it. This is a valuable exercise, as it develops the memory and leaves the fancy free, for the students are not hampered by an endeavour to reproduce the unit as they would be if it were still before them. It is rather a good plan here to ask the pupils to close their eyes and try to visualise the unit after it has been exhibited and withdrawn. Another look at the unit will help them to realise how near their visual image had been to the original. They can rectify false impressions, and in using it for pattern the image will be clearer and

more easily reproduced. These exercises in planning pattern and space-filling should be carefully executed and thoroughly understood, for upon them depends every type of design. They are the groundwork upon which all future problems will be based, for designing for specific materials and purposes presents exactly the same difficulties, combined with those that arise out of the limitations of the material and the purpose of the object.

**ANIMAL FORMS:** Animal, bird, and fish forms are valuable in ornament, but as previously stated, the higher the position in the organic scale, the less fitted is the form for repetition. Even when highly conventionalised it is doubtful whether frequent repetition is in good taste. Some of the wall-papers designed by the late Walter Crane, in which infant satyrs, winged female forms, deer, dogs, and peacocks are charmingly interwoven with conventional foliage, whilst very beautiful in the single unit become somewhat overpowering when covering a whole wall surface. It is a risky experiment anyhow, and even the skill of Walter Crane has not been able to dispel that sense of monotony which results from a too frequent use of the higher animal forms. There is undoubtedly a wonderful decorative quality in birds, fish, and quadrupeds, whilst the human figure stands pre-eminent in this quality. From the earliest efforts of mankind to satisfy the craving for artistic expression, animal forms have figured in every period and in every style of art. From the bone scratchings of our pre-historic forefathers, through Egyptian, Assyrian, Persian, Phœnician, Chinese,

Japanese, Indian, Greek, Roman, Byzantine, Gothic, and Renaissance up to modern times, animal forms have been extensively used for decorative purposes. The treatment of these forms by the Egyptians is full of ornamental feeling, and affords excellent examples of a decorative as distinct from a naturalistic rendering. The Assyrians also exhibited a fine sense of fitness in their use of animal forms, their winged bulls and other symbolic animals being essentially architectural in treatment. Similar in sculpturesque and architectural feeling is the work of the Phœnicians, Persians, Indians, and also a good deal of the Chinese. Greece, with her anthropomorphic religion, gave human attributes to her gods, and so came to worship the beautiful human form. It is, therefore, easily understood why such a state of perfection should have been reached by the Greek sculpture. There is hence no cause for wonder that one of the most perfect renderings of animal form is seen in the Panathenaic procession that formed the frieze of the Parthenon. Those horses so full of life and movement are yet governed by true ornamental feeling and form a perfect example of the value of lines and shapes. Other instances occur in the metopes, pediments, and other parts of the temples, whilst further ones may be seen in the vase paintings, armour, and utensils of the period. The Romans, who owed their art to the Greeks, adopted many of their animal forms, and also developed some of their own. The bull's head, ram's head, lion's head, the griffin, eagle, sphinx, chimera, serpent, and many others, afford useful examples for study. Byzantine work is full of animal forms, largely with a symbolic

significance; stags, peacocks, sheep, fish, doves, and other suggestive forms occur frequently. Celtic and Gothic art affords numerous instances of animals treated frankly as decoration, whilst the Renaissance artist has bequeathed to us a wonderful store of useful forms. Animals, sometimes resembling natural forms, and sometimes fanciful as dreams, wander through the realms of decorative art, and very few could be better suited for the purpose they are called upon to serve.

Many beautiful examples of frankly decorative animal forms are to be found in heraldry. Here they are necessarily simple, but at the same time they are distinct and characteristic. Careful studies of the use of these forms in the decorative work of the past, and also in a good deal of modern work, will teach the student how far it is legitimate to go in the ornamental treatment of animals.

In addition to these studies from historic and modern ornament the student should make others from the animals themselves, or from good photographs. The Zoo is an excellent hunting-ground for the seeker after animals, and even the museum will furnish good examples. Here, however, it is necessary to make a careful selection, as too often the animals are so badly stuffed and mounted that they bear but little resemblance to the natural creature. On **Plates 41 to 50** will be found some studies of butterflies, birds, fish, and quadrupeds, useful in design. The majority of these will lend themselves readily to decorative treatment, some, of course, being more easily adapted than others. Butterflies are exceedingly useful as, in addition to

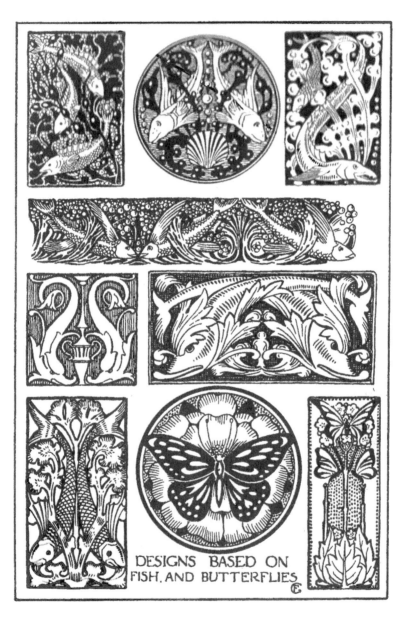

PLATE 76—*Designs based on Fish and Butterflies.*

148

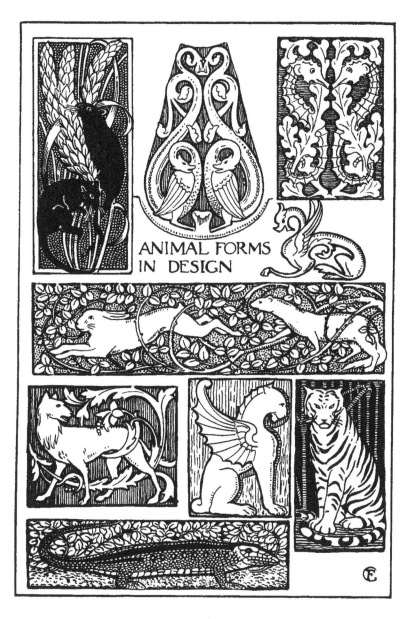

PLATE 77—*Animal Forms in Design.*

the beauty of their shapes, the pattern formed by the colouring of the wings and bodies is in itself of great value. Beautiful colour schemes may be obtained from them, but care should be taken to preserve the balance of the hues. Fish are also very serviceable for design, as they take fine curves and readily lend themselves to ornamental treatment. Birds are extensively used, and if one considers their beautiful shapes and the exquisite marking in the plumage of some, it can easily be understood. Japanese drawings of fish and birds are full of decorative suggestiveness. Quadrupeds provide much valuable material, as their lines are usually very harmonious. Who that has watched the lions, tigers, panthers, jaguars, etc., at the Zoo, or even the domestic cat, has not been struck by the wonderful lithe grace of their movements, and the beautiful lines that sweep through their bodies as they crouch, walk, turn, or spring. Often, too, their coats are marked with interesting patterns in spots or stripes, which possess great decorative value. **Plates 76 and 77** show a few adaptations of butterflies, fish, and animals, to various shapes. These are merely intended as suggestions. The student is advised to make studies both from nature and from historic examples for his own use.

For class work it is quite easy for the teacher to obtain rabbits, mice, birds, butterflies, dogs, and other animals for the class to study. Following this, suggestions might be made as to the decorative qualities of the animal, showing, if possible, examples of its use in ornament. Generally, it is necessary to combine these forms with foliage, seaweed, or other convenient

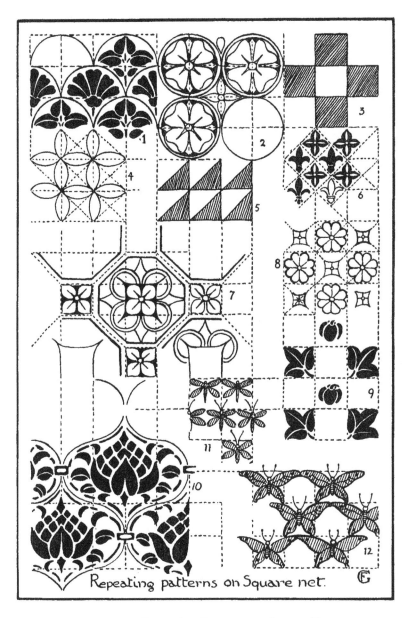

PLATE 78—*Repeating Patterns on Square Net.*

material, the procedure being similar to that described in space-filling. Much more might be said on the subject of design, but as this outline is intended merely to serve as an introduction the space available is limited. If it serves to impress upon the teacher the importance of design in the curriculum, and helps in the formation of a course of lessons, its purpose has been served. To treat it with anything approaching thoroughness, a book three or four times the size of the present one would hardly be sufficient.

There are already a number of works on design which may be perused with more or less profit, but the best study of all is the analysis of designs that have been produced by the various masters, combined with practice. Suggestions for designs suitable for them are made in the sections dealing with the various crafts that come within the scope of this work.

## REPEATING PATTERNS

**REPETITION:** Repetition is the simplest method of obtaining pattern. The mere ordered repetition of practically any unit will produce pattern. Patterns which are used to cover a large surface, as in wall-papers, printed fabrics, textiles, etc., are invariably designed on the repeating plan.

**SQUARE NET:** A network of squares or triangles will form the basis of an endless variety of patterns. **Plate 78** illustrates a few of the patterns that may be derived from the square net. **Figure 3** is the simplest

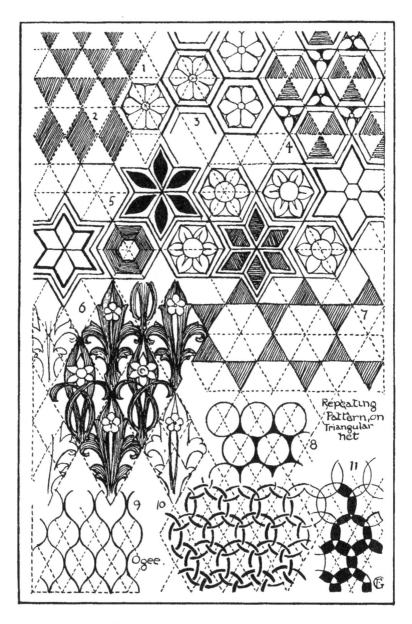

PLATE 79—*Repeating Patterns on Triangular Net.*

and also one of the earliest arrangements possible. The chequer or draught-board obtained by painting alternate squares black and white. **Figure 1** is made up of semi-circles, which form a series of overlapping scales, known as imbrication. **Figure 2** is a series of tangential circles. **Figure 4** is made up of interlacing circles. **Figure 5** makes use of the diagonal which divides the squares into right-angled triangles. **Figure 6** is a further use of the diagonal, here producing diamond shapes filled with the Fleur-de-lis, and a four-petalled flower form. **Figure 7** results in octagonal shapes with intervening squares. **Figures 8 and 9** are other suggestions for developing pattern. **Figure 10** is an "Ogee" pattern constructed with semi-circles. **Figures 11 and 12** are examples of pattern formed by the ordered spacing of conventionalised natural forms.

**TRIANGULAR NET:** The patterns on **Plate 79** are built on a network of equilateral triangles. This is easily constructed with the 60° set-square. **Figure 1** shows an alternation of light and dark triangles. **Figure 2** gives a diamond pattern. **Figures 3, 4, 5, and 7** are hexagonal shapes with intervening triangles and star forms. **Figure 6** introduces plant form. **Figure 9** is an "Ogee" of different proportion from the one founded on a square net. **Figures 8, 10, 11** introduce the circle. These are but a very few of the many patterns that are possible on geometric nets. **Plate 80** illustrates four counterchange patterns. Here the black and white shapes are exactly similar, a repetition of the same shape in two colours or tones. **Figure 5** is an all-over suggestion designed on the "half drop" system, which

154

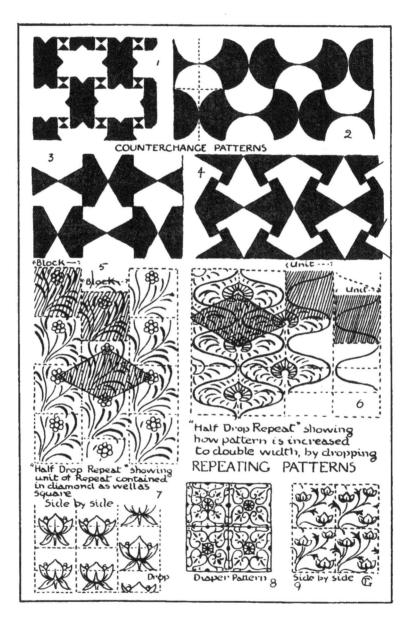

PLATE 80—*Counterchange and Repeating Patterns.*

is a method largely employed in designing wall-papers, textiles, and printed fabrics, where an "all-over" effect is desired. The whole of the "repeat" or unit is contained in one square as indicated by the shaded portion at the top of the diagram. The next row is "dropped" halfway, so that the repeats are on the same level in alternate rows. This method of planning is particularly useful in avoiding awkward lines that are apt to appear when a single unit of repeat is multiplied over a large area. If the pattern illustrated were used as a side-by-side repeat, the flower forms near the top would have a tendency to form horizontal lines that would become very insistent. The dropping obviates this tendency. The diamond shape in the centre (shaded) shows a further method of finding the "repeat." It will be observed that a complete unit is contained within the diamond as well as in the square. The diamond may be taken as a basis for the pattern instead of the square, in fact it is often better to use the diamond network instead of the rectangular. **Figure 6** shows how the apparent width of a pattern may be increased by the use of the "drop." The shaded portions show the main lines of the repeat, together with the apparent doubling of the width when this is dropped one half of its length. The usual width of a wall-paper is 21 inches, so, if the plan described is adopted, a pattern double the width of the "repeat = 42" is obtained. **Figure 8** is a Diaper pattern where each unit is kept rigidly within the limits of the square, emphasising thereby the rectangular plan upon which it is based. **Figure 9** is a "side by side" repeat. **Figure 7** is a simple flower motif repeated side by side, and also

half dropped to show how the horizontal line which was forming becomes a more interesting undulating one by adopting the half drop method.

**TURNOVER: Plate 81, Figure 2,** shows the "Turnover" pattern. This plan is largely used in weaving, where it enables the weaver to double the width of his pattern. The advantages of doubling a pattern on a centre line are obvious. If one half of a stencil pattern is designed and the paper folded in the middle, a double or turnover pattern will result, after cutting through both sheets. This is a simple illustration of the turnover. It illustrates the principle of symmetry. **Figure 3** is a device which is valuable in block-printing for wall-papers, etc. The block upon which is cut the unit of repeat (shaded portion) is given a half turn after each printing. The result of this will be a pattern four times the size of the original unit. If the pattern is then used as a "half drop" (in this case the drop will be the whole of the pattern) the apparent size is still further increased. Wall-papers are printed in strips of considerable length but usually 21 inches wide: the dropping is done by the paperhanger. **Figure 4** shows a method useful in the designing of tiles. They are arranged "brickwise," the tiles being set so that the edges of each alternate row come level, the row between being moved half-way along. In planning a repeating pattern the difficulty lies in arranging for the correct repetition of the unit. The whole design lies within the single unit, but it must be so designed that repetition produces the desired result. The safest plan is to rough in three or four repeats, and,

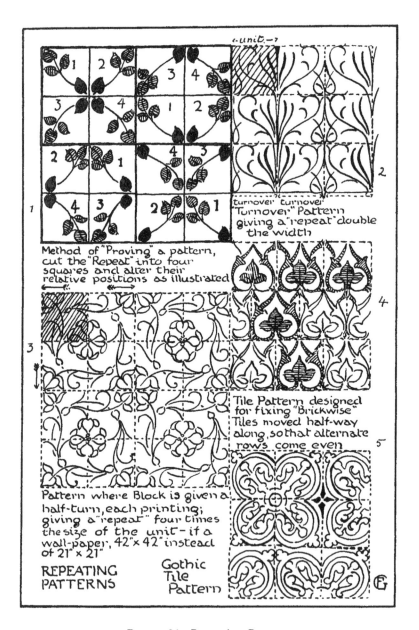

Method of "Proving" a pattern, cut the "Repeat" into four squares and alter their relative positions as illustrated

"turnover" "turnover" "Turnover" Pattern giving a "repeat" double the width

Tile Pattern designed for fixing "Brickwise" Tiles moved half-way along, so that alternate rows come even

Pattern where Block is given a half-turn, each printing; giving a "repeat" four times the size of the unit — if a wall-paper, 42"× 42" instead of 21"× 21"

REPEATING PATTERNS

Gothic Tile Pattern

PLATE 81—*Repeating Patterns.*

158

after carefully drawing one, trace or stencil this unit into the other spaces. Care must be exercised to get the lines to flow smoothly from one repeat into the others. Another safe but more drastic method is illustrated in **Figure 1, Plate 81**. When the unit is designed cut it into four squares, 1, 2, 3, 4, and transpose the pieces as shown. Lines which do not flow easily can then be corrected. Wall-papers are uniform in size, 21 inches by 21 inches. They are usually printed from rollers, but better papers are sometimes printed by hand from wood blocks. In the latter case, blocks 21 inches by 21 inches being somewhat large to handle, they are frequently made 21 inches by 17 inches, or 21 inches by 15 inches. A separate block being required for each colour and another for the outline, it is advisable to be economical in the matter of colour. The blocks are cut from pear or sycamore backed with deal. The portions not required for printing are cut away, leaving the design in relief. Thin outlines and fine details are represented by thin slips of copper bent and filed to shape, and driven edgewise into the wood. Rollers are also of wood, the outlines being made of metal, and the intervening spaces, such as are intended to print, being filled with felt to the level of the outlines. Printed fabrics, silks, velveteens, cretonnes, chintzes, muslins, etc., are also printed from rollers or wood blocks. Cretonnes and cottons up to 30 inches wide, and from 15 inches to 30 inches in depth. Tiles are generally 6 inches square.

## INTERLACING

The interlaced borders on **Plate 62** form interesting exercises. The knots at the top of the sheet should first be attempted, and, when the principles involved in these are understood, the intricacies of this type of ornament will become less puzzling, as the knots form the motifs for the bulk of these interlaced patterns. These patterns are best planned as line designs, ignoring for the time being the interlacing of the strands, simply aiming at a well-spaced network of lines with no loose ends, or as few as possible. As soon as a satisfactory arrangement has been achieved, the interlacing may be proceeded with. It will be necessary to commence at one point, and make the strand pass over at the first crossing, under at the next, over at the next, then under, over, and so on until the whole of the strands have been attended to. Care must be taken that no line passes under or over two others in succession, as this will destroy the continuity of the pattern. It is fatal to adopt two starting points, as the probability is that the interlacing will work out unevenly, and a fresh start will be necessary. The most satisfactory result is obtained by making the strands fairly stout, and by arranging them closely, so that the ornament and the ground are nearly approximate in quantity, *i.e.* the black line and the white space should be fairly equal in width. Even distribution is the principle involved in this type of work.

# CHAPTER IV

# SCROLLS

**Plate 82** illustrates a lesson that will be found interesting and valuable. Strips of paper are cut, twisted, and rolled until they take different curvatures. This might be done by the pupils after a little instruction from the teacher. These scrolls should then be placed in front of the pupil and an attempt made to render the curves as they appear. It affords good practice in drawing the various types of curvature and provides valuable material for use in design. Later the class might be allowed to elaborate upon the simple paper scrolls, as suggested in the illustrations on **Plate 82.**

## LETTERING

Lettering should form a part of every course in drawing or art work. The individual beauty of the letters afford excellent examples of proportion and combination of line. Curve and straight, thick and thin, are so beautifully composed in the Roman alphabet that it seems impossible to conceive of any improvement. Many attempts have certainly been made, some of them

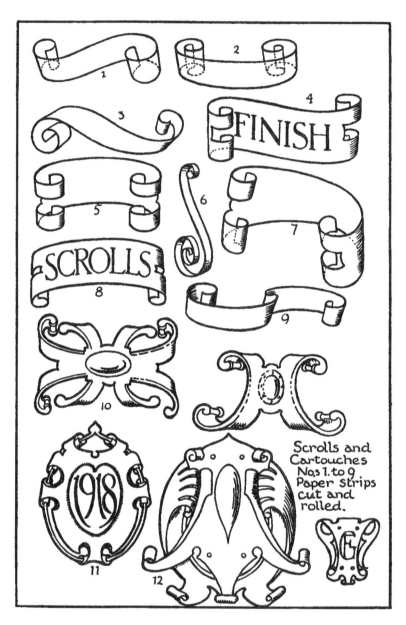

weird and wonderful, but very few have lasted, and the Roman letter always returns triumphant.

**DEVELOPMENT:** Practically all the lettering we use to-day has descended from the Roman, which was evolved through Phœnician and Grecian from the Egyptians. So the earliest forms from which our alphabet derives, date back some eight or nine thousand years. The inscription on the Trajan column (the classic example of Roman lettering) dates from about A.D. 114, so the Roman letter as we know it is nearly 2000 years old. The forms were evolved from the use of the chisel under the influence of writing. This influence is distinctly traceable in the use of thick and thin strokes. The pen naturally makes a broad line on the down stroke, and a thin one of the upward and horizontal. This variety in the width of the line has, therefore, a perfectly natural origin in the use of the tool. The beauty has grown out of a legitimate employment of the medium, hence all down strokes are thick, and all up strokes and horizontal strokes are thin. All vertical strokes, except the N and M, are thick; all strokes running downwards from left to right are thick. All strokes upwards from left to right, except in the Z, are thin. All horizontal strokes are thin. The curves swell gradually until the thickest parts fall naturally where the full width of the pen permits the greatest pressure. By reference to **Plate 84** it will be seen that the letters are divided into "round," "square," and "narrow." The round letters look best when the line bounding them most nearly approaches the circle. The square letters are practically as wide as they are high. The narrow letters occupy less space, particularly

the I and J. The width, however, depends somewhat upon the space at our command, for wider or narrower letters are quite permissible, but round and square may be taken as typical forms, and should be used where possible. The round letters are better if they slightly overlap the bounding lines at top and bottom, instead of being merely tangential, as there is a tendency in the latter to appear shorter than the adjacent letters, owing to the minute fractions that reach the lines. Letters which are divided in their height as B, E, F, R, S, Y, X, K, P, and H are better if the lower portion is slightly larger than the upper. This helps to preserve the balance and prevents the top-heavy appearance that otherwise occurs. A is an exception to this rule, for here the horizontal bar, if placed low, lends an appearance of weight and support to the sloping sides. The S is a letter that often gives trouble, but a couple of circles, the smaller one above, as shown on **Plate 84**, will assist in obtaining good form. The "serifs" add a finish to the letters and help to preserve the horizontal band feeling that good lettering always possesses. The serif in the vertical stems is merely a transition from the vertical into the horizontal, an added refinement. The size of the serif depends to some extent upon the type of letter used, but should never be more than a gentle curve arising from very near the end of the stroke. Students occasionally carry the curve of the serif so far that the stroke is convex practically the whole length. This weakens the letter and detracts from the severity so characteristic of the Roman alphabet.

ABCDEFGHIJKLMN
OPQRSTUVWXYZ&
SKELETON

**ABCDEFGHIJKLMN
OPQRSTUVWXYZ&**
BLOCK LETTERS

ABCDEFGHIJKLM
NOPQRSTUVWXY
Z1234567890&&1
ROMAN          A.Serifs.

abcdefghijklmnopqrstuvwxyz
LOWER CASE

abcdefghijklmnopqrstuv
xyzzw. space fairly close
HALF UNCIALS

abcdefghijklmnopqrstuv
BLACK LETTER

wfyz   I.II.III.IV.V.VI.VII.VIII.IX.X.L
              1  2  3  4  5  6  7  8  9  10  50
ROMAN NUMERALS

PLATE 83—*Lettering*.

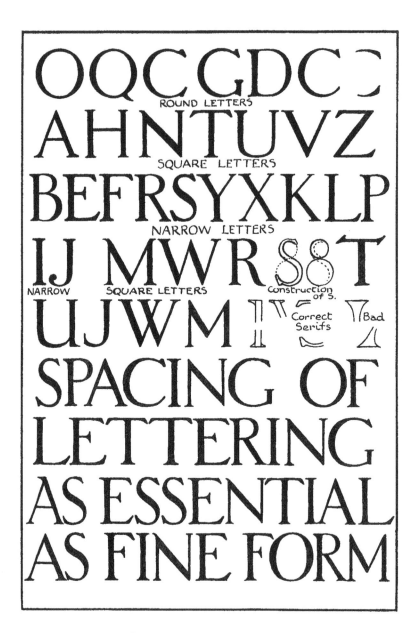

**SPACING:** Spacing is very important and needs as fine discrimination as the shape of the letter. Fine lettering is often ruined absolutely by bad spacing. There is no geometric rule for spacing; it depends entirely upon the eye, and the taste of the draughtsman. The only rule that can be formulated is: *The space between the letters should appear equal.* To make the spaces geometrically equal is impossible, for, if the letters L, A, W came together, and the spaces between the letters were made exactly the same width, the gap between the L and A would appear much greater than between the A and W. In cases like this it is customary to put the two first letters as close as possible, and keep the W away until something like equality in the appearance of the spaces is obtained. Lettering usually looks well if placed fairly close; it helps to form a coherent mass; but this again depends upon purpose and position. When introducing lettering into class work, the skeleton letter illustrated on **Plate 83** is perhaps the easiest to start with. There is no variety in thickness and no serifs to contend with, simply the form. Block lettering is merely a heavier edition of skeleton. Roman should be practised as soon as convenient, not only for its inherent beauty, but because a knowledge of good lettering is of great value. If pupils are familiarised with good examples and are taught the principles upon which lettering is based, it cannot fail to affect their taste, and we may confidently look forward to an improvement in the lettering that adorns our shop fronts, hoardings, newspapers, magazines, and books, as the result of the instruction. The first essential of lettering is that

it should be readable. We may certainly claim this quality for Roman, and it is in this essential quality that "fanciful" lettering fails. Certain individual qualities, slight variations peculiar to the draughtsman, will be introduced into the lettering, until ultimately he forms an alphabet of his own. We can recognise the lettering of well-known craftsmen by these slight variations, these individual qualities, but this is not done by departing from the standard type, and producing something difficult to read; it grows out of an earnest endeavour to obtain fine form and good spacing. A few varieties in the shapes of the letters are shown on **Plate 84**, all of which are correct, and may be used according to taste. "Lower case" should be practised after the "Roman caps," as the bulk of our modern literature is printed in this type. A very useful form of lettering is the "half uncial" (**Plate 83**), which has been brought to its present state of beauty by Edward Johnston. This is essentially quill work, and though similar in many respects to lower case is more adapted to the pen, and, therefore, more easily written. The quill is more flexible than the steel pen, and lends itself more fluently to the subtle gradations of the letters. The brush is also a useful implement; it is used almost exclusively by the Japanese for their lettering. Black letters and Roman numerals are also illustrated in the plate. Monograms and initials are shown on **Plate 85**, and the production of these will form a useful lesson. The interest aroused by combining and decorating the letter forms, makes the lesson worth while. If the pupils are allowed to use their own initials and to form them into a monogram, which might be

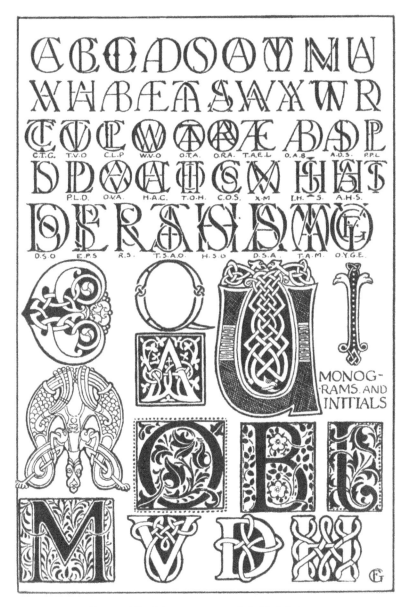

PLATE 85—*Monograms and Initial Letters.*

written or stencilled on their books or portfolios, the interest is sustained, and the practice in arrangement and execution is valuable.

## HERALDRY

Heraldry is essentially symbolic. It owes its origin to the necessity for distinguishing between those armour-clad warriors who participated in battles and tournaments, and whose trappings rendered them otherwise unrecognisable. Adopted originally as a necessary label, it flourished because it was both beautiful and useful. Each heraldic composition has its own definite meaning, conveyed through its connection with some particular individual, family, dignity, or office. Heraldry may be defined as a symbolical, pictorial language in which colours, devices, and figures are used as the means of expression. This language, like all others, has its rules of composition and laws of grammar, which cannot be violated with impunity.

**Plate 86** illustrates a very few of the more elementary facts of heraldry. At the top of the sheet are the Tinctures, which comprise two metals, five colours, and eight furs; of the latter but four are illustrated.

## METALS

| Heraldic Name. | Abbreviation. | Symbolisation. |
|---|---|---|
| Gold, | Or, | Or. | Dots. |
| Silver, | Argent, | Arg. | White. |

## COLOURS

| Heraldic Name. | Abbreviation. | Symbolisation. |
|---|---|---|

| Blue, | Azure, | Az. | Horizontal lines. |
|---|---|---|---|
| Red, | Gules, | Gu. | Vertical lines. |
| Green, | Vert, | Vert. | Oblique lines (left to right). |
| Purple, | Purpure, | Purp. | Oblique lines (right to left). |
| Black, | Sable, | Sa. | Crossed vertical and horizontal. |

Note a colour must not be placed upon a colour, nor a metal upon a metal.

## FURS

| Ermine | . . . . | Black spots on white. |
|---|---|---|
| Ermines | . . . . | White spots on black. |
| Erminois | . . . . | Black spots on gold. |
| Pean | . . . . | Gold spots on black, spots similar to Ermine or Erminois. |

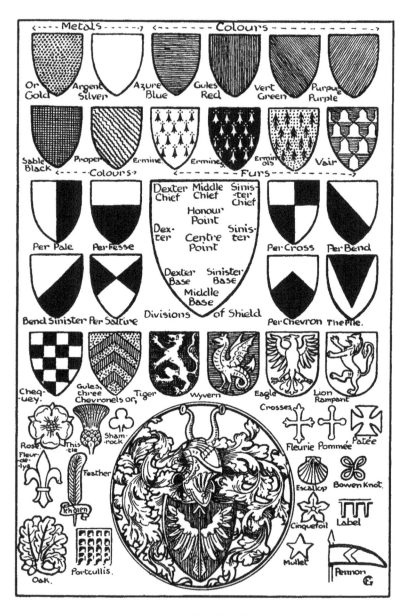

PLATE 86—*Heraldry.*

172

Vair is illustrated, counter vair, potent and counter potent are the remaining three. The points and divisions of the shield are shown in the plate. The shield has three main divisions from side to side, dexter, middle, and sinister. The dexter is the right-hand side, and the sinister is the left-hand side of the shield. This, however, applies to the bearer of the shield and not to the observer, so that, looking at the shield in the illustration the sinister side is on the right hand, and the dexter on the left. The points of the shield are shown in the diagram. The main divisions are also indicated. Per pale = the vertical parting of a metal and a colour. Per fesse, the horizontal division of a metal and a colour. Per cross, a combination of the first two. Per bend, an oblique division. Per bend sinister, an oblique division from right to left. Per saltire, a combination of bend and bend sinister. Per chevron, two lines issuing from the lower margins of the shield and meeting at a point in the middle. Per pile, two lines converging towards the base. Other divisions are paly, an even series of pales, forming vertical stripes; barry, an even series of bars forming horizontal bands; wavy, undulating or waved bars, crossing from side to side; chequey, a field divided into squares or chequers; lozengy, a field divided into diamond or lozenge shapes.

When an armorial device or composition is described in heraldic language, or represented in correct colour and arrangement it is said to be "blazoned." This term originated at the tournaments, for when a knight entered the lists, his presence was announced with a flourish of trumpets, after which the official heralds

declared his armorial insignia. They "blazoned" his arms.

**ORDINARIES:** This "blazoning" or "heraldic" representation is divided into ordinaries and charges. The ordinaries are those geometric divisions and figures which are formed by straight and curved lines extending to the margin of the shields; per pale, per fesse, per saltire, etc., are examples of this.

**CHARGES:** The charges are the natural, imaginative, or artificial forms derived from the heavenly bodies, natural phenomena, or from those associated with art, trade or mechanics. Charges usually stand free in the field of the shield, whilst the ordinaries usually touch the margin. These charges are highly conventionalised, vigorously drawn, and because the form is more typical it is usually represented in profile. The lion, tiger, wyvern, leopard, eagle, rose, portcullis, feather, fleur-de-lis and thistle are all excellent examples of charges. The tinctures are rarely those of nature, but usually of frankly conventional heraldic colour. When the charge is represented in its natural colouring it is said to be proper, and is represented in black and white by an oblique wavy line running from left to right. The illustration at the foot of the plate shows the helmet, crest, mantling shield, and charge. The helmet, strictly speaking, belongs only to knightly families, as it was worn by the warrior alone. Towns, corporations, ladies, and the clergy usually do not bear the helmet, although exceptions occur. Above the helmet comes the crest forming its crowning adornment. These are often identical with the principal charge in the shield of arms.

The mantling, which forms a useful connecting link between the helmet and the shield, probably originated in a scarf or cloth which often covered the helmet. The decorative value of this was promptly realised by the heraldic artist, and it certainly adds to the beauty of a complete coat of arms. The shield and charge complete the composition.

The subject of heraldry is full of glamour and romance, and the memories of knightly deeds. Its very nomenclature fires the imagination with dreams of chivalry; blazon, charge, armory, battled, cadency, ensigned, esquire, king of arms, marshalling, pennon, pursuivant, rampart, guardant, are all words rich in suggestiveness, recalling knightly prowess and valour. At one time heraldry was considered an essential element in education, and even to-day a knowledge of its more important rules and components will, at least, be useful. The designer must be acquainted with it; and owing to its national and civic use, in addition to its employment by families and individuals, an elementary knowledge cannot fail to be of service to the average citizen. The banner of royal arms, the national banner or Union Jack, and the banners bearing the arms of cities; the arms on our coinage, and the devices used on ecclesiastical, national, civic, and private buildings, afford instances of the use of heraldry. A knowledge of the principles of heraldry would add to the interest and enjoyment with which these works of art are regarded. The space available here is too limited to do anything more than touch the fringe of this subject; the notes given are mere hints written in the hope that a little more attention

may be given to heraldry in the drawing lesson. The vigorous rendering of the charges, the decorative spacing of the ordinaries, the frankly conventional colouring, combined with the ornamental quality of the mantling and other accessories, all afford excellent exercises for the draughtsman and the designer.

## TEXTURES

In addition to its colour, and its light and dark portions, each object has a surface quality or texture, which requires rendering. Rough and smooth, glazed and matt, hard and soft; scales, down, fur, feathers, silk, plush, water, bark, foliage, etc., etc., all suggest a difference in texture, requiring a suitable treatment. **Plate 87** shows an attempt to render a few surfaces likely to occur in ordinary class work. **Figure 1** illustrates the use of vertical lines to suggest a vertical plane, whilst the other side of the box has upright lines crosshatched by lines which convey the impression of a surface receding from the spectator. A vertical surface receding from the eye is thereby suggested, this suggestion being enhanced by modifying the tone as it recedes from the near corner of the box. **Figures 2 and 3** show two treatments of a cylindrical surface. In **Figure 2** the lines follow the curved contour of the cylinder. In **Figure 3** the lines are vertical, as the cylinder is vertical: the circular surface being suggested by the variation of the tone. Note that neither the lightest or the darkest passages of tone are directly on the edge. For the explanation of this see light and shade section. Other instances of this occur in the

vase, **Figure 8**; the tree-trunk, **Figure 10**; and the berries, **Figure 11**. **Figure 4** suggests a suitable treatment for feathers; the lines follow the direction of the barbs as they sweep outward from the quill. **Figure 5** shows two treatments of a brush. **Figure 7** suggests the massing of detail which constitutes the rounded forms taken by foliage. A tree, though composed of a multiplicity of separate leaves, invariably impresses itself upon us as a series of rounded masses, bright where the light falls directly upon them, merging into shade as they turn away from it. The student in his first efforts "cannot see the tree for the leaves"; he knows the foliage is made up of them, and so endeavours to get into his drawing as many as possible. This is a hopeless task from the start, in the first place because the scale he is working to is so much less than nature's; in the second because in his endeavour to render detail, the broad masses are lost sight of. If the eyes are half-closed and the big facts thus seen are grasped, the broad masses of tone instead of the detail occupying our attention, a more truthful representation will result. The lights are better kept broad and simple; the texture of the foliage, caused by the leaves of which it is composed, is usually seen most plainly on the edge of the dark tones. In other words, the texture is most visible in the tones that are intermediate between the lights and shades. The same remarks apply to the bark on the stems of trees. **Figure 10**. The markings are strongest just between the light and the dark portions of the stem. **Figure 8** is a glazed vase of a dark colour, bright spots of high light contrasting with the dark general tone of the vase, and

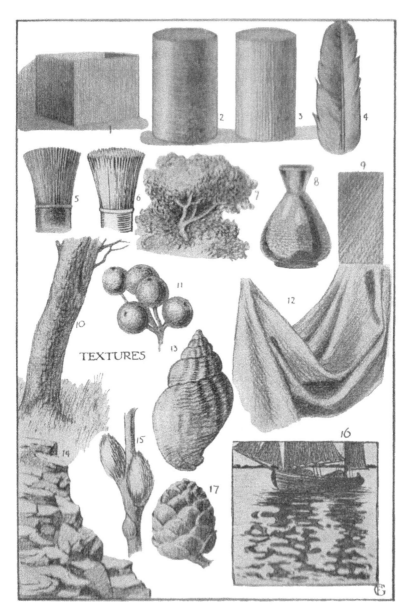

TEXTURES

PLATE 87—*Textures.*

the patches of darker tones reflected into it. The lines follow the contour. **Figure 9** shows the easiest method of laying a tone; lines drawn obliquely from right to left, as the hand works most freely in this direction. Left-handed draughtsmen work from left to right. **Figure 11** is a group of berries, spots of high light, lines following the contour, darker where the light is lost. **Figure 12** shows a piece of flannel draped into folds, with the modelling suggested by lines which follow the direction of the folds, and occasionally working across them. **Figure 13** is a shell in which the ribs are suggested by an undulating line following the general contour of the shell. **Figure 14** is an attempt to suggest rock; sharp dark crevasses and planes of varied tone, light or dark in proportion to the angles they make with the light rays. **Figure 15** shows soft downy catkins on a smooth firm twig. **Figure 17** is a pine cone, sharp touches of light and dark modified by the rounded surface of the scales. **Figure 16** shows a boat, the rippling reflections of which are in sharp contrast to the tone of the sky reflection.

## COLOUR

The study of colour presents many difficulties. The information obtainable is so chaotic, and the classification of hues so vague and contradictory, that a really scientific grounding in the principles of colour is rarely if ever accessible. A certain amount has, however, been established, and this we adopt as our basis. Light is the presence of all colour, darkness is the absence

thereof. Without light there is no colour, as light is the source of it.

**SPECTRUM:** The spectrum breaks light up into six specific colours: red, orange, yellow, green, blue, and violet. Owing, however, to the disproportionate space in the spectrum occupied by blue and violet, scientists have decided to introduce another colour between the two, *i.e.*, purple. This does not concern us much, for to the artist dealing with pigments there are three primary colours, and three secondary colours.

**PRIMARIES:** The primaries are red, yellow, and blue, because they cannot be split into other hues, but combined, give us the secondary colours; thus red and yellow give us orange; red and blue, purple; and yellow and blue, green. The scientist who deals with coloured lights has taken green, orange, and violet as primaries; but this does not concern us, only it is as well to recognise it, lest being confronted by the scientist, we should be confused.

**SECONDARIES:** Each primary has a complementary or contrasting colour, composed of the other two primaries; thus the complementary of red is green, of blue is orange, and of yellow is purple. In introducing colour theory into class work—and I think it may be done as soon as the teacher feels the intelligence of the pupils will grasp it—a good plan is to take a piece of glass of suitable section and allow the sun's rays to filter through on to a sheet of white paper. This breaks the light up into its component parts. Or, should the rainbow be visible (as it often is), point it out to the class.

In each case, endeavour to help them to see the different hues, merging one into the other. This arouses interest, and a simple explanation of colour and light will lead up to the introduction of colour exercises.

**APPEAL OF COLOUR:** It is claimed in some quarters that colour should not be brought into the work too early, but at the same time it is admitted that colour has the utmost fascination for the child mind, which admission seems to me to furnish the strongest possible reason for the early introduction of colour work.

**MATERIALS:** The materials required are, some cheap water-colours in tubes (the large tubes are best), and the teacher can squeeze out the necessary quantity for each pupil. Two saucers for each pupil (those with four compartments are most useful), a water jar and two brushes (a No. 5 and a No. 8 are useful sizes). These had better be of good quality, sable for preference; camel hair is not springy enough, when wet the point is liable to remain at an angle instead of returning to the straight. Fitch brushes are good. The choice of the colours is somewhat difficult, they mostly have a tendency towards one of the secondaries. For instance, Prussian blue has a greenish tinge and makes a poor purple. Crimson lake has a purplish tinge, whilst chrome inclines to green. The safest plan is to get about six colours and mix them. I have found the following six work very well: Prussian blue, cobalt, chrome No. 1, yellow ochre, crimson lake, and vermilion.

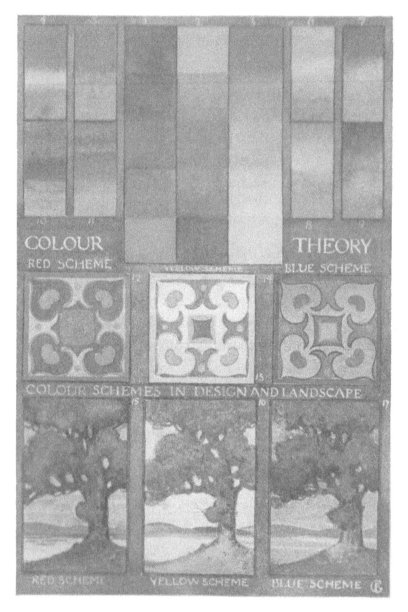

PLATE 88—*Colour Chart.*

Download a colour version of this plate from:
*www.yesterdaysclassics.com/extras/plate88.pdf*

**EXERCISES:** The first exercise should consist of laying a wash. A rectangle of suitable size, say 4 inches by 2 inches, or 6 inches by 3 inches, is first drawn, the requisite amount of colour mixed in the saucer, and laid on so that an even flat tint results. The brush, fully charged with colour, is first drawn across the top line and part of the way down the two sides, then, always fully charged, from side to side down the paper until the base line is reached, when any superfluous colour is lifted off with the brush squeezed dry. The board on which the paper rests should be tilted, and the colour allowed to float over the surface. No attempt should be made to repair faulty patches when the colour is partly dry; the pigment should be fluid, plenty of water, and must not be dragged on with a partly dry brush. This exercise is a useful one; on it depends the success of all future colour work, is not quite so easy as it looks, but is soon acquired. The next exercise might take the form illustrated in **Plate 88**. A rectangle 6 inches by 4 inches is constructed, divided into three equal parts from side to side, and 5 or 7 equal parts from top to bottom. Then mix the cobalt with a little Prussian blue until a satisfactory hue is obtained, the crimson lake and vermilion for red, whilst the chrome may be used pure. Into the first compartment from the top to the last space but one, lay a wash of of blue, into the next in a similar way yellow, and in the last red. These washes should be gradated in strength, the strongest at the top, becoming paler as they descend until the last space is but a faint tint. This is done by diluting with water. The first space is filled with a full brush of strong colour,

for the next the brush is dipped in clear water and a little colour taken up, more water and less colour for the next, and so on. When this is thoroughly dry the paper is reversed, and the process repeated. The white spaces at the bottom (now at the top) are charged with strong tints of the primaries, and the next strongest comes over the faintest of the tints below, the next strongest over the next faintest, until the last space is again untouched, leaving the primary clean and pure. The yellow is washed over the red, the red over the blue, and the blue over the yellow. The result will give a colour chart graded from one primary to another with the secondaries midway between, and others tending towards the two primaries represented in each strip. Thus yellow, yellowish-green, green, blue-green, blue, and so on. The next exercise might take the form of mixing the secondaries in the saucers and applying directly.

**TERTIARIES:** There is a further sub-division of colour, known as tertiaries, obtained by mixing two secondaries, citron, russet, and olive. Citron—orange and green; russet—orange and purple; olive—purple and green. This, however, merely amounts to a mixture of the three primaries in the proportion of one to two. Citron, being composed of orange and green, means that there are two parts of yellow to one of red and one of blue. The others are similar in proportion. The trouble is, though, after the first simple mixtures, that the colours tend to become muddy. Theoretically a correct proportion of the three primaries will give us grey, brown, and black, in addition to the three

tertiaries above-mentioned. Black I have never been able to obtain by these means. Grey can easily be mixed, but browns do not reach the quality of burnt umber or brown madder.

**HARMONY:** From the above theory a good working system may be deduced. Where a harmony is desired (and it usually is) we decide to bind the whole scheme together by using one colour as a basis. For instance, we decide on a blue scheme. Blue enters into the composition of green, purple, grey, and brown. So all these colours may be used in the one scheme, but as their relative proportion plays an important part, this suggestion is no royal road to success, merely a help by the way. A red scheme might include orange, purple, grey, and brown. A yellow: orange, green, grey, and brown, with black in each case, and white if desired. Should the scheme when complete seem insipid, lacking in force, a note of contrast might be beneficially introduced. The contrasting or complementary colour being the two remaining primaries mixed in equal proportions. Hence the blue scheme might be saved by a note of orange, the red by a touch of green, the yellow by a little purple (see **Plate 88**).

Another factor that has to be taken into consideration when dealing with colour harmony is the influence of colour upon colour. Red, when placed in juxtaposition with its complementary green, becomes intensified. The same applies to all the others. A dark tint alongside a light one strengthens both; the dark appears darker and the light lighter. Other changes that apparently take place are: Blue seems to incline to green when

next to red, whilst the latter inclines to orange. Blue seems purplish and yellow of an orange tint when together. From this we gather that when two colours are placed side by side, each will seem to partake of the complementary of the other. Grey appears greenish near red, of an orange tint near blue, purplish next to yellow, reddish near green, bluish next to orange and yellowish next purple. These are a few of the changes that juxtaposition of tone and colour appear to produce. Interesting and instructive experiments might profitably be carried out in this direction.

**INTENSITY:** Other experiments with the intensity of hues will be valuable, gradating a colour from its deepest tone to its palest, and again, from bright colour to grey. Some of these exercises are illustrated in **Plate 88**; rectangles 4, 5, 6, 7, 8, 9 are primaries and secondaries merging into grey.

**IMPORTANCE OF COLOUR:** Colours on a white ground appear darker, on a dark ground lighter. This subject of colour has never received the attention it deserves in systems of education. It plays a very important part in our lives, and has a tremendous influence upon us, none the less affecting because we are normally unconscious of it. It is now an establshed fact that colour affects us mentally and physiologically. Doctors recognise this, and are using colour for the cure of certain nervous diseases. A dull, drab room strikes a chill into us upon entering, whilst a bright cheerful one invigorates. A bright spring day with its blue sky and fleecy clouds, the fresh green of the bursting buds, and cheerful colour of primroses, cowslips, and wild

hyacinths has an enlivening influence. Even so the dull grey of the winter sky, the bare grey trees, dull muddy roads, and heavy mist obscuring the distant landscape all play their part in the general depression of spirits produced by a typical winter day. It is obvious that colour is the main factor here. "Punch" on one occasion said, "If, instead of calling in a lawyer when things run off the rails, we called in a colour expert, all sorts of horrors might be avoided, for he would prove that most of our misdeeds were due to our colour environment." Whether this is so or not, the colour sense is capable of cultivation, and might be the source of much pleasure.

The effect of one colour upon another by juxtaposition has already been touched upon; the following scale indicates in tabular form some of the apparent changes:—

Red by Orange:     The red looks yellower, and the orange more grey-green.

Red by Green:     Both colours look more intense.

Red by Blue:     Red more orange, blue greener.

Red by Violet:     Red more orange, violet unchanged.

Green by Orange:     Green more blue, orange yellower.

Green by Blue:     Green becomes olive, blue more violet.

Green by Violet:     Green becomes yellower, violet bluer.

Orange by Blue:     Orange becomes redder, blue deeper.

Orange by Violet:       Orange becomes greener, violet bluer.

Violet by Blue:       No change.

    Many attempts have been made to arrange a colour scale analogous to the octave in music, whereby colour compositions may be produced under similar laws to those obtaining in musical compositions. The seven spectral colours, being similar in number to the seven notes in the octave, form a good basis for such a scale, but the difficulty of standardising the colours has so far proved a stumbling-block. It would certainly be of great value if some such scale of colour, with rules for composition, could be formulated, and efforts are being made at the present time to do so. A brief outline of the analogy as it seems to stand at present may be of interest. The three fundamental notes in music are the first, third, and fifth of the scale, represented in the key of C major by C, E, and G. These notes sounded together produce the common chord, and are the foundation of harmony in musical composition. In colour, red, yellow, and blue are the equivalents of these notes, and by combining two colours a secondary may be obtained, so that, by the various combinations possible, three secondaries are obtainable, and these, together with the purple that occurs between the blue and the violet in the spectrum, give the seven colours to correspond to the seven notes in music. Each of these colours is capable of forming an archeus or key for an arrangement, to which all the other colours introduced must refer subordinately. This subordination to one

particular colour, gives the character to the scheme, as does the key note in a musical composition. The melody or harmony of succession is seen in the rainbow and the spectrum, where each colour is melodised by the two compounds which it forms with the other two primaries. Mr. H. R. Haweis in "Music and Morals" says: "No one who has ever attentively watched a sunset can fail to have noticed that colour, as well as sound, possesses all the five qualities which belong to emotion: the passing of dark tints into bright ones corresponds to elation and depression. The palpitations of light and mobility of hues give velocity, poorness or richness of the same colour constitutes its intensity, the presence of more than one colour gives variety, whilst form is determined by the various degrees of space occupied by the different colours. Yet, there exists no colour art as a language of pure emotion.

"The art of painting has hitherto always been dependent upon definite ideas, faces, cliffs, clouds, incidents. . . . The painter's art uses colour only as the accessory of emotion. The composer's art makes sound into a language of pure emotion. No method has yet been discovered of arranging colour by itself for the eye, as the musician's art arranges sound for the ear. We have no colour pictures depending solely upon colour as we have symphonies depending solely upon sound. In Turner's works we find the nearest approach; but even he, by the necessary limitation of his art, is without the property of velocity." This is quoted as it expresses a feeling that all artists, teachers, and others who handle colours have often experienced. If sound

alone without expressing any definite idea is capable of producing emotion, why should colour always have to be subordinate to an idea? Why not a colour-music as well as a sound-music?

A few notes on the visibility of colours may not be amiss. White on black appears larger than black on white. Dark letters on a light background are more visible than light letters on a dark background.

Experiments carried out by Messrs. Sheldon, Ltd., some little time ago led to the following conclusions. The combined colours are placed in the order of visibility, black and yellow being the most visible, red and green the least.

1. Black on yellow
2. Green on white
3. Red on white
4. Blue on white
5. White on blue
6. Black on white.
7. Yellow on black.
8. White on red.
9. White on green.
10. White on black.
11. Red on yellow.
12. Green on red.
13. Red on green.

# MODELLING

Modelling should certainly be introduced at an early stage. The interest and pleasure that accompanies the actual moulding of forms in some plastic material, make the lessons valuable in that the creative instinct is encouraged and the appreciation of form developed.

Modelling *clay* is the best, but it is somewhat messy, and needs considerable care to keep it in condition.

**PLASTICINE:** Plasticine or modelling wax is perhaps preferable, as it is more cleanly and keeps plastic for any length of time. The fingers are the best possible tools, but for some work a boxwood tool is necessary.

**BEGINNING:** To learn the nature and possibilities of the material simple balls and egg shapes might be rolled up, which could then be used to form simple patterns, or a cherry, apple, pear, or simple fruit form evolved from them. With the aid of a few match sticks animal and bird forms are readily suggested. Keep the interest aroused or the lesson loses its efficacy. Shells, leaves, simple flower forms, fungi, fish, and even common objects of a simple shape may be pressed into service. For older pupils conventional ornament, a simple rosette, the Tudor rose, fleur-de-lis, an acanthus leaf, or details of Gothic carving, form useful exercises. The teacher should here explain the nature of conventional treatment, and why it is adopted. The

difference between forms designed for wood, stone, bronze, terracotta, etc., should be indicated.

**LIGHT AND SHADE:** Another important factor is light and shade upon which relief work depends for its intelligibility, the light and shade again depending upon the arrangement of the planes. These planes are so placed that some reflect light whilst others remain in shade. Concave surfaces are contrasted with convex, sharp edges give value to broad smooth surfaces, smooth planes are enhanced by others that have a texture, whilst deep hollows well placed will give the dark touches necessary to enliven a design that threatens to become insipid.

**PURPOSE AND POSITION:** The position to be occupied by the work for which the design is modelled must also be taken into consideration. Delicate low relief work will require a strong side light and a position near the eye-level. Architectural work must harmonise with the surrounding features, and the quality of relief determined by its situation with regard to the spectator.

**MATERIALS:** Bronze, pottery, and terra-cotta are essentially modelled work, rendered permanent in the first case by casting in bronze, and in the second by firing the clay. Whatever is possible in clay is, therefore, legitimate in bronze or terra-cotta. For carving, the nature of the material into which it will be translated determines the character of the work. For wood, the grain is an important factor, whilst hard woods will admit of a higher finish and finer detail than soft. Stone,

again, differs from bronze, terra-cotta, or wood, whilst marble, bath stone, and granite all require their own peculiar treatment. Much might be said of modelling, a book could be written on the subject alone, but sufficient has been said to suggest to the teacher the possibilities and value of the work in the training of the scholar.

## CHAPTER V

# FIGURE DRAWING

"THE proper study of mankind is man," says Pope. This being so, it can easily be understood why pupils of all ages find the greatest pleasure in drawing the human figure. The child's first efforts are usually of this nature. He attempts to represent the beings with whom his dawning consciousness first became acquainted, those persons who have made the deepest impression upon his mind as it develops. The human figure has provided the artist of all periods, from the prehistoric savage to the highly cultured Greek, the giants of the Renaissance and the artist of to-day, with his most perfect means for the expression of thought. Though difficult to draw well where a high standard is looked for, there is not the slightest reason why children should not be encouraged to attempt the expression of that form which has made the deepest and most lasting impression upon them. Figures in action provide excellent opportunities for free line work, for developing observation, and encouraging thought. The skeleton lines on **Plate 89** are merely intended to suggest action and proportion. It is recognised that action or the possibility of action must be conveyed in a figure drawing, or the result is stiff and

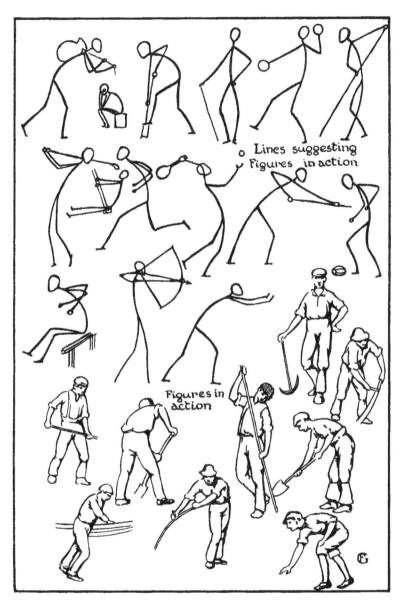

Lines suggesting
Figures in action

Figures in
action

PLATE 89—*Simple Figure Suggestions.*

wooden. These line drawings form an easy approach to the more complete rendering of the figure, and the interest aroused by the lesson makes it well worth while. The teacher might make a sketch on the blackboard to indicate the treatment, and then suggest a few forms of activity for the pupils to represent. Running, digging, jumping, pushing, swinging, etc., might be mentioned, and the pupils allowed to choose other actions for themselves. The attempt to render these actions will make them keen to observe the essential movements that constitute them, and for this reason alone, the time spent on the lesson is time well spent. Later, the more complete figure might be attempted, either with one of the pupils as model, or the class may be asked to draw some figure seen out of school. Road sweepers and repairers, carters, blacksmiths, agricultural labourers, boatmen, and figures engaged in playing games, such as football, cricket, tennis, golf, etc., all provide useful material. Good proportion and action being the first essentials in figure drawing, and this easy method of dealing with both, before the delicate, subtle contours of the human form are attempted, should make the movement and relation of part to part in the more complete later attempts much easier to represent. The habit of observing essentials will prevent the pupils from losing sight of them in their later endeavours to render the curves of the muscles, the straighter lines of the bones, and the folds of the drapery. With the drawing of the figure, necessitating a knowledge of anatomy, and the difference between the male and the female forms, this is no place to deal; other writers have

gone fully into the subject. As treated here it merely forms an introduction for children, with the object of developing observation and a method of expression.

## SYMBOLIC ORNAMENT

Symbolism is one of the most interesting and universal of the various means adopted by man for the expression of ideas. Apart from the decorative value of the symbol, there is the thought inspiring significance that lies behind the obvious and the external. This inner meaning, this suggestive quality, in addition to its shape and colour, gives a charm to symbolic ornament that is lacking in the purely abstract.

The alphabet is symbolic, each letter being a sound symbol, which has evolved from some early picture sign used in ancient Egypt to convey an idea.

**Plate 90** contains a few familiar examples of symbolism. **Figures 1 and 2** are swasticas or fylfots, amongst the oldest and most universal of symbolic signs. Found in practically every part of the world, it seems to signify the motion of the sun, rising in the east and setting in the west. It has since become a sign of good luck. **Figure 3** is a symbol of eternity; the snake with his tail in his mouth makes an endless circle. **Figure 4** is the Cross overshadowing the world. **Figure 5**, cross forms, the Tau being the earliest. **Figure 6** is Egyptian—the divine creative power sustaining the universe: a winged globe encircled by two serpents. **Figure 7** is Assyrian with the same significance. **Figure 8** is a triumphal

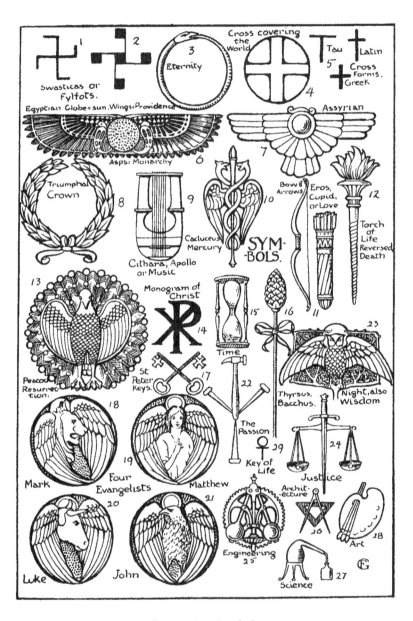

PLATE 90—*Symbols.*

198

crown, the prize awarded for prowess in the Grecian games. A symbol of victory rather than a prize of any intrinsic value. **Figure 9** is the cithara, signifying Apollo or music. **Figure 10**, the Caduceus symbol of Mercury or Hermes, used later to signify commerce: winged serpents entwined round a staff, suggesting speed and wisdom, useful qualifications for the messenger of the gods. **Figure 11** shows the bow and arrows, the well-known weapons of Eros, or Cupid, the god of love. **Figure 12** is the torch of life; when the torch is reversed death is understood. **Figure 13** shows a Byzantine rendering of the peacock, emblem of immortality or resurrection, probably adopted because it loses its plumage in the winter, only the more gorgeously to attire itself in the spring. **Figure 14** is the monogram of Christ. **Figure 15** is the hour-glass, emblematic of time. Father Time mowing down the hours with his relentless scythe is another familiar form. **Figure 16** is the thyrsus or pine-cone crowned staff carried in the Bacchanalian feasts. **Figure 17** shows the keys of St. Peter. **Figures 18, 19, 20, and 21** are the symbols of the four evangelists, easily memorised as A. L. O. E., the initial letters of angel, lion, ox, eagle, giving the symbols in the order taken by the Gospel versions, bearing the names of the evangelists, Matthew, Mark, Luke, John. **Figure 22** symbolises the Passion. **Figure 23** is the owl standing for night and wisdom. **Figure 24** shows the sword and scales of Justice. With the scales are weighed the deeds, with the sword judgment is executed. **Figure 25** is an engineering sign. **Figure 26** an architectural, also a masonic sign. **Figure 27** suggests science. **Figure 28** art.

**Figure 29** is the Egyptian key of life. Justice cannot be done to so huge a subject in the space at our command, the object is to suggest a few of the better-known symbols in the hope that it will lead to a further study of this fascinating branch of art. There can be little doubt that symbolism commenced with the dawn of reason. The mysteries and wonders of the universe so impressed the thoughts and feelings of mankind that some attempt at expression was inevitable. The great powers at work in nature are felt rather than understood, and any attempt to define them has always ended in a sense of the utter impossibility of definition. The very effort to define seems like setting bounds to the infinite. Hence the growth of a symbolic language, suggestion, rather than definition, is all that is possible.

The sun has always been an object of wonder and mystery, as the many forms of worship with their attendant sun signs bear witness. Life is another mystery, and an attempt to suggest it by a sign or symbol is seen in the Norse Igdrasil or Tree of Life. Its boughs stretched out to heaven, overshadowing the hall of heroes, Valhalla. Its three roots reached down to Hel, to Jotunheim, and to Midgard where dwelt the children of men. The Tree of Life in the garden of Eden is another instance of the use of a tree in this significance, and other instances of this symbol occur. In fact, the art of all periods is full of symbolic signs, that of ancient Egypt being almost entirely symbolic. Here we have the Scarabæus, or sacred beetle, emblem of immortality; the lotus, suggesting immortality, and many others. Greek art is full of symbolism. Zeus with his thunderbolts;

Poseidon with his trident; Helios with his horses of the sun; Aphrodite with her golden apple; Mars in the panoply of war; Pallas Athene with her serpent, lamp, and owl; and Diana with her crescent, are but a few instances of the use of symbols whereby to suggest the attributes of the gods who were the dramatis personæ in the Greek mythological interpretation of the universe. The Romans adopted and amplified the religion of the Greeks, using the same symbols. Christianity has made an extensive use of symbolism to express its beliefs. Besides those illustrated we find the vine, symbol of Christ; the lily of the Virgin, also of purity; the passion-flower, and the crown of thorns of the Passion; the sheep, Christ's flock; the fish and the Vesica standing for Christ. The dove, used alone, is the emblem of meekness and purity; with the nimbus it signifies the Holy Ghost; when bearing an olive branch in its beak, it symbolises peace. The dragon is emblematic of the Evil Spirit, whilst the serpent signifies the Devil. The anchor means hope and patience.

Plants have been used considerably as symbols. Honeysuckle stands for faith; the olive branch for reconciliation and peace; the oak for strength and endurance; the palm for martyrdom; the pomegranate bursting open and displaying its seeds, for future life and immortality, and the apple for the fall of man. In Christian art the colours are frequently used with a symbolic significance. White is emblematic of purity, light, life and innocence; red for passion, and the martyrdom of the saints; yellow or gold for brightness and the goodness of God, for faith and fruitfulness; green

signifies bountifulness, hope, youth and prosperity; violet stands for passion, suffering, sorrow, love, humility, and truth. Martyrs are frequently clad in garments of purple, or violet. Black, the absence of colour, signifies death, darkness, mourning, and despair. G. F. Watts, one of the greatest of painters, was a symbolist. His work treats always of the great fundamental facts of life, which can hardly be expressed, merely suggested by means of symbolism. He says, "The noblest art is in a great degree symbolic, dwelling upon that which is generic and general"; and again, "I cannot claim more for my pictures than that they are thoughts, attempts to embody visionary ideas. The material language of art cannot teach with Plato or preach with Bossuet, but, with the aid of beauty and nobility in form and colour, art may not be without power to stir in the mind the sense of the essential human qualities, the great distinctively human attributes not bestowed upon the lower orders of creation." From these words we may gather something of the great ideas he strove to embody, and his aims in so doing. Life, love, hope, faith, charity, time, death, and oblivion, are the themes upon which he built his thought-inspiring harmonies, such themes being so huge, so vague, and yet so all-encompassing and insistent, that whilst we fain would grasp them, and so tell the world what they are, they always baffle any attempt at definition, for the mind loses itself in their immensity. Visions there may be in moments of inspiration, when the mystery seems likely to be solved, but the vision can hardly be fully expressed, however clear it may be to the seer, and so Watts, who

was essentially a seer, has treated his conceptions as they could only be treated, symbolically. Many of the public galleries possess pictures by G. F. Watts, and there is no reason why pupils (those sufficiently advanced to appreciate) should not be taken to visit them. Failing this, reproductions of his work are always available, and the teacher might profitably spend a little time in talking about the work of this, possibly the greatest artist since the Renaissance.

## SKETCHING FROM NATURE

"Call that a sunset?" said a lady to Turner, as she stood before one of his pictures. "I never saw a sunset like that." "No, Madam," said Turner. "Don't you wish you had?"

Outdoor sketching from nature is one of the most delightful occupations, for as Hazlitt says, "One is never tired of painting, because you have to set down not what you knew already, but what you have just discovered; with every stroke of the brush a new field of inquiry is laid open; new difficulties arise, and new triumphs are prepared over them." The attempt to represent the scene we have chosen, to fit it harmoniously into the shape decided upon; the selection and rejection, the subordination of certain passages—with emphasis laid on others, will keep the mind fully occupied. Given favourable weather, nothing could be more beneficial in every way than work in the open air. Where the situation of the school renders it possible, a good deal of the summer drawing instruction might with advantage

be given out of doors. If the country is within easy reach there will be no difficulty, and a vast quantity of material will be at the disposal of teacher and class. We will assume that the work is of a pictorial nature. The first attempts should be confined to the representation of simple subjects such as a tree bole, an old gate or group of palings, a bridge, a barn, or a well-head. See that the subject is well placed on the paper, and that the lines compose well. The next attempts might consist of a tree or group of trees of simple contour, a boat and stretch of shore, or a bit of roadway.

**COMPOSITION:** The laws of composition were touched upon in the design section, and a brief mention made of their application to pictorial design. From the remarks made there, the importance of careful planning and good spacing may be gathered.

**LINES:** The main consideration at first is the disposition of the lines, so let the first compositions be in pure line. Plan these lines thoughtfully with due regard to the shape you desire to fill, and also with regard to each other. Watch attentively for the essential lines, and endeavour to see the big things. "The whole is greater than the part." Trees should be regarded as simple contours and masses, and not as a conglomeration of small leaves. The value of these efforts in line alone lies in the necessity for seizing only those lines which are useful to us, *i.e.* the essential ones, and in their careful combination when once they are seized. A strong bold line is the most suitable for these compositions, and a number of attempts are better than one worried one. The next stage might be the

introduction of a few strong simple notes of dark tone, to emphasise the points of interest (see **Plate 92**). In this case the lines of the composition should lead up to these darks, and they should form the keynotes of the design. When the value of a simple note of dark tone has been realised, compositions in tone should be attempted.

**TWO TONES:** As suggested before, an arrangement in black and white, or grey and white, or any two tones is most suitable to commence with. A good deal of the black and white illustrations of to-day will give the student some idea of what can be done with two tones. The shapes of the tones and the balance of the one against the other, together with the line arrangements are the principal factors here.

**THREE OR MORE TONES:** After the use of two tones, compositions should be made in three, then four, five, and so on (see **Plate 91**).

It may seem that too much stress has been laid on composition in these exercises, especially when the subject is sketching from Nature, but when it is granted that no picture can be successful which is not well planned and composed, it must also be granted that these things should receive the first consideration.

**STUDIES:** Careful studies of natural objects should also be made with a view to learning the nature and growth of the object. These studies are better at first if treated simply as studies, keeping the two problems separate. As the powers of rendering increase, more detail may be added to the compositions, and textures,

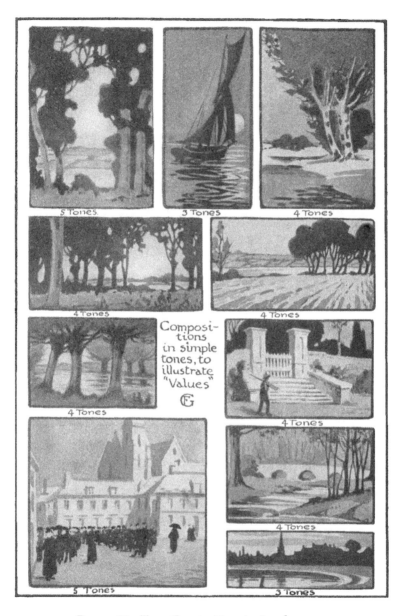

PLATE 91—*Tone Composition in Landscape..*

206

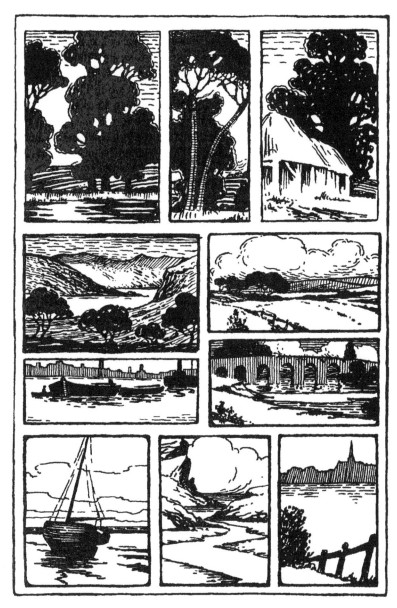

PLATE 92—*Landscape Composition.*

light and shade, etc., introduced. Ruskin says: "No human capacity ever yet saw the whole of a thing; but we may see more and more of it the longer we look. . . . Every advance in our acuteness of perception will show us something new; but the old and first discerned thing will still be there, not falsified, only modified and enriched by new perceptions."

**COLOUR:** The introduction of colour enhances our difficulties. In the section on colour a few hints are given which may help in composing our colour scheme. The safest plan is to perhaps begin with the three primary colours, not necessarily limiting ourselves to three pigments, but taking say two varieties of each primary. Cobalt and Prussian for blues, alizarin crimson and light red for reds, and yellow ochre and chrome No. 1 for yellows. The reason for this is explained in notes on colour. The value of this limitation lies in the knowledge we thus gain of the possibilities of a restricted range, and in the practice we get in mixing intermediate tints. Besides which a multiplicity of pigments tends to confusion; it is far better to add colours when we are sure we need them. The student will be surprised at the possibilities of three colours alone if he gives them a fair trial. It is also less difficult to achieve harmony with a limited range than with a wide one. With the increase of power, however, the need for further colours will become apparent, for the colour-sense becomes more acute, and the student will find in Nature many tints that he cannot match. Problems will arise which are difficult of solution even with a wide range, but bear in mind that a picture is an arrangement of line, tone,

and colour, and can never be an attempt to portray all that Nature places before us. A few truths out of the many that Nature exhibits are all that we can hope to represent, and a wise selection and rejection of these will result in a good sketch. There are some critics who will object to this statement, and will say, "Paint all that you see, as you see it." A little consideration will show what a large order this is. Nature paints her scenes with particles of matter for sky and clouds, with earth, grass, leaves, trunks, branches, twigs, rocks, moss, water, etc., all illuminated by the sun. On a cloudy day a patch of light will gleam here, a shadow will lie there, whilst on sunny days the light changes hour by hour. All that we have is a sheet of paper or canvas, and a few pigments with which to represent all this. And if you sit for any length of time you will find the lights and shades have changed their positions. The difference in scale between your picture and Nature is also very great. It, therefore, follows, that some selection is not only advisable but absolutely necessary. Which of the many gleams of light or patches of shadow that flit over the landscape are you going to seize, for you cannot seize them all? What light and shade will you adopt from the changes that take place? On a grey day the colours and forms are certainly more constant, but is it necessary to restrict one's sketching to grey days to please these critics when sunlight and shadow present us with such beautiful pictures? A sketch is after all but an attempt to state an impression produced on the artist by some scene in nature, and the personal note is really important. We can hardly portray, we can only interpret. Let us do

this as earnestly and as conscientiously as we may, but let us at the same time recognise our limitations and endeavour to work within them.

**BOATS:** The frontispiece gives a few sketches of boats. Ruskin says: "But one object there is still, which I never pass without the renewed wonder of childhood, and that is the bow of a boat, . . . the blunt head of a common, bluff, undecked sea boat, lying aside in its furrow of beach sand. The sum of navigation is in that. You may magnify it or decorate it as you will; you do not add to the wonder of it. I know nothing else that man does which is perfect, but that." Boats certainly provide us with some exquisite forms for drawing, and if beauty may be defined as perfect fitness, there are few things so well fitted for their purpose as boats.

## CHAPTER VI

# WOOD-BLOCK CUTTING AND PRINTING

THIS forms a valuable exercise in designing and hand-training. Simple repeating patterns can be cut in wood and printed *ad lib*. The pattern is carefully thought-out on paper, with a view to its repetition, and is then transferred to the wood by means of carbon paper. Another method is to paste the design on the block.

**TOOLS AND MATERIALS:** The wood may be of almost any close-grained type, kauri-pine, cherry, or box. American white-wood I have found to work well. The tools required are, a *knife*, sharpened on one side only, as shown in diagram, **Plate 93**. *Four or five gouges*, a *baren, paper,* some cheap *water-colour* or *powder-colour, rice starch, brushes* for applying colour, *saucers* (those with four compartments as illustrated are useful), *mallet* (for heavier gouges; this is not absolutely essential), and a *cramp* for holding block whilst cutting.

**PROCEDURE:** Having transferred our design to the surface of the wood, which has been smoothed with glass-paper, the safest plan is to ink or colour in such parts of the wood as we require to leave intact,

211

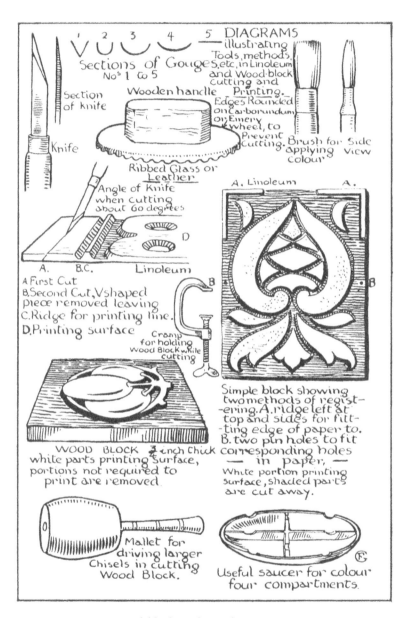

The following text appears within the diagram:

1 2 3 4 5 DIAGRAMS
illustrating
Tools, methods,
etc., in Linoleum
and Wood-block
Cutting and
Printing.

Sections of Gouges,
Nos 1 to 5

Section of knife

Wooden handle

Knife

Edges Rounded
on Carborundum
or Emery
wheel, to
Prevent
Cutting.

Brush for
applying
colour

Side
View

Ribbed Glass or
Leather

Angle of Knife
when cutting
about 60 degrees

A. Linoleum

A.

A. B.C.                Linoleum
A First Cut
B. Second Cut, V shaped
piece removed leaving
C. Ridge for printing line.
D. Printing surface

D

.B

Cramp
for holding
Wood Block while
cutting

Simple block showing
two methods of regist-
-ering. A. ridge left at
top and sides for fit-
-ting edge of paper to.
B. two pin holes to fit
corresponding holes
— in paper. —
White portion printing
surface, shaded parts
are cut away.

WOOD BLOCK ⅜ inch thick
white parts printing surface,
portions not required to
print are removed.

Mallet for
driving larger
Chisels in cutting
Wood Block.

Useful saucer for colour
four compartments.

**PLATE** 93—*Wood-block and Linoleum Cutting Diagrams.*

212

to avoid cutting the wrong portions. Then outline the pattern, by cutting with the knife, which is held so that it slopes away from the design. Hold the knife firmly in the right hand, and place the middle finger of the left at the back of the blade, near the point. The first cut, at about 60 degrees sloping away from the pattern, is then followed by another on the opposite slope, which results in a V-shaped groove (see diagram, **Plate 93**). When this groove has been cut round the whole design, the ground can easily be cleared by means of the gouges.

**PRINTING AND PAPER:** The block is now ready for printing. Almost any paper does for ordinary rough prints. For delicate work a good Japanese paper is easily the best. The paper must be thoroughly damped by allowing it to lie for twelve hours between damp blotting paper. A board should be placed on the top to prevent paper cockling whilst damp. The block is now coloured, ordinary water colour is suitable, mixed with rice starch or glycerine, but powder colour ground stiffly in water with rice starch added is best. The rice starch is prepared as follows: mix about two teaspoonfuls of rice flour (which can be obtained from the grocer) to a smooth cream with cold water, add about half a pint of boiling water, stirring well. Bring to the boil again, and allow to simmer gently for a few minutes. Wipe the block over with a damp sponge, and brush over the colour. Experience will soon show how much moisture is required. If the colour is too wet it prints unevenly, whilst if it is too dry it refuses to leave the block. Place the damp paper carefully in position, and a piece of smooth dry paper on the top. Hold them in position

with the left hand, and rub firmly and smoothly with the baren. The first two or three impressions will probably be somewhat poor and thin, after which the block will work better. For fine work (as before stated) Japanese paper is best, but it needs sizing before use, being too absorbent. The size is made from gelatine, six sheets to a pint of water. Dissolve in warm water, not boiling, add a little powdered alum, just about as much as will lie on the tip of a pallette knife. Place the paper on a sloping board and apply with a broad flat brush. Pin the paper by the two upper corners to a cord stretched across the room, to dry. Where more elaborate work is attempted, the method of registering is described in Linoleum Printing and illustrated on **Plate 93**. In the case of a small block containing a unit of repeat, the block can be pressed heavily on the damp printing paper, a pad of blotting paper being placed underneath. This is the more convenient method, as the block requires fitting to the geometric shapes drawn on the paper for its reception. These lessons, together with those on linoleum printing, can be usefully employed to give the students an insight into modern printing methods, and, by introducing some good examples of Japanese prints, to inculcate an appreciation of the wonderful skill and artistic taste shown by the Eastern craftsman.

## LINOLEUM PRINTING

This is a very useful process, the linoleum being easier to manipulate than wood-blocks, whilst the tough

nature of the material permits of a good number of prints being taken before the surface begins to wear.

**MATERIALS:** Another advantage is that very few implements are necessary, the following being sufficient: a *knife*, specially sharpened at the tip: an ordinary *penknife* does very well, but a special knife, as shown in illustration, **Plate 93**, ground down and sharpened on one side only is preferable; *four or five gouges* (including a V tool) of the sections shown; these can be obtained from any dealer in wood-carving tools; *brushes* for applying colour; a few fairly large *hog-hair brushes*, long and flat; an *oil-stone* for sharpening tools and knife; *a strip of fine emery-cloth*, and a *leather buff* is useful for keeping the knife keen; *a printing pad or "Baren"*; some *cheap water-colours; rice starch* or *glycerine* for tube colours, and a piece of *linoleum* completes the outfit.

**PROCEDURE:** First let the design be made, then select a piece of linoleum about half an inch larger all round than the design. The linoleum should be about $3/16$ inches in thickness, hard and close in grain (cork linoleum is too spongy in texture, does not cut clean or print well). The design is then traced on the linoleum by means of carbon paper and a hard point. This can either be done straight on the linoleum, or it may be prepared as follows: A thin coating of glue laid over the surface, after which a coating of oil paint (white) is rubbed on, smoothing finally with glass-paper. The method should, however, not be adopted if water-colour is used for printing, as the colour does not lie well on the greasy surface; it is only suitable for oil-colour printing. We

will assume that the design is a simple pattern which can be produced by one block, for, if more blocks are used, there will be the difficulty of "registering," which will be dealt with later.

**CUTTING:** Having traced the design through the linoleum we decide what portions have to be cut away, remembering that the surface we intend to print from must be untouched, and all parts not intended to show removed. To avoid confusion it is a good plan to paint over the design with ink or colour before commencing; beginners are very apt to cut away the wrong parts. Then cut firmly round the design, holding the knife at about 60 degrees; this ensures adequate support for the line when the unnecessary parts are removed. The V or "Parting" tool may be used for the purpose, but, unless it is very sharp, it does not give so clean a cut as the knife, so that where a sharp outline is necessary the knife is preferable. Having made this first cut at about 60 degrees, we proceed to make another at right angles to it, this clears out a V-shaped groove all round the design (see diagram, **Plate 93**), after which the ground can be cleared away with the gouges. A sharply curved one will be useful for starting, after which flatter ones can be employed. The next process is printing.

**PAPER:** Almost any paper of medium thickness can be utilised, but the best is undoubtedly Japanese. The paper should be damped (whatever kind is used) by placing in a bowl of water, and then laying between sheets of blotting paper, or by laying it dry between sheets of damp blotting paper. It should not be too

damp or too dry; experience is the best guide in this matter.

**COLOUR:** The colour is then prepared. Ordinary cheap colours in tubes work very well if of the right consistency. Here again a little experience is necessary, because if too dry the colour refuses to leave the block, whilst if too damp it runs. A little glycerine, photo-mountant, or rice starch is valuable in obtaining the requisite "tackiness." Powder-colour mixed with rice starch works well, especially for large surfaces. Rice starch is prepared by mixing a couple of teaspoonfuls of rice flour into a stiff paste, and adding boiling water until it stiffens. This is added directly to the colour, no other medium being necessary. The colour is then applied to the surface of the linoleum with the brushes mentioned (note here that the colour prints in exactly the same way as it is applied to the block, so that textures may be obtained by drawing the brush across, or lengthwise, or by stippling). Care must be taken to apply sufficient colour; the dark quality of the linoleum tending to make it appear darker than it will when printed on white paper.

**"BAREN":** Having cut and coloured the block, put the damp paper in position, care being taken not to allow it to touch until it is finally placed; over this lay a sheet of smooth paper to facilitate rubbing, which is done with a baren. The baren used by the Japanese is about 5 inches in diameter, with a surface of ribbed bamboo sheath. They can be obtained from some of the artists' colourmen. The following, however, are quite as good. Get a glazier to cut you a disc of stout glass, with

a strongly marked rib, about 4 or 5 inches in diameter. To the smooth side of this, fix a small block of wood somewhat smaller than the glass, and of a convenient shape to grasp. "Seccotine," fish-glue, or other cement of a similar nature, with a little fibre or hair added, will fix the wood and glass together. **Plate 93**. A piece of stout leather glued to a circular board with a handle similar to above, is another form. The leather must be grooved, evenly, with a gouge giving a succession of ribs as in the case of the glass. This is more easily done when the leather is damp. The rubber is moved freely and smoothly from side to side, and from top to bottom, care being taken that the whole surface is well rubbed. The proof may be lifted a portion at a time to see how it is progressing, but if taken completely off it is almost impossible to replace it accurately. If the impression looks weak more colour may be added, after partly lifting the paper, which is then gently let down again and the rubbing continued. So far the process described has been where one block only is used. Very beautiful and elaborate prints can be obtained by using more. The chief point to bear in mind when designing for linoleum printing is that pattern and shape are of vital importance. The best effects are perhaps obtained where each colour has a block to itself; the colours may be varied, but a blurred effect often results which gives the impression of faulty workmanship.

**REGISTERING:** Where more blocks than one are used the only difficulty is in the registering. In the diagram, **Plate 93**, two methods of registering are illustrated. It is essential to mark these points of

registration on the first drawing, so that they may be traced through on to each plate, which ensures their being in the same position on each block. Where one block only is used, as in the case of a repeating pattern (very suitable for class exercises), these registering marks are not necessary. In this case it is best to have the linoleum just large enough to take the design, and to rule the paper (before damping) in such a way that the pattern repeats correctly. A square, rectangular, circular, or triangular repeat is the easiest to manage. Where the design necessitates more than one colour, the light tints are printed first. When the backing paper becomes damp, replace immediately with a dry sheet, or the rubber will catch and spoil the proof. In polychromatic designs it is best to print a number of proofs of each colour in succession; it is more economical of time and labour. Prints should be left to dry uncovered, and when mounted should only be attached by the top edge.

## WOOD STAINING

This is a form of decoration which (unlike gesso or oil painting) does not interfere with the texture of the wood. On the contrary, this grain or texture enhances the charm of the work.

**WOOD:** Whilst the most suitable wood is white-wood of a smooth even texture, bass-wood, box, and pear are all good, and even the darker woods may be stained, but the range of colour is here naturally more limited, since it is impossible to stain a wood to a lighter colour. The stain being transparent is always influenced

by the ground colour; an opaque medium, gesso or oil is alone capable of producing lighter tints. The stains are obtainable from any dealer in artistic materials.

**PREPARATION:** The wood is first prepared with glass paper until a smooth even surface is obtained. It is then brushed over with size. The most convenient form is the concentrated size made with boiling water, which should be used fairly thin. The object of this is to prevent the stain spreading, which it readily does on unsized wood, blurring the edges and oozing over other colours, with unfortunate results. After sizing, rub smooth with fine glass paper, as the wet size raises the grain of the wood and roughens the surface. The design is then drawn or transferred to the wood. Do not use carbon paper for transferring, as the stain will not penetrate the greasy line obtained thereby.

**DESIGN:** A frankly decorative treatment is best suited to this work; flat shapes of colour, pure and bright, floated on, and finally outlined, give the most satisfactory results. For class work the articles produced in the manual training class can be decorated in this way. **Plate 111.** Collaboration between the manual training instructor and the art master will clear difficulties as to suitability out of the way. The lesson affords fine opportunities for the use of colour, and forms a practical adjunct to the study of this subject. Wood staining is simple and easily handled. Practically any design, from the simplest geometric pattern to the most elaborate figure composition, can be executed in the medium. But restraint is necessary, and flat colours, rather than

attempts at light and shade and surface modelling, will be found most satisfactory.

**POLISHING:** When the staining is completed the work should be polished. French polish and wax polish are both used, and either will increase the brilliancy of the colour, and at the same time afford protection from dirt. French polishing gives a brilliant gloss to the surface, whilst wax polishing produces a duller sheen which is often more desirable than the high French polish. French polish consisting of shellac dissolved in methylated spirit is applied with a "rubber" (a pad of wadding enclosed in a piece of soft linen); a circular motion well covering the whole surface is the best. From four to five coats of shellac are necessary, with a corresponding amount of rubbing. After a while the shellac becomes tacky and develops a tendency to stick. This is obviated by applying a touch of raw linseed oil, merely enough to lubricate. At least a day should intervene between the application of each coat of shellac to allow the spirit to evaporate, and as long as the polish sinks in the wood, it is impossible to get a durable finish. When a film has been spread which shows no tendency to sink, the final polish is obtained by "spiriting off." In this case methylated spirit alone is used on the rubber instead of shellac. Here lies the difficulty of the process, for the polish is gradually diluted until the spirit alone gives the gloss required. A clean rubber is taken on which there is no polish, merely spirit, and a good plan is to rub off finally in the direction of the grain. The process is a very difficult one,

and important work should be placed in the hands of an experienced polisher.

Wax polishing is much easier. White beeswax is scraped into fine shreds with a penknife, and enough turpentine added to dissolve it. The jar containing this is placed into a saucepan of water and boiled until the wax is melted. As the turpentine is merely a vehicle to aid in the application of the wax, which alone is too stiff to handle, just enough is used to dissolve the beeswax. The surface of the wood must be perfectly smooth before the wax is applied. The wax is applied with a soft rag and the polish is obtained by repeated rubbing. For carved work a nail or toothbrush is used for polishing the interstices. The polish is dependent entirely upon the rubbing, and not upon the quantity of wax applied, too much of which will cause a lumpy and uneven surface, which must be got rid of by vigorous rubbing. This method of polishing is very suitable for stained wood, and has the additional advantage that the whole work can be accomplished by the student without external help.

## WOOD CARVING

"The value which is given to wood by carving led to the carving over the whole mountain of stone of a Cathedral."

—EMERSON.

Wood carving affords valuable training for hand and mind, and might be employed in school work far more than it is.

**TOOLS:** The necessary equipment (see **Plate 94**) consists of a *mallet*, a *V or parting tool, two flat chisels, some eight or nine gouges* of different sizes and curvatures, *two cramps*, and a suitable piece of *wood* for each student (see **Plate 94** for diagrams and sections of tools). For general use, a *grindstone* and *oil-stone*, some *"slips"* of *"Arkansas"* and *"Washita,"* a *leather buff* for stropping, and *benches* made of a stout wood. The gouges mentioned are sufficient to start with, but, as the student advances to more elaborate work, the need for other shapes and sizes will arise.

**OIL-STONE AND "SLIPS":** The oil-stone known as "Washita" is perhaps the best; one side should be kept for flat chisels and one for gouges, as the latter wear the surface into grooves.

**LUBRICANTS:** Olive or any lubricating oil may be used, but any oil which coagulates should be strictly avoided since it ruins the stone. A little soap and water forms a good lubricant; paraffin is also useful. The slips are used for sharpening the insides of the gouges. One of the slips should have a knife edge for use on the V tool.

**WOODS:** Almost any wood will do to commence with. Yellow pine, lime, kauri-pine, sycamore, beech and holly are all fairly soft and close in grain, and therefore good for beginners. Oak and walnut are undoubtedly the best for fine work, but, being somewhat hard, are not so suitable for the tyro. The tools should be kept sharp; this is even more essential for soft than for hard wood, but quite essential for both. Tools used for soft

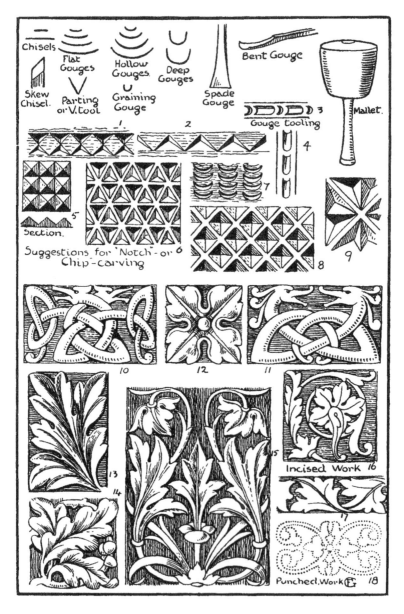

PLATE 94—*Wood Carving.*

woods require a longer bevel than those used for hard woods.

**SHARPENING TOOLS:** To sharpen the tool it should be held at about an angle of 15° with the stone, and rubbed steadily up and down. When the one side has been rubbed a while, turn it over and repeat the process on the other. Gouges, in addition to being rubbed up and down the stone, must be rocked evenly from side to side with a regular motion of the wrist, to ensure that the whole of the edge comes into contact with the stone. Sharpening requires a little practice, and should form a part of the early instruction. When the outer edge has been evenly rubbed, the inner edge must be rubbed also, using the "slip" and oil.

**"BUFF":** The result of this rubbing will probably be a "burr," which is got rid of by stropping on the buff, which has previously been smeared with emery and crocus powder mixed to a paste with tallow or grease. A smooth keen edge should now be on the tool.

**CHIP-CARVING:** Chip-carving is the simplest form, and, therefore, the easiest to begin with. A fairly close-grained wood is most suitable. Lime, holly, or pear are good. Clamp a scrap of wood to the bench and practise cutting with the chisels and parting tool until some familiarity has been acquired with the behaviour of the tools and material, after which a geometric pattern, based on a square or triangular net, should be set out upon a suitable piece of wood.

**HANDLING TOOLS:** In handling the tools, which to some extent is a matter for the individual student,

the left hand is used to control the tool. The right hand grasps the handle firmly, with the top resting against the palm. This grip permits the necessary force to be applied, whilst the left hand assists in guiding and controlling. Unless the left hand helps in this way, the tool will slip, and, as the student is often foolish enough to put his left hand in front of the tool, a nasty gash often results. Some instruction of this type should be given, and the student left to develop his own method.

**CHIP-CARVING:** Having drawn the pattern on the wood, proceed to cut the shapes out, using the small straight chisel, the angle chisel or the V tool, according to the shape to be cut. The rectilinear patterns on **Plate 94** can all be cut with a straight chisel. The gouge tooling is, of course, executed with a gouge, which is chosen to suit the size of the cut required. The broader semicircle end of the cut is made by holding the gouge vertically and forcing into the wood; the second cut is made with the tool sloping, so that the hollow gouged out slopes directly into the first cut. If the first cut is sufficiently deep, the piece will come away clean. Chip-carving is valuable in that it gives a knowledge of tools and materials, and it also affords useful decoration if used sparingly. The practice, however, of covering table-tops, boxes, frames, and other articles, with a pattern which palls by its sheer monotony, is one to be avoided. It should be regarded rather as a means to an end than an end in itself.

**INCISED WORK:** Incised work follows naturally upon chip-carving, and because of its greater freedom affords more scope for artistic treatment. When

preparing the design for incising it should be borne in mind that, as the pattern is quite flat, with but little or no attempt at surface modelling, the ultimate effort will depend solely upon line and shape. The silhouette is the important factor. There should be no overlapping of forms necessitating relief treatment to render them readable; if the incised line does not serve the purpose, the design is unsuitable. When prepared, the design is transferred to the wood by means of carbon paper. A smooth close-grained wood, such as pear, lime or holly, lends itself readily to this type of decoration. The outlines are next incised with the V tool, after which the ground is cleared, leaving the ornament as a flat plane slightly raised above the background. If preferred, the background need not be cut away, but the effect is better where the ornament stands above the ground.

**COLOURING:** The effect is enhanced by colouring, either the background alone, or both background and ornament. Wood stains, oil or water colour are suitable for this purpose. It is generally advisable to size the wood before colouring, but for broad simple effects it is not absolutely necessary, as the incision keeps the colour within bounds. It is obvious, from the above brief description, that this type of work depends solely upon the pattern for its effectiveness; shapes and lines are of great importance as the ornament lies entirely in one plane. There can be no attempt at surface modelling without destroying the peculiar character of the work. The colour is added merely to emphasise the shapes (**Figures 16 and 17, Plate 94**).

Incising was practised considerably towards the end of the sixteenth and during the early part of the seventeenth centuries. This work consisted entirely of incised lines, which were then filled with a black composition, the result having much the same quality as niello in metal-work. Beautiful work was executed in this way, but it seems to have been superseded by the quicker, easier type known as "poker-work," or to give it its more dignified title, "Pyrography."

**PUNCHED-WORK:** Punched-work is still another mode of decorating the surface of wood, in which patterns depending entirely upon line for their effect are punched into the material. **Figure 18** in the plate is for punched-work.

**CARVING:** All the processes described so far are subordinate to carving in relief, each involving but a portion of the skill and labour necessary for relief carving. Having learned something of implements and materials in the foregoing exercises, the next stage should be some such work as the Celtic designs (**Figures 10 and 11, Plate 94**). Here the outline is incised, either with the V tool or suitable gouges held almost vertically and driven into the wood, after which the ground is cleared to the depth desired. The forms are then rounded, and interlaced by sinking one portion below another. Thus by simple stages we arrive at surface modelling. The next exercise might take the form of a simple leaf, or a conventional flower, as at **Figure 12.**

**SUITABLE TREATMENT:** In work of this description, all the resources at the carver's command

may be employed, and the skill of the craftsman will be
evidenced by the treatment he gives it. In relief carving
the tools and wood may be used to their utmost capacity.
By this it is not intended to convey the idea that wood
may be wrought into tissues fine as flower petals, or
spun as thin as a spider's web. Such delicate stuff is
not within the legitimate scope of wood. If one dared
to criticise the work of Grinling Gibbons, it is on this
ground that the temptation to do so would arise. Some
of his productions have already suffered because of their
exceeding delicacy, and the wonder is, how they stood
the strain of the tool when the carving was in progress.
Those fragile festoons of flowers that seem to tremble
with every passing breeze, and birds that are poised as
if for flight, almost make one dare to utter the heresy,
"Not suitable for wood." The doubt arises whether the
skill and dexterity of the craftsman have not led him
beyond the limits of good design, and the reasonable
bounds of his material. One is inclined to feel that a
Tudor rose is more satisfying in its simplicity than a
rose by Gibbons in all its naturalistic elaboration. The
fact that his work has not stood the test of time so well
as the work of the much earlier Gothic carvers, affords
some justification for this doubt. The garlands with
which Grinling draped the buildings he was called upon
to decorate, seem as though they were hung for some
festive season, and when this is over they should be
removed. There is hence a feeling of transitoriness that
is hardly in keeping with the permanent architectural
surroundings in which they are placed. If the observer
knew that the material used was bronze instead of

wood, how much more satisfying his impression would be. These remarks, which will probably appear heresy to Gibbons' admirers, only serve to emphasise the necessity for a suitable treatment that shall not exceed the just limitations of the material, and shall be in harmony with the surroundings. Good carving should always appear to grow from, and be, a part of the ground. It should convey no sense of detachment nor any semblance of being stuck on. In its right sphere it forms an enrichment for architecture and furniture. It should, therefore, be designed rather as an added beauty to the construction it decorates, than as an obtrusive element clamouring for attention.

**CUTTING:** Taking some simple design like **Figure 12** as our exercise, we proceed to mark it upon the wood. The outline is then cut with suitable gouges, choosing those which fit the line, and using one as large as circumstances will permit. By means of gouges of slow and quick curves, the whole outline can be cut. Remember that the tool sinks more easily when its cutting edge is parallel to the grain than it does when cutting across it, and also, that a narrow one requires less pressure than a broad one. The outline should be cut in such a way that the cut portion slopes outward to the background, *i.e.* the handle of the tool, instead of being absolutely vertical, should lean slightly inwards towards the ornament when cutting.

**GRAIN:** The ground must now be cleared away: this is best achieved by cutting *across* the grain, the finishing being done *with* the grain. The surface modelling may now be proceeded with. Here the grain of the wood is

a factor to be reckoned with. The tools must follow the grain of the wood if a clean smooth cut is to result, *i.e.* work with the grain and not against it. It will often be found that when working in one direction the tool has a tendency to dip into the wood, and also that fibres will flake off. In the opposite direction the tool takes a clean shaving, and has no tendency to sink. The latter direction is the right way to cut, and as far as possible one should adhere to this. Gouge cuts are never so satisfactory as when taken in one smooth sweep, and the aim should be to cut the wood so that the surface left is true and even. Patching and tinkering with it afterwards leaves a poor, laboured surface alien to the character of carving. **Figures 13, 14, and 15, Plate 94**, are sketches indicating forms suitable for carving. The shapes are such as the tools naturally give, and the modelling runs in long sweeping curves characteristic of carving.

**LIGHT AND SHADE:** It should be borne in mind when preparing designs for carving, that the ultimate effect depends upon light and shade. The balance of the one against the other is, therefore, our first consideration. The background may generally be looked upon as dark, with the ornament worked upon it in light and shade. To achieve this it will be necessary to arrange the planes in the ornament, so that, whilst some will catch the light, others will remain in shade. Convex surfaces should be contrasted with concave, smooth surfaces with others that have a rougher texture, sharp edges with broad surfaces, and so on. It is only by a skilful handling of these matters that

good carving can be designed. Its surface and position, too, will demand attention. Delicate carvings must be well lighted, and placed where they can be easily seen. Vigorous work in high relief is necessary for more dim or distant situations. Furniture must not be carved in such a way as to destroy its utility or simplicity. Chair seats, or even backs, are hardly the places for carving, unless in the case of the back it is so arranged as not to come in contact with the person seated in the chair. Architectural work should fit into the general scheme and form an integral part of it; if there is any appearance whatever of obtrusive decoration, the purpose of the designer has not been achieved.

The student will be well advised to model in clay or wax such work as will require careful surface treatment; in fact, any work will proceed with greater confidence and directness once the forms have been realised in the more plastic material. The effect may be judged in this way before translating the forms into wood, and better results are likely to follow. In addition to this, the knowledge of relief treatment so obtained is of inestimable value to the carver. Lessons in modelling should be given in connection with the carving lessons.

***Notes on Woods Suitable for Carving.***—English oak holds the premier position as the carver's favourite; it is close-grained and hard; it takes a fine finish, and may be wrought into detail of great delicacy.

Austrian and American are not so good, the grain is more open, and the texture more unequal than English;

hard fibrous portions alternate with soft spongy patches which makes these woods difficult to finish well.

Walnut is a good wood for carving, the Italian variety being the best. English is not so good owing to an obtrusive figure in the grain.

Mahogany is sometimes used, especially Honduras and Spanish, but the colour is somewhat unpleasant, and it is, therefore, used more frequently where the work is to be painted.

Yellow pine is a good soft wood suitable for first exercises. Cherry, box, and pear are good close-grained woods, taking a fine finish and admitting of delicate detail.

## GESSO

Gesso may be described as modelling with a brush, for, whilst an effect of relief is produced as in modelling, the result should still preserve that free, fluid sweep associated with the brush.

**DESIGN:** In designing for gesso, advantage should, therefore, be taken of the full flowing curves obtainable by this flexible implement.

**RECIPE:** A good recipe for making gesso is: boil together one part of powdered resin, four parts of linseed oil, and six parts of melted glue, mixing well. Soak some whiting in water; add to the above mixture until it has the consistency of cream, thin enough to flow freely from the brush. When high relief is desired

it should be a little stiffer and mixed with cotton wool pulled into small pieces. Yellow ochre mixed with the gesso gives it a fine ivory colour. Alabastine and denoline are ready-made preparations recommended by some artists. Gesso is very suitable for the decoration of wood. Glove boxes, finger and lock-plates, clock cases, frames, caskets, etc., lend themselves readily to this form of enrichment.

**PREPARATION:** The wood is first smoothed with glass-paper, then coated with varnish, shellac, lacquer or size before painting with gesso. A little glycerine added to the preparation helps to keep it fluid, and prevents cracking and sealing. For high relief the gesso is applied in coats, one laid on another as soon as the under coats have become tacky, with the cotton wool soaked in gesso applied if necessary. As the work is essentially brush-work it should bear this character; it is possible, however, to model with the fingers or a modelling tool well oiled, or even to carve when dry; but as this detracts from the character of the work it should be avoided as far as possible.

**COLOURING:** When thoroughly dry it can be coated with beeswax dissolved in turpentine; with linseed oil or shellac, and finally polished. This gives a creamy colour, and hardens the surface. Oil-colour floated on with turpentine, or powder, or oil-colour mixed with the beeswax and turpentine can be applied, and, if wiped from the highest portions with a soft rag, gives a very charming effect. Water-colours are also used in colouring, being applied before waxing or varnishing, which is done afterwards to fix the

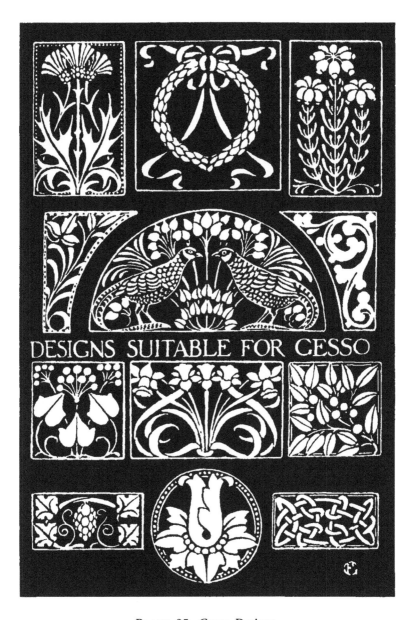

PLATE 95—*Gesso Designs.*

colour. When gilding is considered an improvement, the leaf may be applied after a coating of gold size has been laid on and become tacky. Transparent oil-colour floated over the gold and finally varnished gives a rich effect. The ultimate appearance of a well-executed gesso should (as before stated) give an impression of having been executed with a brush, and, therefore, smooth and textureless. **Plate 95** illustrates the type of design suitable for gesso.

## CHAPTER VII

# STENCILLING

THIS useful and widely employed method of decoration has many possibilities, ranging from the simple border pattern used by the house decorator, to the elaborate patterns of the Japanese, and the figure and landscape panels executed by modern artists. The process is a simple one, merely cutting shapes from paper or thin metal and dabbing colour through.

**MATERIALS:** The only tools required are: *a sharp-pointed pen-knife*, and *oil-stone* or *strip of emery cloth* for the sharpening. Some stout *cartridge paper*, and a *sheet of glass* or *cardboard* for cutting on. A few *stencil brushes*, some cheap *water-colours* in tubes, and *saucers*. *Shellac* is useful if stencil plate is to be used much.

**DESIGN:** In designing a stencil plate it is necessary to bear in mind that each shape must be bounded by paper, and all parts linked together by ties. A glance at the stencil patterns on **Plate 96** will show clearly what is meant. The result being, in a single plate stencil, that the pattern consists of a series of shapes, bounded everywhere by the background colour. It is particularly useful for repeating patterns where the unit requires

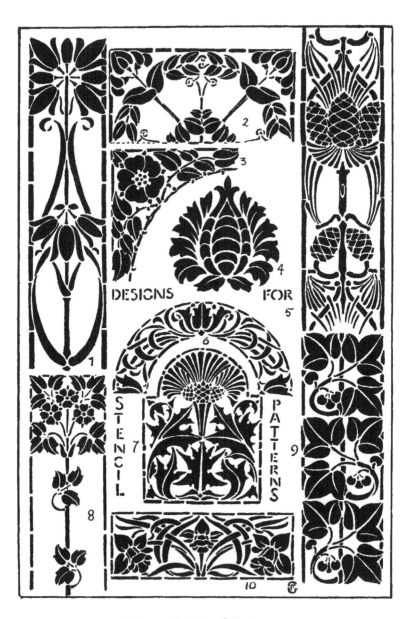

PLATE 96—*Stencil Patterns.*

printing a number of times, for once the pattern is cut it can be used as often as desired. Having prepared a design for a stencil, either directly on the paper to be cut or on a separate piece, and traced it through to a stout cartridge, the next procedure is to give it a light coating of knotting or shellac.

**CUTTING:** When thoroughly dry the plate should be laid on a sheet of glass (this gives a clean sharp edge) or cardboard, and with a sharp-pointed knife the shapes required are cut away. If the design has been carefully considered the plate will hold well together, and be in no danger of falling apart. Before cutting, a good plan is to darken in, or lay a wash of colour over the parts to be cut out; this avoids confusion. In this process the necessary ties should be frankly accepted, and made to form a part of the design. The veins of leaves, markings on fruit and flowers, buds, twists and knots in stems can all be taken advantage of, and utilised to break up a line that would otherwise be too long and weak. There is a character about stencilling peculiar to itself, and any attempt to paint out ties afterwards destroys the character and thereby enfeebles it.

**PRINTING:** When the plate is cut it is laid on the surface to be stencilled and the colour dabbed through with stencil brushes. Water-colour, oil-colour, dyes, or wood stains may be pressed into service, but care must be exercised not to use the colour too thin as it will ooze under the edges and blur the impression, which should be sharp and clean-cut. A little experience will soon teach you how dry your brush should be. A separate brush must be kept for each colour, which can be varied

at will. This is one of the charms of the process, the ease with which the colour may be varied. You may start a shape in blues and gradate it into greens or purples, and so on at will.

**JAPANESE METHOD:** A description of the Japanese method of dispensing with ties (as we understand them) is of interest. A sheet of paper double the required size is folded down the middle and the design drawn on one face, ignoring ties, or leaving only such as will keep the parts in place until the next process is completed, when they are cut away. Having cut the pattern through both sheets of paper, the upper sheet is lifted and folded back on the centre crease. The craftsman then covers the lower sheet with a slow-drying varnish and lays across numerous hairs or strands of silk, which adhere to the varnish. When this is completed, he carefully folds down the upper sheet and puts his stencil under pressure. The ties which held the parts together are then cut away and the plate is ready for use, after it has been well varnished. In use, these threads or hairs move slightly from side to side, and are too fine to interfere with the colour, so that in the final print they are not visible. The result is somewhat puzzling to anyone not cognisant of the method employed.

**COLOURS:** For stencilling on paper, water-colours should be employed. Winsor and Newton's matt-colours, or powder-colour ground with gum and glycerine can be used for large surfaces. Wood may be stencilled with wood stains or with oil-colours. The surface of the wood must first be sized, shellacked or painted, however. Textile fabrics may be printed in oil, water-

colour, or dyes. Japanese fabrics are often beautifully stencilled with dyes; gum water or rice starch is mixed with the dye to prevent spreading beneath the plate, after which the material is subjected to a steaming process or immersed in a chemical solution to fix the dye. A final washing removes the gum or starch. Another method is where a "resist" is used. A white fabric is stencilled with the "resist," of which rice starch is the chief component, and allowed to dry. It is then dipped into the dye-vat. This dyes the ground, leaving the pattern white. The dye is fixed as in the previous process. Stencilling can well be introduced into class work, the implements necessary being few and the process simple. Elements, such as those illustrated on **Plate 57**, or simple flower, leaf, animal, or bird forms, can be placed before the class, after a demonstration of the methods employed. These can be turned by them into stencils, and treated for panels, repeating patterns, or any other purpose. The interest aroused in cutting and printing keeps the class absorbed, and is of great educational value. Each pupil should be provided with three stencil brushes (Nos. 3, 4, and 5 are useful sizes for small work), a saucer (four compartments), water jar, and a piece of glass or cardboard for cutting upon. Don't attempt cutting on the drawing board, as the grain of the wood holds the point of the knife and makes good, clean cutting impossible (besides spoiling the board). Each pupil should also have a penknife, and to keep this sharp a strip of emery cloth, No. 0, might be served out. **Plate 110** shows some stencil patterns produced by a class of boys.

## LEATHER-WORK

Embossing or modelling leather is a mode of decoration, capable of producing the most charming effects. It is delicate low relief modelling which depends mainly upon combination of line and beauty of form.

**LEATHER:** Calf-skin, cow-hide, and sheep-skin are the leathers used, but for fine work the best is undoubtedly calf-skin of natural shade. Heavier work requiring a stouter leather is often carried out in cow-hide.

**TOOLS:** The tools used are two modelling tools and a pointing tool of burnished steel, a knife, Dresden tool, ground punches, and a small Repoussé hammer (**Plate 97**). For line work a wheel is useful. A sponge for damping the leather and a slab of glass or marble. Having prepared the design, it is transferred to the leather by means of a hard point, pressed firmly, so that an impression is made through the paper upon the leather, which should be carefully chosen. It is best to try a piece before committing oneself to an important work. When the design has been impressed on the leather, a damp sponge is passed over the whole surface until the material is soft and pliable. With the steel modelling tools, the outline is pressed in, and the background well worked down on the marble or glass slab with the Dresden tool and steel modelling tools. For fine work this is often sufficient, and very charming effects are obtainable by it alone. Do not attempt to use the tools when the leather is too wet, the result will be an

objectionable greyish tint; if just right, the tools slightly darken the colour, adding to the beauty of the work. Fine markings and detail stand better if worked on leather nearly dry. Experience is the best guide. For higher relief, the leather is pressed up from the back, by laying it on a soft material, clay or modelling wax, protecting the leather with a sheet of paper placed between. To maintain this relief, a stiff rye paste, mixed with sawdust or cotton wool is spread into the hollows. Use the paste as stiff as possible or the damp will percolate and alter the colour of your leather. Usually, pressure of the modelling tools is sufficient to obtain the desired relief, but for bold work it is sometimes necessary to use rounded punches or the boss on the Repoussé hammer. The surface is then modelled as previously described, by damping and pressing with the tools. When damping, always pass the sponge evenly over the whole surface, or an uneven colour will result.

**CUTTING:** Another method introduces the knife (**Plate 97**). The outline is cut partly through the leather; take care not to press too heavily or the knife will go right through. This cut is then opened out, with the tools, and the pattern modelled as before. This emphasises the outline.

**COLOURING:** Colour is often added, and if well done, certainly adds to the beauty of the work. Wood stains are good because they leave the grain or surface undisturbed. Care is necessary in the application, because the absorbent nature of the material quickly soaks up the stain. Unless evenly and quickly applied, it looks patchy and unequal. Water colours may be

used, but it will be necessary to varnish afterwards or the pigment will rub off. Size the work with starch size before varnishing. The starch is prepared by mixing to a stiff paste with cold water and then adding boiling water. Well cover with this, and, when dry, a quick drying transparent varnish is quickly and evenly applied. Gold is often used, and a rich effect may be obtained by colouring the gold with transparent oil colour. The gold is applied on gold size in the usual manner or with white of egg.

**POKER-WORK:** Pyrography or poker-work is still another mode of decorating leather. A special platinum point attached by means of a rubber tube to a bottle containing benzoline is maintained at the requisite heat by the vapour from the benzoline. Hand bellows blow the vapour from the bottle to the previously heated point which is thus kept at a steady glow. This method gives a brown outline, and tones of brown on the background as desired.

**INLAY:** Leather is sometimes decorated with inlays, or perhaps "applique" would be a more correct term: one colour is applied to another. Simple shapes are most suitable. The leather for applying is cut into strips of suitable size, damped and pared very thin. When dry, it is cut to shape, and the edges made very thin and uniform, paste or fine glue spread over the back, the shapes carefully placed in position, and the whole put under pressure until dry. If the edges are tooled, or decorated with a series of dots, it is difficult to detect the process. When a fair-sized panel is to be applied it is best to paste a sheet of paper to the face of the leather

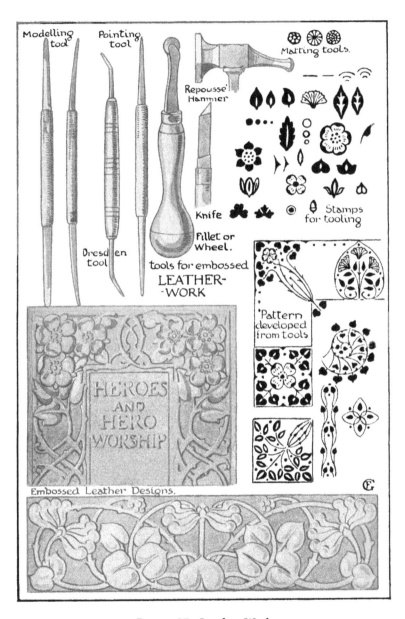

PLATE 97—*Leather-Work.*

before cutting to shapes and paring the edges. This has the effect of preventing the thin leather from stretching when the paste is applied. This method is not often practised, as stains will give a similar effect.

**TOOLING:** Gold tooling is another process, largely used and capable of producing the most beautiful results. The tools used are of special shapes, fillets (straight lines), gouges (curved lines), circles, dots, stars, spirals, leaf and flower forms (**Plate 97**). The pattern is produced by a combination of these simple elements. This pattern is pasted on the leather at the four corners, and the elements impressed with the appropriate tool, previously heated, and then slightly cooled on a wet pad, taking care to put the shank as well as the end of the tool on the pad, otherwise the heat retained in the shank will return to the end, making it too hot again. When the whole pattern has been impressed the paper is removed, and should no gilding be required, merely blind tooling, the pattern is simply deepened and sharpened by a further application of the tool. If gold is necessary the leather is then well washed, porous leather such as calf or sheep-skin will require washing over with paste water and sized with isinglass or gelatine dissolved in warm water. When nearly dry the impressions to be gilded are painted with white of egg well beaten up in an equal quantity of vinegar, which has been allowed to settle. This is known as "glaire." The glaire is applied with a fine sable brush. When the first coat is thoroughly dry, a second coat should be added. Care is essential, for too much glaire will mess up the edges. The gold leaf is laid over the pattern, when the glaire has become tacky, and

the whole work has been lightly rubbed with a pad of cotton wool greased with a little cocoa-nut oil. Press the gold into the depressions with a pad of cotton wool, a second coat of metal will probably be necessary. It will readily adhere to the under one after it has been lightly breathed upon. Press into position with the cotton wool, after which the pattern should be perfectly visible. It is then tooled again with the hot tools. Experience alone will guide in gauging the heat required for leaving the gold clear and bright. The tools must, of course, be clean and polished. If the leather is slightly damp it helps a clear impression. It is essential that the tool should be placed into the impression in exactly the same way on each occasion. A wheel or fillet is used for long lines. When the tooling is finished the loose gold is removed by rubbing with a soft greasy rag. Where the impression is not sound, re-glaire, gild, and tool. Finally wash with benzine to remove grease, and varnish lightly with a pad of cotton wool. A light French varnish specially prepared is less likely to turn brown, but it requires to be used sparingly. On **Plate 97** will be found a few suggestions for designs suitable to leather.

## METAL-WORK

Of the educational value of this subject there can be little doubt. The combination of hand and brain work involved affords a training of exceptional value. The instruction should include design and execution, giving thereby an insight into the nature and possibilities of the material, together with practice in handling tools,

and a knowledge of the peculiar treatment to which the metals should be subjected to achieve sound results.

**TOOLS:** The tools required for each pupil (**Plate 98**):—

Repoussé hammer.

1 dozen punches (assorted).

1 pair round-nose pliers.

1 pair flat-nose pliers.

1 saw frame (deep).

Piercing saws.

1 pair straight shears.

1 pair bent shears.

Files, various.

Pair tweezers.

Borax slab and brush.

Steel foot rule.

Scriber.

Mouth blow-pipe.

Jeweller's soldering burner.

Charcoal block.

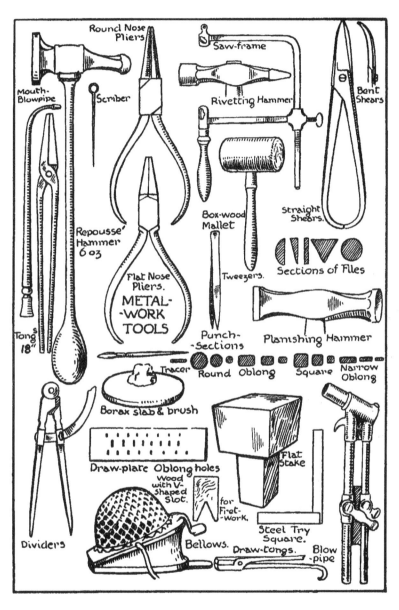

Mouth-Blowpipe

Round Nose Pliers

Saw-frame

Scriber

Rivetting Hammer

Bent Shears

Repoussé Hammer 6 oz

Box-wood Mallet

Straight Shears.

Sections of Files

Flat Nose Pliers.

METAL-WORK TOOLS

Tweezers.

Planishing Hammer

Tong's 18"

Tracer

Punch-Sections

Round   Oblong   Square   Narrow Oblong

Borax slab & brush

Flat Stake

Draw-plate Oblong holes

Wood with V-Shaped Slot. for Fret-work.

Dividers

Bellows.

Steel Try Square.

Draw-tongs.

Blow-pipe

PLATE 98—*Tools for Metal-Work.*

249

The following tools for general use:—

Boxwood mallet.

Two or three parallel vices.

Dividers.

Blow-pipe about 12″ (Fletcher Russell).

Bellows (foot).

Flat stake.

Furnace tongs.

Draw-plate (oblong holes).

Draw-tongs.

Revolving soldering tray, 10″ or 12″.

Try-square.

1 pair tinman's straight shears, 11″ or 12″.

1 pair bent shears, 11″ or 12″.

Sheet-lead for punching upon.

Sulphuric acid for pickle.

Ammonium sulphide.

1 planishing hammer.

Copper and brass, soft annealed finish, in sheets 20 to 24 standard wire gauge.

Copper wire.

1 hand drill.

Paraffin.

Some silver solder and soft solder.

Fluxite.

**USE OF PUNCHES:** It is necessary first of all to acquaint the pupils with the nature of the metal, and the methods of decoration best suited to it. This may be done by briefly explaining what copper or brass is, followed by a demonstration in annealing, and the use of the Repoussé punches. Each pupil might then be given a piece of metal (preferably copper) to anneal, after which he may be instructed to produce patterns by a combination of punch impressions. For convenience, a piece of sheet-lead is perhaps best to begin on. It is cleaner, requires less preparation than pitch, and admits of sharp, clear impressions. The copper is placed on the lead, the punch held in position with the left hand, and struck sharply with the Repoussé hammer. A depression the shape of the punch results, with a boss of corresponding shape on the reverse side of the metal. By this method, design, as the outcome of tools and materials, is taught. Piercing might be practised next, simple shapes drawn on the metal, and pierced with the fret saws.

**DESIGNS:** When a reasonable familiarity with tools and metal has been acquired, designs for escutcheons, finger-plates, etc., might be prepared, **Plates 99, 100, and 106**. Here proportion and shape will play an even more important part than the actual decoration. Point out the primary importance of suitability to its purpose, and the secondary importance of decoration. Good form and restraint in decoration are essential factors in design.

**Plates 99 and 100** illustrate a few suggestions for

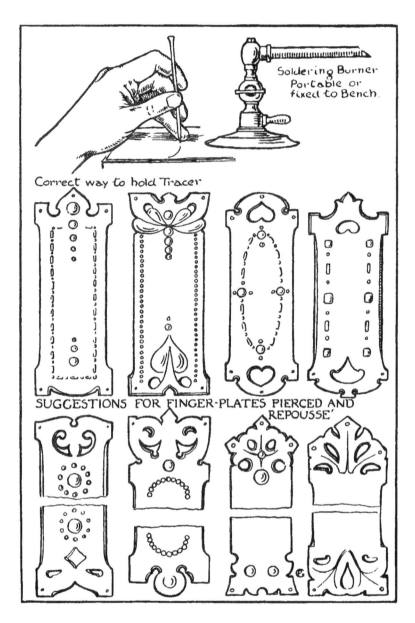

PLATE 99—*Suggestions for Metal-Work Designs.*

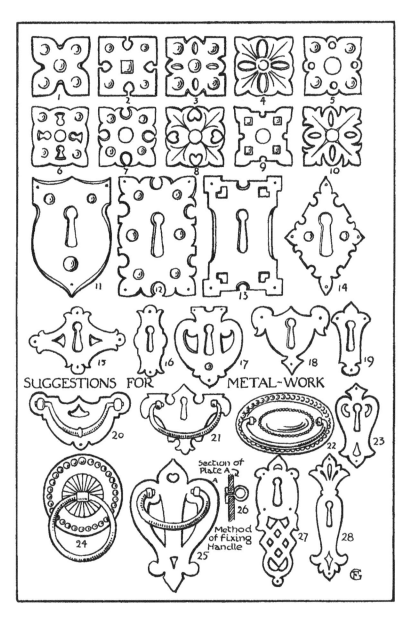

PLATE 100—*Suggestions for Metal-Work Designs.*

finger-plates, escutcheons, etc., which can be easily produced by cutting, piercing, and punching.

The photographs on **Plate 106** were taken from examples produced by pupils.

First, let the design be prepared; a good plan for this is to make a few suggestions on the board, setting the size, and then allowing the pupil to make his own selections, and developing.

**PIERCING:** The method of working should first be explained. The designs are then transferred to the metal, by means of carbon paper placed between the metal and paper, and traced through with the scriber—a knitting needle does as well. Where the work is fretted, or sawn with piercing saws, a piece of wood 6 or 7 inches by about 3 inches, having a V-shaped slot sawn from one end, and screwed to the bench, or held in a vice, facilitates sawing. After fretting, the edges need finishing with files of various sections and sizes, ranging from 6 or 7 inches to needle files. The holes for passing saw through in starting can be drilled or punched, the latter is the speedier method.

**BOSSING:** Bosses of various shapes and sizes might be added by placing the metal on a piece of lead, and using punches of the desired shape and size, striking them smartly with the Repoussé hammer. An interesting lesson can be given on the possibilities of producing patterns by means of the punches alone; combinations of bosses and depressions of various shapes and sizes. This is the best way to teach design; it grows out of the tools and materials, as design should.

**ANNEALING:** The work may now be heated and plunged into diluted sulphuric acid, 1 part acid to 10 parts water. This cleans and anneals. True up on flat stake with the boxwood mallet, and polish with emery flour, Sheffield lime, tripoli powder, or powdered pumice, and a soft rag.

**COLOURING:** A fine colour may be given by wiping over with a brush or rag dipped in ammonium sulphide; it produces a fine bronze tint, and by polishing the bosses or other outstanding parts with a little whiting and water (which exposes the copper colour) a fine finish is given. The colouring should be done in the open air if possible, or in a room not occupied, as the fumes given off are very unpleasant; it should not be allowed to touch the hands as it stains badly. Many articles such as escutcheons, finger-plates, bell-pushes, ash-trays, etc., can be easily produced by the above method.

**PITCH-BED:** For more advanced work in Repoussé a pitch-bed is required. This is a rough wooden tray 1 inch deep filled with the following composition:—

Pitch, 6 parts.

Brickdust or Plaster of Paris, 8 parts.

Resin, 1 part.

Tallow, 1 part.

After the design has been transferred to the metal, it is laid flat on the composition softened with the flame from the blow-pipe. This should be carefully done, as it

easily burns and loses its elasticity. Press the work down, keeping under pressure until it is gripped.

**TRACING:** The next stage is to incise the outline with the tracer; this is a punch about 4 inches long, shaped like a blunt chisel, the tracing edge (in contact with the metal) being slightly wider one end than the other, with the angle rounded off. This is held between the thumb and first and second fingers almost perpendicularly, but sloping a little backwards from the direction in which it is travelling. The third finger rests on the metal at the back of the punch and acts as a guide, **Plate 99**. A little practice will enable the student to produce a smooth, even line, but, at first, it will have a tendency either to stick or slide. If it sticks it is held too vertically, if it slides it slopes too much; the correct angle, once attained, will carry the tool gently forward in an even track. For sharp curves the tracer is held at a greater slope so that only the heel of the tool rests on the copper. After tracing, the copper or brass is removed from the pitch, a punch inserted and given a sharp upward jerk will cause it to spring off when the pitch is cold: if not, it will be necessary to warm the metal. The pitch is then wiped off with a soft rag and paraffin, and the work is placed on the pitch again reversed, *i.e.* the traced lines will show as ridges instead of grooves.

**REPOUSSÉ:** Then with punches of required shape the raising or embossing is produced. Always use a punch as large as possible, it produces a smoother and more even surface. These punches will vary considerably; besides those illustrated on **Plate 98**, a number of oval, elliptical, and other shapes will be required. These can

be made as they are needed from rods of tool steel, cut to the required length and shaped with files. When the embossing is completed, the work is finished on the face with "modellers" and "chasers."

**"MATTING":** If desired, the ground may be "matted." This is done with the matting tools, and produces a texture which enhances the value of the ornament. **Figure 1, Plate 101**, shows a tray with the method of production. A disc of metal, 10¼ inches in diameter, is cut from a sheet of 20 or 22 standard wire gauge, and circles inscribed with the dividers to mark the limits of the depression in the centre, and the position of the decoration. A curved hollow of the section shown in the plate at A is cut from a block of hard wood.

**BEATING:** Anneal the disc, hold firmly in the left hand, fit the edge against the two guide nails C, C, and with the ball-ended hammer work the metal to the section of the wood. This must be done evenly, a series of blows being struck at regular intervals as the metal is revolved. After one or two courses have been taken round the disc, it will require annealing and flattening. The flattening is done on an even surface with the mallet. This process is continued until the centre is beaten to the required depth. A couple of rounds with the hammer is followed by annealing and flattening, otherwise the metal will get hopelessly out of shape, and will probably crack.

**PLANISHING:** When the depression is completed it must be "planished" on a smooth stake. "Planishing"

helps to true up the surface, at the same time giving a series of small smooth facets to the metal. It requires a little practice, as the face of the planishing hammer must fall squarely upon the metal, pinching it between the hammer and the smooth stake. If the edge of the hammer catches the metal an ugly dent results, hard to get rid of. The elbow should be held close against the side, when once the right position has been obtained, and the hammer allowed to rise and fall with a steady even stroke, adjusting the metal to the surface of the stake, so that each blow rings directly upon the stake. After planishing, clean the tray and mark the design upon it. Prepare a pitch bed, and, whilst warm and soft, press the tray (face upwards) upon it. Trace the design with the tracer, and, if any Repoussé is required, reverse the tray and work on the back.

**WIRING EDGE:** The edge must now be wired. For this, cut another section in a wood-block as shown in the diagram, **Plate 101**, and with a sharp-edged hammer beat the metal in the groove. Lay the wire into the depression thus formed, and beat the edge of the metal over the wire. Finish off with the grooved punch shown in the diagram, **Plate 101**. The tray may now be cleaned, polished, and oxidised if desired.

**CANDLESTICK:** The candlestick illustrated on the same plate forms an exercise in setting out the development of conical form.

**DEVELOPMENT:** An elevation full size is first prepared, and from this the various parts may be developed. The shaft is drawn 7 inches by 1¾ inches,

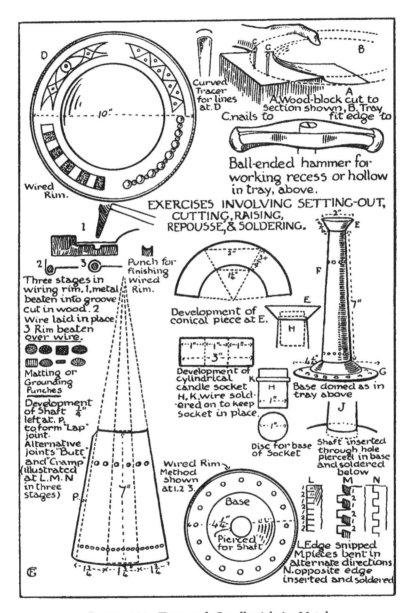

PLATE 101—*Tray and Candlestick in Metal.*

259

tapering to 1 inch; the two converging lines are produced until they meet. With the meeting point as centre, arcs are struck at the top and base of the shaft. Produce the arcs and mark off on either side of the elevation drawn, widths equal to the width of the elevation (see diagram). The elevation is necessarily one diameter in width, so, as the diameter goes, roughly, three times into the circumference, our pattern represents a piece of metal sufficiently large to bend into a truncated cone of the size required. The curves at top and bottom allow it to assume the conical form, and ensure the top and bottom being level. ¼ inch is allowed for the lap joint. The other portions are developed along similar lines, and the pattern is ready. If these patterns are cut out and fitted together, some idea of the proportions and ultimate appearance of the finished article may be obtained before committing oneself to the metal. The metal is cut to these patterns, and the bosses that encircle the shaft beaten up from the back. The conical and cylindrical portions are rounded and made true on the mandril—a steel stake of circular section which tapers slightly; an old steel cotton spindle does very well. The base is made in the same way as the tray described in the previous exercise.

**JOINTS:** The joints in the shaft and similar parts may be either "butt," "lap," or "cramp." The "butt," as the name implies, is bringing the two edges into immediate contact throughout their length, and soldering. The "lap" is where ¼ of an inch or so is allowed on one edge, which is made to overlap the other edge. This lap is filed thin and soldered. The "cramp" joint has a

similar piece allowed on one side, which is snipped at regular intervals to a depth of $1/4$ or $3/8$ of an inch. The separate portions thus made are bent alternately up and down (see L, M, N, **Plate 101**). Into the angle thus formed the opposite edge is fitted, after being filed to a knife edge.

**SOLDERING:** The portions cut are now hammered flat and soldered. The "butt" joint must be hard soldered, the two edges are filed, smeared with borax and brought into contact; small paillons of silver solder, clean and boraxed, are placed on the joint, preferably inside, and the metal brought gradually to the requisite heat. The foot bellows and large blow-pipe will be required, **Plate 98**. The advantage of placing the solder on the inside is that the flame can be kept away from it, and also that, when the requisite heat has been obtained, the solder will flash through the joint in a thin line, with no lumps and patches to need filing away.

**SOFT-SOLDERING:** The "lap" and "cramp" joints may be soft-soldered, but even for these the hard or silver solder is better. For soft-soldering the metal must again be cleaned, after which smear the portions where it is desired that the solder should run with "fluxite" or "killed" hydrochloric acid. Cut the soft-solder into small portions and lay at intervals along the joint, only using as much as is necessary. Gradually heat the metal until the solder flows over the flux, *i.e.* into the joint. This is known as "sweating," and works very satisfactorily without the need of a soldering bit. Scrupulous cleanliness should be observed in either hard or soft-soldering, and the flame kept away from the solder as

far as possible. When the joints are soldered the shapes should be hammered true on the mandril and the joints filed smooth. This completed, the various parts will need fitting together. The grease catcher is soldered to the top of the shaft. The candle socket is a cylinder with a disc soldered to the base, and a square wire near the top, which will rest on the top of the shaft and keep the socket in position. The shaft is dropped through a circular hole pierced in the base and soldered below. The diagrams will help to explain the construction. Clean and, if desired, oxidise as described.

**Plate 102** shows a shallow tray and a small box easily constructed in metal. Prepare a paper pattern, from which proportions may be judged, and corrections made if necessary. Set out on the metal and cut with the shears. Mark the design on the metal and execute with the tracer and punches. Then with a scriber, or sharp point, incise a line where the angle will come in bending.

**BENDING:** The bending is done on a square stake, upon which the surfaces and edges are hammered true. The "lap" joints are soldered either with the hard or soft-solder. Thoroughly clean and paint with borax for hard soldering; place some small snippets of silver solder on the joint, and direct the flame on to the metal until sufficient heat has been obtained to melt the solder. Soft-soldering is not so strong, but is fairly easy. The joint is smeared with "fluxite" or "killed" hydrochloric acid, and small portions of solder placed on the joint. Heat the metal until the solder runs into the joint. The lid of the box should be set out, allowing three thicknesses of

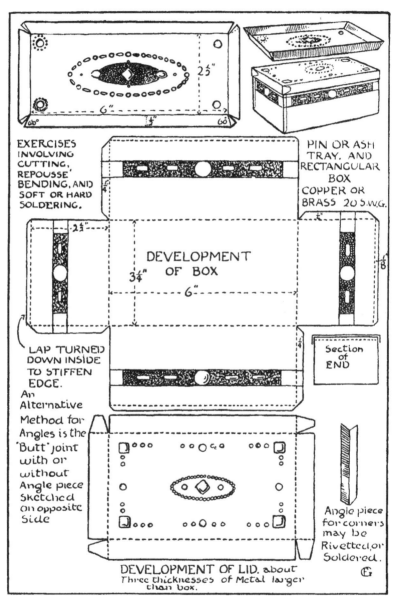

EXERCISES INVOLVING CUTTING, REPOUSSÉ BENDING, AND SOFT OR HARD SOLDERING.

PIN OR ASH TRAY, AND RECTANGULAR BOX COPPER OR BRASS 20 S.W.G.

DEVELOPMENT OF BOX

3¼"  6"

2½"  ⅛

LAP TURNED DOWN INSIDE TO STIFFEN EDGE.

An Alternative Method for Angles is the 'Butt' joint with or without Angle piece Sketched on opposite Side

Section of END

DEVELOPMENT OF LID. about Three thicknesses of Metal larger than box.

Angle piece for corners may be Rivetted, or Soldered.

PLATE 102—*Tray and Box in Metal.*

263

metal larger than the box, so that it may fit into place. An alternative method of treating the angles of the box is shown in the diagram. Instead of the "lap" joint, the corners are butted, and an angle piece soldered into place. This gives a neat finish to the box.

**OCTAGONAL BOX: Plate 103** shows the development of an octagonal box. The pattern is first made and from it the metal cut. The decoration is then added with the tracer and Repoussé punches. The angles are then incised with a scriber or sharp point, and bent over a square stake. The joints are soldered and the whole work polished. The lid should be about three thicknesses of metal larger than the box to allow it to slip over. The main problem here is the setting out.

## WIRE-WORK

The lessons on the use of sheet metal may be augmented by further ones on the use of wire. The tools necessary are given in the list at the beginning of the section. Copper wire may be used at first, as it is cheaper than silver.

**DRAWING WIRE:** The first part of the process is to draw the wire through the (rectangular) drawplate until a wire of sufficiently small section has been obtained. The wire will need to be annealed a few times whilst this is being done, as it gets very hard in passing through the drawplate. A wire of oblong section is suggested, as it bends more readily than round or square.

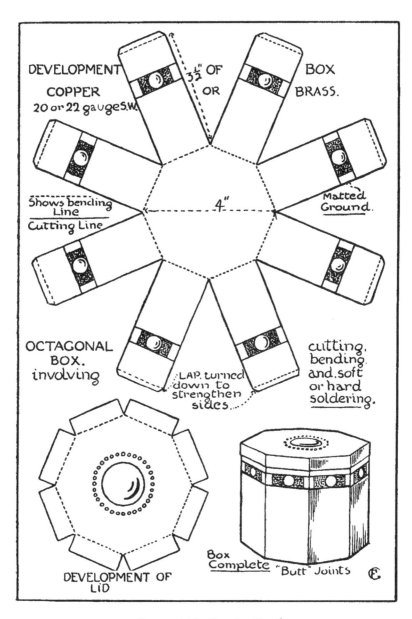

DEVELOPMENT BOX
COPPER 3½" OF BRASS.
20 or 22 gauge S.W. OR

4"

Shows bending Line
Cutting Line

Matted Ground.

OCTAGONAL BOX. involving
cutting, bending, and soft or hard soldering.

LAP. turned down to strengthen sides.

DEVELOPMENT OF LID

Box Complete "Butt" Joints

PLATE 103—*Box in Metal.*

265

**UNITS:** A number of lengths of wire are now cut, from 1 inch to 1½ inches, and bent into the forms illustrated in **Plate 104, Figures 1, 6, 7, 8, 9, 11, 12, 13, 14, and 15**. A little practice will be necessary before satisfactory forms are obtained, but with the round-nose and square-nose pliers (**Plate 98**) they are not difficult to produce. A little instruction from the teacher will materially assist.

**COMBINING UNITS:** When a number of these units have been prepared, various combinations should be essayed. It will be found a fascinating exercise, bringing the fancy into play, and, at the same time, teaching design in the best possible way, *i.e.* by means of the tools and materials. The pupils should be encouraged to produce as many combinations and arrangements as possible, and asked to choose the ones they think best. The teacher discusses the matter with the pupil and so helps to develop taste. When satisfactory arrangements have been arrived at, the units might be soldered together.

**PICKLE:** Thoroughly clean the units, either by heating and plunging into "pickle," or by boiling them in a copper or lead vessel containing this solution. This "pickle" is a solution of sulphuric acid, six to ten parts of water to one part of acid. *Note*, always pour the acid into the water and not the water into the acid or an explosion may result. Keep the solution in an earthenware or lead vessel, as it reacts upon copper; a

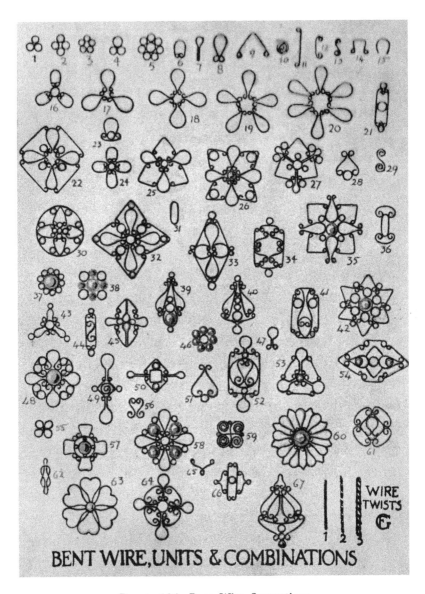

PLATE 104—*Bent Wire Suggestions.*

copper vessel may be used for boiling the solution, but pour it out immediately.

**BORAX:** When the units are perfectly clean, take the borax slab (**Plate 98**) and rub a lump of borax upon it, adding a little water until a solution of a creamy consistency has been obtained. Arrange the units on a charcoal block and paint the joints with the borax solution.

**SOLDERING:** Cut a number of snippets of silver solder and drop them into the borax on the slab. These paillons or small pieces of solder may be picked up on the tip of the brush and carefully placed on the joints. The amount of solder should be just sufficient for the purpose; too much makes an unsightly joint, too little will not hold well. When all is ready, place the charcoal block with the units upon it within easy reach of the soldering burner (**Plate 99**). Take the mouth blow-pipe (**Plate 98**) and direct the flame from the burner towards the work, using a very gentle current of air. Play lightly over the whole work until the moisture in the borax is evaporated. If heated too quickly it will boil up and displace the solder. Should this occur, replace before proceeding. When the borax ceases to bubble bring the whole work gradually up to a uniform heat. The flame should not be allowed to play upon the solder if it can be avoided, as it may melt and run into a ball, after which it is useless. The secret of soldering is to heat the metal to be soldered to the degree requisite to melt the solder, which will then spread itself over the metal which has been protected with borax. The solder must necessarily melt at a lower temperature than the metal

to be joined. This will explain why the flame should not be allowed to play upon the softer alloy while the metal remains cold. By altering the position of the mouth blow-pipe, whilst blowing gently, the flame may be directed to any part of the work, which may thus be brought gradually to the requisite temperature. As soon as this is reached the solder will flash and run into the joints. Remove the flame immediately this occurs, or the solder will burn.

**CLEANING AND POLISHING:** When the soldering is completed, boil the work in the pickle to remove the borax, and polish with a plate brush and tripoli, powdered pumice or Sheffield lime. The designs thus formed of bent wire units may be soldered to sheet metal and form interesting and suitable decoration. Thoroughly clean the metal either by scraping or pickling; arrange the units (also clean) upon it and paint the joints (as before) with borax. The tweezers (**Plate 98**) are very useful for handling the small units. Paillons of solder are applied to the joints with the tip of the borax brush, and the whole gently heated to evaporate the moisture. The heavier sheet metal should be heated first. To do this it will be necessary to arrange the work so that the flame may reach the under side of the sheet upon which the filagree rests. When the heavier metal has been brought to the requisite heat, the solder will run between it and the wire; by finally directing the flame to the surface the entire soldering may be completed. The work must now be cleaned and polished. Whilst copper has been mentioned as a suitable metal for commencing, the filagree work is

eminently suited to silver and gold. The process is the same as for copper, except that for gold, gold solder is used. Very beautiful articles of jewellery may be constructed of filagree, or combined filagree and sheet. Besides the wire units described, small discs of metal cut from a sheet with a circular cutting punch, and small balls, made by melting portions of metal, can be introduced. These little balls dropped into the joints, and the larger discs of sheet metal used as features in the design give variety, and, therefore, interest in the work (see **Plates 107 and 108**).

## HARD-SOLDERING

***Points to be Observed in Soldering***—Thorough cleanliness is essential to all soldering. The amount of borax should be sufficient; do not stint. The paillons of solder should be just enough for the joint, no more and no less. The heat should be applied gradually and steadily. Keep the flame away from the solder as far as possible. The flame and blow-pipe will require a little practice before they can be handled successfully. When the burner is lighted, it will be noted that a flame varying from about twelve inches in length to a mere spark results. For fine work, the gas should be turned down until a flame, between four and six inches in length, is obtained. Place the small end of the blow-pipe immediately over the horizontal tube of the burner, just behind the flame, and blow gently. The character of the flame will at once change from its previous yellowish-white to a blue colour. This denotes a hotter flame,

which is caused by the additional oxygen now being consumed. By blowing harder a fiercer heat is obtained, suitable for larger work; for filagree and other delicate soldering a steady gentle flame is desirable. Note the difference in colour between the outer and the inner parts of the flame. The outer is of a darker blue, whilst the inner consists of a light blue cone extending about half-way along. The hottest part of the flame is just beyond the tip of this inner cone. A little experimenting, shifting the position of the blow-pipe with regard to the flame, and varying the amount of wind, will soon acquaint the pupil with the possibilities of the burner and blow-pipe.

## NOTES ON METAL

Copper has a red colour and is very malleable and ductile. It melts at a bright red or dull white heat = 1996° Fahrenheit. It is used for sheathing and bolts of ships, for brewing, distilling, and culinary vessels, for rollers for calico printing and paper-making. It is also used for many artistic purposes, and in alloying gold and silver.

The alloys of copper are numerous and important, brass, bronze, gun metal, bell metal, Muntz's metal and spelter are a few of the most important.

Brass is an alloy of copper and zinc in varying proportions according to the quality of the brass. The proportions vary from $3/8$ to 8 ounces of zinc to a pound of copper.

Bronze is an alloy of copper and tin; for statuary bronze, tin, zinc, and lead are used as alloys. Gun metal is an alloy of copper, tin, and zinc.

Nickel is a white metal, rarely used alone, but largely with copper and zinc, in producing German silver, British plate, electrum, etc., employed largely for articles of plate.

Silver is a pure white metal, it is very malleable and ductile, and is one of the most useful and beautiful metals at the craftsman's command. It melts at a bright red heat = 1873° Fahrenheit. Pure silver is very soft, and is, therefore, not often used in that state, but alloyed with copper.

Silver coins are made of 222 parts of silver and 18 parts of copper, this is also the quality necessary for the "Hall-mark." Silver solder is an alloy of silver and brass, varying from 2 to 3 parts of silver to 1 of good brass.

Silver is largely used in electro-plating, *i.e.* a coating of silver is electrically deposited upon copper, brass, German silver, etc.

"Sheffield" plate is produced by fitting into close contact a stout sheet of copper and a thin sheet of silver; they are then united by partial fusion without the aid of solder, and rolled to the required thickness. The two metals retain their proportional thickness, and will not part.

Tin is a white metal with a slight tinge of yellow; it is used with zinc and copper in the production of bronze. It melts at 442° Fahrenheit, and with lead as

an alloy gives pewter. Tin is most frequently used for coating iron which is then employed for manufacturing culinary utensils, and other purposes.

Zinc is a bluish-white metal, fairly hard, and fuses at 773°, combined with copper to produce brass.

Gold is a precious and beautiful metal of a deep yellow colour, which fuses at a bright red heat = 2016° Fahrenheit. It is highly malleable and ductile, so much so that leaves of one two hundred and eighty-two thousandth part of an inch can be beaten from it, and a grain can be drawn into 500 feet of wire. The pure acids do not act upon it. Owing to its softness gold is rarely used pure, but when alloyed with copper and silver it is extensively used for coins, medals, jewellery, dental work, etc. For gold coinage 22 carat gold is used = 22 parts of gold to 2 parts of copper, 18 carat gold (largely used by jewellers) contains either 9 parts of gold to 2 parts of silver and 1 of copper; or 36 parts of gold to 7 parts of silver and 5 of copper, the latter is the deeper colour. Gold solders are made by melting a portion of the gold to be soldered with a small proportion of silver and copper. For 22 carat, 1 pennyweight of 22 carat gold, 2 grains of silver, and 1 grain of copper. For 18 carat gold, 1 pennyweight of gold, 2 grains of silver, and 1 grain of copper.

## INLAYING AND MARQUETRY

Inlaying consists of cutting out shapes of veneer, ivory, mother o' pearl or other material, and fitting them

into hollows of corresponding shape in the ground material. These shapes should be of such a nature that they may easily be cut with the gouges and chisels used for wood-carving, illustrated on **Plate 94**. It follows, therefore, that they should be as simple as possible, to permit of easy cutting, and to obviate the risk of breaking. The units shown on **Plate 105** are all readily obtained by the process, and form useful motifs with which to build up designs. Practice in cutting shapes should form the first lesson, so that the class may be familiarised with the nature of the veneer, and the shapes most suited to cutting with the gouges.

**DESIGNS:** Designs should then be prepared, and the knowledge gained in the previous lesson will teach the pupils what to avoid, and what may be legitimately attempted. The panel suggestions, **2 to 9, Plate 105**, show the type of design most fitted for inlaying. A few simple units suggested by the instructor and arranged by the class is perhaps the best approach.

**CUTTING:** When the design is prepared, tracings of the different units are made to use when cutting the veneer. The design is then pasted or glued upon the ground, gouges of the desired curvature are fitted to the outlines, and, whilst held vertically, are struck smartly with the hand. The wood within these outline cuts can easily be removed with a small chisel, leaving shallow cavities for the reception of the units. The prepared tracings are now fastened to the selected veneer, and using the same gouges for corresponding lines the units are cut to shape. Note, the units should be cut on the outside of the line, and the cavities on the

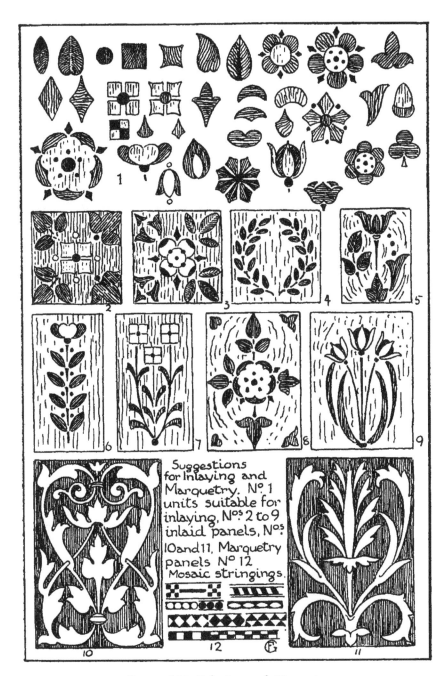

Suggestions for inlaying and Marquetry. Nº 1 units suitable for inlaying, Nºˢ 2 to 9 inlaid panels, Nºˢ 10 and 11, Marquetry panels Nº 12 Mosaic stringings.

PLATE 105—*Inlaying and Marquetry.*

275

inside, otherwise there is a danger of the units being too small.

**FITTING:** Having prepared the units and the hollows for their reception they should be fitted, and, if necessary, trimmed; after which, gluing may be proceeded with. Inlaying is a suitable mode of decoration for many of the articles executed in the Manual Training Class, and collaboration between the Instructor of Manual Training and the Art Master would tend to improve the design of these objects, and also to render desired ones more suitable for inlaying.

**MARQUETRY:** Marquetry, which is often confused with Inlaying, is a totally distinct process. In Marquetry, the veneers required for the work in hand are fastened together with pins or by some other temporary method, and the whole thickness cut simultaneously. Six or even more sheets of veneer are cut to the required design with a fret saw or special machine, whilst temporarily fastened together. The result is a series of corresponding shapes in each layer of veneer. These shapes are then interchanged, a piece being taken from one layer, and a different piece from another, until the desired effect is obtained, which is then glued to a sheet of paper. The face which will ultimately appear is now in contact with the paper. The reverse side is levelled and toothed, and, a good coating of hot glue having been applied to the surface of the wood upon which the veneer is to be laid, the two are placed in position and subjected to pressure. Where such appliances are available, the work is screwed down on heated metal beds until the glue is hard, but this is not always practicable. For Boulle

work the thin sheets of material—brass, tortoise-shell, ebony, etc.—are glued together temporarily with a thin sheet of paper between each layer of material, to make separation easy. The design is applied and cutting proceeded with as before.

**VENEERS:** The woods used as veneers are: Amboyna, box, ebony, pear, walnut, oak, maple, satinwood, chestnut, boxwood, tulipwood, rosewood, hornbeam, sycamore, kingwood, etc.; whilst stained woods are used for greens, reds, blues, and other tints not obtainable in natural woods. The glue must be of good quality, and, when it is thoroughly dry, the paper is cleared off the surface of the veneer, which is then smoothed with a toothing plane and a joiner's scraper, followed by glass-paper. The final process is polishing. Inlaying dates back to ancient Egypt and Assyria, as may be seen by examples in the British Museum. The Greeks and Romans made use of it, and Homer mentions it in the "Odyssey." The finest examples of Inlaying and Marquetry that remain for our study, however, are those that belong to Mediæval and Renaissance times. A quantity of good work has been done in England: the room at Sizergh Castle, the suite of furniture at Hardwick Hall, are notable examples; whilst the work of the brothers Adam, of Hippelwhite and of Sheraton, afford tasteful instances of its use as applied to furniture.

PLATE 106—*Bell-Pushes and Escutcheons in Metal. (Class Work).*

278

PLATE 107—*Jewellry by Mr. W. A. Burton.*

PLATE 108—*Jewellry by the Author.*

PLATE 109—*Hall Lamp.    Brass.*

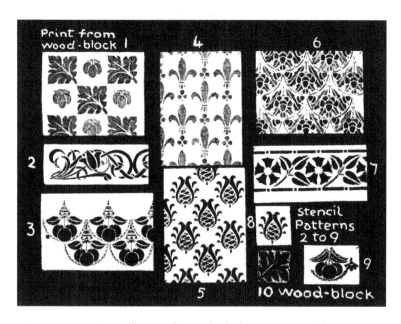

PLATE 110—*Stencilling and Wood-Block Printing.    (Class Work).*

280

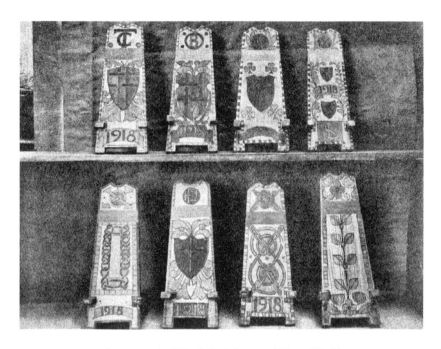

PLATE 111—*Wood Staining.* *(Class Work).*

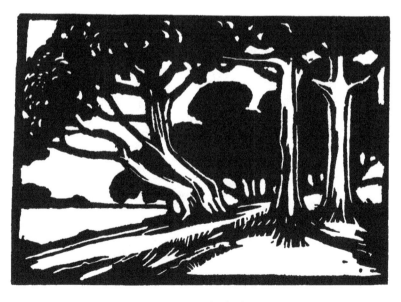

PLATE 112—*Wood-Block Printing.*

281

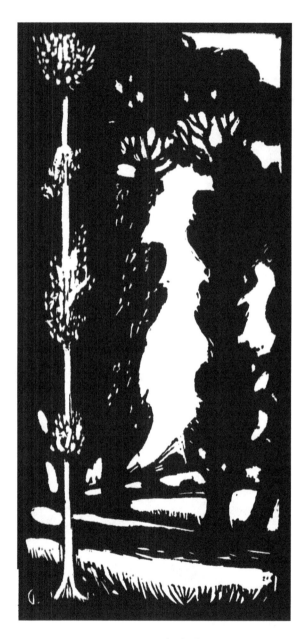

PLATE 113—*Wood-Block Print.*

PLATE 114—*Linoleum Print.*

283

Printed in the USA
CPSIA information can be obtained
at www.ICGtesting.com
LVHW031559250224
772763LV00029B/247